Iterations: The New Image

Iterations: The New Image

Exhibition Curated by
Timothy Druckrey and Charles Stainback

Edited by
Timothy Druckrey

International Center of Photography *New York City*
The MIT Press *Cambridge, Massachusetts, and London, England*

This publication was made possible by The Andrew W. Mellon Foundation,
and accompanies the exhibition

Iterations: The New Image

July 11– August 29, 1993 Montage 93: International Festival of the Image, Rochester, New York
October 15, 1993 – January 21, 1994 International Center of Photography Midtown, New York City

Curated by Timothy Druckrey and Charles Stainback and organized by the International Center of Photography.

Iterations:The New Image is sponsored by Professional Imaging, Eastman Kodak Company, with additional support from the National Endowment for the Arts, a Federal agency, and the New York State Council on the Arts.

Library of Congress Cataloging in Publication Data
Iterations: the new image / exhibition curated by Timothy Druckrey
 and Charles Stainback; edited by Timothy Druckrey.
 p. cm.
"July 11-August 29, 1993, Montage 93: International Festival of
the Image, Rochester, New York; October 16, 1993-January 21, 1994,
International Center of Photography Midtown, New York, New York"-
T.p. verso
Includes bibliographical references and index.
ISBN 0-262-04143-X
1. Computer art—Exhibitions. I. Druckrey, Timothy.
II. Stainback, Charles, 1952- . III. International Center of Photography.
N7433.8.I85 1993
760—dc20
 93-31695
 CIP

ISBN 0-262-04143-X

Edited by Timothy Druckrey
Designed by Emsworth Design, New York, NY
Production by Red Ink Productions, New York, NY
Printed in Iceland

On the cover: MANUAL (Suzanne Bloom/Ed Hill. Installation view of
The Constructed Forest ("This is the End - Let's Go On"- El Lissitsky), 1993
On the back cover: Detail from *Childhood/Hot and Cold Wars (The Appearance of Nature) (1993)* by Ken Feingold

Distributed by The MIT Press, 55 Hayward Street, Cambridge, MA 02142

Contents

Acknowledgments

Without the advice, assistance, and commitment of numerous people *Iterations: The New Image* would not have been possible. First and foremost we want to thank the artists—Gretchen Bender, Michael Brodsky, Jim Campbell, Michael Ensdorf, Ken Feingold, Carol Flax, Rocio Goff, Lynn Hershman, George Legrady, MANUAL (Ed Hill and Suzanne Bloom), Esther Parada, Keith Piper, Alan Rath, and Grahame Weinbren—for their input and patience in the organization of this exhibition and publication. We also want to thank those artists included in the video screenings included in the exhibition—Peer Bode, Patrice Caire, Sara Hornbacher, John Knecht, Elizabeth LeCompte and the Wooster Group, and Miroslaw Rogala. We also want to thank Paul DeMarinis, Ed Tannenbaum, and Susan kae Grant for their assistance in making Jim Pomeroy's work available for this exhibition.

With a project of this size and technical complexity the overall requirements are staggering. A very special thanks for their assistance and input in making this exhibition and publication a success is due to many individuals. At the International Center of Photography, Cornell Capa, Steve Rooney, Buzz Hartshorn, Ann Doherty, Phyllis Levine, Marie Spiller, and the entire staff of ICP's Exhibitions Department—Robert Hubany, Tom Hruby, Paula Curtz, Suzie Ruether, and Art Presson—were essential to the overall success of this project; and thanks particularly to David Zaza, who tirelessly oversaw the countless details of this project; and to Elissa Meyers and Susan Litecky for their exceptional work on various aspects of the exhibition and book. Diana Stoll deserves a special note of appreciation for judicious attention and good-humored patience editing all the text material in this publication and in all the exhibition signage. Additionally we would like to thank Amy Hughes for her input on the Introduction to this book. The technical expertise and wise assistance of John F. Simon, Jr. was invaluable throughout the organization of this exhibition and its installation. We are also indebted to Tony Drobinski and Jill Korostoff of Emsworth Design for designing this beautiful book.

Additionally we would like to extend our gratitude to the following people, whose help was vital to this project: Lisa Barlow; James Cathcart; Jim Davis of Hansdone Studio; Andy Deck; Roberta Friedman of Black Maria, Inc.; Christine Heun of Christine Heun Design; Rick Hock; Dieter Froese of Dekart Video; Michael Josefowicz of Red Ink Productions; Ron Kniffen of Uniset Corporation; Sarah Lazin of Sarah Lazin Books; Nathan Lyons and Susie Cohen of Montage 93; David Lubarsky; Lee Moulton, Jim Davis, Joel Romer, Grant Holcomb and the staff at the Memorial Art Gallery; Tracey Leipold, Scott McCarney; Debra Nelson of RCS Artsource; Robert Riley of the San Francisco Museum of Modern Art; Johanna Sophia; and Jim Via. Our deepest appreciation also goes to Roger Conover of The MIT Press whose initial and continued interest, commitment, and support of this publication were essential to its completion, and to Claude Lee, also of The MIT Press, who supervised so many details of the production of the book.

For their invaluable technical assistance with many of the works in *Iterations: The New Image*, we would also like to express our thanks to the following individuals and companies: Tom Reilly of SuperMac Technology; James Thomas of Polywell Computers, Inc.; Barbara Pennington and Hank Evers of Pioneer New Media Technologies; Bob Stein of the Voyager Company; Katie Morgan of the Time Warner Interactive Group; Thomas Hiniker of Blue Earth Research; Scott Geffert at Ken Hansen Electronic Imaging; Eastgate systems; and Michael Starks of 3DTV.

Finally, we extend our sincerest appreciation to Professional Imaging, Eastman Kodak Company, without whose generous support this exhibition could not have come about, and to the New York State Council on the Arts and the National Endowment for the Arts, a Federal agency, for awarding grants in support of this project.

TD & CS

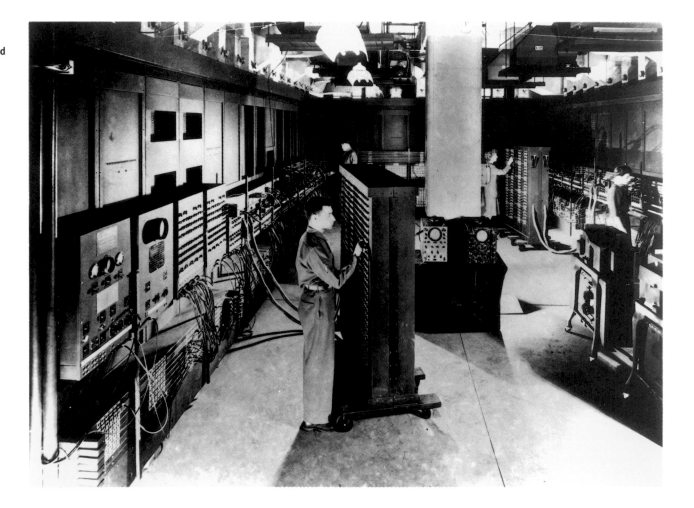

ENIAC (the electronic numerical integrator and computer) with attendants, 1946.

© Smithsonian Institution

Photo No. 72-2644

From Those Wonderful People Who Brought You Innovation

by Charles Stainback

What's past is prologue.

—William Shakespeare[1]

Wouldn't it be funny, if one could pierce the future, and find that photography was accepted as the great art form, because the mind—"intelligence" is more comprehensive—could be directed through a machine in a purer form, without the bungling interference of the hand!

—Edward Weston[2]

Throughout the past century and a half, beginning around the time of the Industrial Revolution, the introduction of new technologies has promoted everything from ardent pessimism and inexorable fear to total devotion and blind admiration. Incidents of nineteenth-century workers breaking into factories to destroy the machines that threatened their jobs gave way to turn-of-the-century homages to the machine by the Futurists, while Dada and Surrealist artists playfully utilized the machine in countless works. The more recent skepticism of the atomic age (with such devastation as the bombing of Hiroshima serving as a persistent reminder of technology's destructive capacities) and the mass-media age (typified by the current run of Hollywood movies awash in dazzling special effects facilitated by sophisticated computers), illustrates how the range of technological advancements plays a complex yet necessary function within our culture at large, to a greater or lesser degree shaping the culture while the culture in turn shapes the technology.

One such technology was born with the development of the first widely used photographic process, the daguerreotype. This techno-mechanical, photochemical process was ceremoniously introduced in Paris in 1839 at a joint meeting of the Académie des Sciences and the Académie des Beaux-Arts at the Institut de France. On that January day, art and science were clearly intended to be on equal footing, an association that has continued, with increasing complexities, through today. More

than a century later, another formal announcement and demonstration was staged: the news-making presentation of the first all-digital electronic computer on Valentine's Day, in 1946, at the Moore College of Electrical Engineering in Philadelphia. It was lauded as "an amazing machine that applies electronic speeds for the first time to mathematical tasks hitherto too difficult and cumbersome for solution."[3] The announcement highlighted what was then the primary, possibly the *only* foreseeable function of this new technology. The idea that it could have connections to the arts, let alone that it would develop the dramatic and far-reaching creative uses that we see today, was unimaginable, or at best conceived only in the futuristic predictions of science-fiction novels. While the basic principles of computing date back to around the same time as the introduction of the daguerreotype, or even earlier, ENIAC (the electronic numerical integrator and computer) essentially signaled the beginning of the digital computer revolution.

Some forty-five years after its introduction, this technological wonder has assumed countless roles in culture—in much the same way that the camera has established itself as a multifunctional technology—placing itself at the center of what could be called the second technological transformation, a shift from the industrial age to the electronic era. Computer technology has become so common in our daily lives (and now in the arts to an ever-increasing extent) that few would refute that it has been the driving force for much of the technological change of the last several decades and is *the* major force of cultural change we have yet seen for the future. It is the fuel for an evolution from the restrictions of the analogue world to the speculative, seemingly limitless potential of an expanding digital universe; a transformation that is already proving to be as resounding to us as the Industrial Revolution was to individuals during the nineteenth century.

With many other technological developments of the past century—X ray, electron microscope, and radio telescope, for example—their viability to future generations was never fully imagined by their inventors. These technologies, in addition to those of photography and computers, have altered our view of the "real" world. This transformation allows artists and scientists alike to explore, investigate, and present images that were previously inconceivable. Today, the computer is being used as both a creative tool and mediator, facilitating a collaboration between cinema, video, text, animation, and photography—it is merging distinct forms of representation with the possibilities of interpretation and integration of the digital age.

Details, January 1993, p.16

Technology generates activity, and as it becomes more accessible and cheaper it can be used as a material, and can give rise to an infinity of possibilities. — BILLY KLUVER [4]

Unfortunately, but understandably, since the introduction of the ENIAC, the use of computers by the artistic community has been limited by the expense. Nevertheless, a half-century after the ENIAC, computer technologies today are progressing at such a rapid pace that within the past decade, and especially within the past year or less, they have been widely disseminated throughout our culture and their cost has begun to drop. Getting a camera in your hands and getting your hands on the keyboard are activities that are beginning to take their distinct but related places within the current and historical context of technology and imaging. While the first photographs fulfilled an implicit social and cultural appetite for a quick and true-to-life direct likeness of everything from architecture to topography to the human figure, it was only the beginning of the disparate uses of the photograph that have come to follow. Today, computer technology has departed from its first uses—political, military, and scientific—and, like photography, has assumed a multitude of functions that are now distant relations to the medium's initial purpose.

Photographs appeared to be reliably distinguishable from other types of images. They were comfortably regarded as casually generated truthful reports about things in the real world, unlike more traditionally crafted images, which seemed notoriously ambiguous and uncertain human constructions—realizations of ineffable representational intentions. — WILLIAM J. MITCHELL [5]

The deconstruction of representation culminated with postmodernist criticism that amplified the disbelief in the long-standing, almost religious fervor for the photograph's veracity. One of photography's great attributes, believability, has been seriously challenged, almost nullified, by the introduction of the technical ability to move Egyptian pyramids, or to reconstruct the Los Angeles neighborhoods devastated in the 1992 riots,[6] or even to produce images that in reality never existed, but for all intents and purposes could soon have the look and the credibility of any photographic document. Photography and video—tools that have been strongly tied to a notion that whatever is presented by them is real and exists out there in the world—have moved squarely into the mainstream of contemporary art. Over the past thirty years, these two camera-based technologies have not only had a profound impact on art, but more importantly, they have reaffirmed the prominence of technology in art.

In the arts, the desire to find new things to say and new ways of saying them is the source of all life and interest

NORBERT WIENER[7]

Often utilized without regard for historical conventions or expectations, video and photography can be credited to some degree with prompting a departure from traditional art-historical canons. This move away from studio-based, handmade, canvas-and-easel art not only fostered greater use of alternative forms (including earthworks, installation art, performance art, and so on), it also gave credence to the notion, as Edward Weston noted, that art can be machine-made.

• • • • • • • • •

"Iterations: The New Image" is an attempt to explore a new generation of image-making systems in their formative stages. The works in "Iterations" utilize diverse technologies, from photography to video, touch screen to laserdisk, and employ sculptural and installation formats, as well as traditional photographic presentation. "Iterations: The New Image" is intended as a forum to begin exploring the potential of technology in the reshaping and redefinition of contemporary artistic practice.

"Iterations: The New Image" brings together an ambitious selection of works by many established figures in the fields of video, film, photography, and media art, artists who have exhibited extensively for many years throughout the United States and abroad. In addition to photography-based works by Gretchen Bender, Michael Brodsky, Michael Ensdorf, Carol Flax, and Esther Parada, "Iterations" includes the sculptural and screen-based works of Jim Campbell, Ken Feingold, Rocio Goff, Lynn Hershman, George Legrady, MANUAL (Ed Hill and Suzanne Bloom), Keith Piper, Jim Pomeroy, Alan Rath, Jeffrey Shaw, and Grahame Weinbren. These works employ a range of technologies that are exploring and defining a hybrid art form: the interactive artwork, which relies not only on the computer and other technologies, but on the interaction of the viewer with the technology itself.

A translation of the exhibition from the gallery to the printed page is not the intention of this book. This publication cannot claim to represent the multifaceted character of "Iterations: The New Image" as an exhibition. The form of some of the works—sculptural, large scale, incorporating sound, or temporal in nature—would make any translation from a carefully ordered gallery space to even the most well-designed page difficult at best. The objective is, however, to relate as closely as possible the

complexity and spirit of the works in "Iterations." Artists' statements have been used to clarify and illuminate the artistic intentions and innovative technologies of the work itself. And, with an exhibition and catalogue concentrating on technology and its potential in our future, it would be inappropriate if the book itself did not utilize the latest technologies. To this end, this publication in its entirety has been designed electronically.

As with the works included in "Iterations," the essays here have been selected to address significant issues related to digital technology today. The texts, by highly respected artists and writers Regina Cornwell, Timothy Druckrey, Brenda Laurel, and Florian Rötzer, investigate the wide-ranging issues associated with technology, at times extending their discussions to reveal the broad cultural concerns raised by technological development. In her essay, "On Dramatic Interaction," Brenda Laurel ruminates on her personal experiences in the computer industry beginning in the 1970s—she designed the Pac Man game—to her current work with virtual environments (virtual reality—which she calls "tele-presence") in which "users can become co-creators, collaborating at the deepest levels in the shaping of a mimetic whole." Laurel's unconstrained writing style, along with her background in theater, her experience in the computer industry, and her work as an artist, give her a voice that speaks as artist, critic, and audience.

Regina Cornwell, in "From the Analytical Engine to Lady's Ada's Art," traces a thread through the computer's history, beginning with nineteenth-century innovator Ada Byron (a.k.a. Lady Lovelace), to today's proliferation of computer-driven video games for the consumer market, and to interactive artworks that challenge the audience with experiences that differ substantially in form and substance from the typical war-driven content of most computer amusements. The militaristic connections (flight simulators) are the precursors—in form although by no means in content—to the interactive artworks of many of the artists in "Iterations."

Florian Rötzer addresses the perplexing crisis of representation in today's culture, and the difference between image and environment in his essay, "Image within Images, or, From the Image to the Virtual World." Rötzer discusses the tradition of machines that elevate the observer into another world, where the viewer can go beyond the image, and ask, "How are images separated from their environment as a world within a world?" However, as he points out when trying to determine what, in fact, an image is, we as a culture still find it necessary to distinguish between "relating to images and relating to reality."

Lastly, Timothy Druckrey (co-curator of "Iterations"), in his essay, "Revisioning Technology," looks at the transformation of "the epistemological order" throughout our culture from the nineteenth-century application of photography to the current technological advances that are having serious repercussions for the photographic medium, bringing us to a period best described as "postphotography." By addressing the numerous historical and societal issues of photography, and today's far-reaching implications of new technologies—from virtual reality to multimedia—Druckrey examines parallel issues integral to the exhibition itself and our attempt to illustrate the impact of technology on the arts and on culture.

The shift from the analogue world (silver-based photographic process) to an electronic one (digital-based), from the viewer (of static, framed artwork) to the participant (in multimedia, interactive artwork), is seen in "Iterations" with the diversity of works presented and strategies used. This shift is not limited to the select artists in this exhibition, but extends to many other individuals working today and is in fact central in our day-to-day lives—as witnessed by the explosion of media attention to the subject. The cover of a recent issue of *Newsweek* magazine reads:

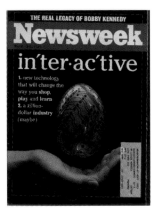

in'ter.ac'tive 1. new technology that will change the way we shop, play and learn 2. a zillion-dollar industry (maybe)[8]

This burgeoning electronic culture has begun to inundate our broader cultural lexicon, with media buzzwords shaping our understanding (or misunderstanding) of what the future holds; from interactivity to virtual reality, the numerous applications of computer technology are at the center of what has evolved into a multifaceted form that serves many mercurial functions—commercial, scientific, personal, artistic—throughout culture. The computer, a mere machine, has radically changed our visual objectivity and our manner of compiling and interpreting information. A technology that is used by many as a tool for communication, documentation, and creativity has placed itself squarely in the middle of our visual, verbal, creative, scientific, entertainment, informational, industrial, and educational needs. Simply stated, the computer is everywhere.

Cultural historian Warren Sussman notes, "Culture provides the very aspirations and other conditions that make innovation possible while at the same time themselves determining how the resulting

technology is shaped and used—or not used, in some cases."[9] Looking at cultural history alongside past technological advancements, the question of how we will choose to shape this newest technology the computer, while it is still in—we can only assume—its formative stages, is one that cannot be answered. Speculation that the only limitation of any new technological development is human imagination is scarcely a prediction. It might prove more prudent merely to take a quick look back over our shoulders at our past encounters with the future.

Notes

1. William Shakespeare, from *The Tempest* (1611–12), act II, sc. 1. Quoted on the frieze of the National Archives, Washington, D.C.

2. Edward Weston, *The Daybooks of Edward Weston,* Vol. II, ed. Nancy Newhall (Millerton, N.Y.: Aperture Books, 1961/1973), p. 228.

3. T. R. Kennedy, Jr., "Electronic Computer Flashes Answers, May Speed Engineering," *New York Times,* February 15, 1946, p. 1.

4. Billy Kluver, "The Artist and Industry," a lecture given at the Museum of Modern Art, New York, December 16, 1968. Billy Kluver was a scientist at Bell Laboratories and the president of Experiments in Art and Technology (E.A.T.), which, during the 1960s and early 1970s, organized exhibitions of innovative artworks that were dependent upon technology, works produced with the aid of scientists, engineers, and technicians. The most notable of these exhibitions was shown at the Pepsi Pavilion, *Expo '70,* in Osaka, Japan.

5. William J. Mitchell, *The Reconfigured Eye: Visual Truth in the Post Photographic Era* (Cambridge, Mass. and London: MIT Press, 1992), p. 225.

6. The cover image of the February 1982 issue of *National Geographic* showed the pyramids of Giza, where—with the aid of a computer—they had been pushed closer together to better fit the vertical magazine cover. More recent urban reorganization is seen with the Los Angeles City Council's use of a computer to simulate an eighty-square-block area (the Pico Union section of L.A.) to aid in the renovation of the devastated neighborhood after the 1992 riots. See *Details* magazine, January 1993, p. 16.

7. Norbert Wiener, *The Human Use of Human Beings: Cybernetics and Society* (Boston: Houghton, Mifflen Company, 1950), p. 134.

8. *Newsweek,* May 31, 1993, headline on cover page.

9. Warren I. Sussman, *Culture as History (The Transformation of American Society in the Twentieth Century)* (New York: Pantheon Books, 1984), p. 289.

Revisioning Technology

by Timothy Druckrey

We are entering a new century in which you are connected to the world, to the virtual world. And much more intimately than you are connected to the real world. . . .Our connection with the real world is very thin, and our connection with the artificial world is going to be more intimate and more satisfying than anything that's come before. MARVIN MINSKY[1]

If information is introduced into the circuit of the degradation of energy, it could perform miracles. . . . JACQUES LACAN[2]

If in fact the end of the nineteenth and the beginning of the twentieth century experienced the advent of the automotive vehicle, the dynamic vehicle of the railroad, the street, and then the air, then the end of the twentieth century seems to herald the next vehicle, the audiovisual one. A final mutation: static vehicle, substitute for the change of physical location, and extension of domestic inertia, a vehicle that ought at last to bring about the victory of sedentariness. PAUL VIRILIO[3]

I Artificial intelligence, artificial life, artificial reality, virtual reality, virtual corporations, virtual libraries, virtual communities, cyberspace, cyberpunk, dataspace, telepresence, interactive television, multimedia, videophones, ISDN, fiberoptic networks, internet, immersion . . . the list is growing. The language of culture is adapting to the language of technology. The past two decades have experienced transformations unimaginable even by the science fiction writers of the 1950s. The convergence of disciplines—science, communication, medicine, entertainment, the space industry, computing, biology, engineering, video, and the arts—represents a watershed of linked ideas, mostly associated with the issue of representation, which are increasingly "enframed," to use a term of Martin Heidegger, by technology. So much so that, as Elie Theofilakis writes, "the capacity of our sensory apparatus has been exceeded."

The discourse between images and knowledge, between cognition and epistemology, is being narrowed within the development of digital technology. For centuries images were linked with illu-

sionism, mimesis, identification, iconography, and the social logic of enlightenment ideology. Their status, and the power structure they represented, were dominated by the burgeoning significance of visual media. The technologies that reproduced and distributed images developed on a track parallel with the shifting subject matter the images were sustaining. Yet there has been little discussion of the urgent issue of the relationship between technology and expression. By the early part of the nineteenth century, technology was reaching a point where its instrumental value could begin to supplant the speculative and often philosophical inquiries of science. Indeed by the announcement of photography in 1839, the bond between technology and representation was firmly established. Photography altered the stakes in the relationship between images and power, and at the same time rooted itself in the experiences of every facet of life. This relationship has proved both profoundly problematic and critically consequential.

Technology and representation could easily be assimilated by the developing institutionalization of culture. Photographic images, misconceived as utterly objective, were effortlessly accepted as currency in the bourgeois order of exchange. As Alan Sekula so rightly observes: "Photography is haunted by two chattering ghosts: that of bourgeois science and that of bourgeois art. The first goes on about the truth of appearances, about the world reduced to a positive ensemble of facts, to a constellation of knowable and possessable *objects*. The second specter has the historical mission of apologizing for and redeeming the atrocities committed by the subservient—and more than spectral—hand of science. The second specter offers us a reconstructed *subject* in the luminous person of the artist. Thus, from 1839 onward, affirmative commentaries on photography have engaged in a comic, shuffling dance between technological determinism and auteurism."[4] By the middle of the nineteenth century, the "conditions were in play," as John Tagg writes, "for a striking *rendezvous*—the consequences of which are still living—between a novel form of the state and a new and developing technology of knowledge."[5]

As the ramifications of the deconstruction of both modernity and photography evolve, one must also consider how the effects of maturing technology affected the politics not just of the state power, but of the meaning of technologies of representation in the subjective lives of those who experienced them. Photography inebriated culture. Transformations—of memory, sentiment, the sense of self, otherness, and difference, the clash between history and experience—are essential to maintaining a grasp of the scope and effect of a symbol-making tradition under siege. The index came to supplant the

icon as a bearer of meaning. Photography measured reality against the yardstick of science while simultaneously providing a gauge to grapple with the subtleties of mortality and emotion.

Photography provided a reference point for the impossibility of sustaining temporality and a reference objcct, rightly viewed as fetishistic, that rationalized the unrealizable goal of immortality. Indeed, time and memory, along with politics and history, are inexorably bound to the photographic. And while the lingering effects of the politics of representation haunt photographic history, it is clear that culture was poised to contend with the conditions of the historical present. What joined these optic subjectivities and panoptic objectivities was a medium whose instrumentality was as persuasive as its mendacity. For all the triumphs and mystifications of what Rosalind Krauss calls "modernist opti-cality," what Martin Jay calls "the scopic regimes of modernity," what Jonathan Crary calls "techniques of the observer," the deconstruction of photography's persuasiveness as an essential element in communication is incomplete.[6]

While the struggle to assimilate photography into the institutions of modernity positioned it uncomfortably within art, politics, and science, the effect of images was transforming the epistemolog-ical order. The relationship between knowledge and power, as Michel Foucault observes became intri-cately related to technologies of seeing and the logic of observation. Photography served as a measure of individual ontological presence as much as it was a legitimation of experience as epistemologically complete. In many ways photography displaced the assumptions of modernist art and not an autonomous, reflexive, subjective connection with experience, but, rather, established a discursive rela-tionship with the stark actuality of being. Indeed when photography struggled to elevate its status to that of so-called high art, it often revealed a comic mimicry that bolstered mediocrity and simultane-ously initiated the eradication of the boundary between technology, creativity, and art.

By the turn of the century, photography's sanguine popularity had been fixed in the development of the amateur camera. And while art photographers balked at the presumptuousness of the hordes of neophytes, photography had soaked into social ritual and popular culture so deeply that linking it with art seemed preposterous. And yet, paradoxically, the most startling innovations in photographic prac-tice developed from a social upheaval masked in aesthetics, specifically in the sublation of what so stultified the importance of photography: form. What emerged in the decade of the 1920s was a recon-struction of photography's relationship with signification. In the usurpation of the medium's menial

correspondence with the world, the image could be defiant and even revolutionary. What salvaged the image was the willingness to make it seize the issue of culture and imagination as representable. What followed was a period in which the photograph was systematically unhinged from an elementary relationship with events.

In Dada, Surrealism, and in particular montage, the role of photography was both shattered and urgent. Photography had become an omnivorous presence whose symbolic strength pervaded culture. The complex history of photography during the twenties and thirties is more than the triumph of a "new vision," it is an unfolding of the persuasive effect of representation, increasingly coupled with technology. The hand camera, the film camera, and mass reproducibility were signifiers of this relationship. While formal investigations into the possibilities of seeing through technology were widely viewed as startling objective form, an(other) side of photography was being examined, that of its bond with subjectivity. Astride the "new objectivity," was a deepening affiliation of representation with politics and psychoanalysis. Suddenly, the stunning complexity of images was exposed as dialectical, related both to the contingency of events and to the temporality of the unconscious. Images had saturated the public sphere and the psyche.

Montage was the crucial form to emerge in this period. Amidst chaotic cultural transformation, the avalanche of competing images, and the technologizing of reproducibility, montage represents an attempt both to separate the image from singular, linear, positions and to situate a constellation of images within a frame. "Testing reality" was the phrase used by Walter Benjamin to describe the revolutionary strength of Dadaism. Reality shocked, authenticity was in question, and the emerging mediating fact was that technology was embedding itself in creativity and imagination. Imagery was expropriated from the stockpile of (al)ready-made productions of culture. Indeed the critique of mass culture itself originated in the recognition of the transformations instituted by the technologies of reproducibility joined with the troubled ideologies of both fascism and bourgeois mastery. In some ways, montage was about more than shock, it was about violence.

The mechanism of photography had indeed "enframed" experience. Modernity, enraptured by optic hegemony, had reached a juncture that equated the "moralization of objectivity" with power. As Rosalind Krauss writes: "Modernist visuality wants nothing more than to be the display of reason, of the rationalized, the coded, the abstracted, the law."[7]

II *If the social machine manufactures representations, it also manufactures itself from representations. . . . Decentered, in panic, thrown into confusion by all this new magic of the visible, the human eye finds itself affected with a series of limits and doubts. The mechanical eye, the photographic lens, while it intrigues and fascinates, functions also as a guarantor of the identity of the visible with the normality of vision.*[8]

This remark about what Jean-Louis Comolli identifies as "the frenzy of the visible," was directed at the second half of the nineteenth century. By 1918, Dziga Vertov was writing: "I am the camera's eye. I am the machine which shows you the world as I alone see it. Starting from today, I am forever free of human immobility. I am in perpetual movement. . . ." The machine and the body are joined as perception itself becomes "enframed" in expression. What seems so clear is that the modification of the visual world in modernity is characterized by the consolidation of the scientific mastery over nature and a representational model wholly linked with technology.

The development of technology is rooted in notions of social progress. So-called primitive technologies were deployed in social systems where the transformation of matter was essential. While the development of technology, particularly through the nineteenth century, was increasingly concerned with vision, the transformative technologies of industry maintained a functional purpose that formed the unfortunate groundwork for a concept of progress that hinged on efficient methods of consumption within a culture of industrial production. Technology was not conceptualized within any coherent discourse of social change, or of the human impact made by its contingent ontological and epistemological changes.

Technology altered a relationship with history in ways that were directed at the present and the future. A fragmented material order—one splintered by the deconstruction of temporality, the split of the atom, the development of externalized sentiment, deracinated signifiers, wireless communication, Taylorism, and a sense of detachment from an uncomplicated realist world view—was supplanting the order of mastery and control. What seems so interesting is that while the shattering of space was proceeding, the emerging image was that of temporal processes. The temporal image replaced the spatial image of the past. Indeed one could find in montage the crisis of a respatialized image merging with a multi faceted, one might say pre temporal, representation.

But while the essentials are comparable, the culture of modernity, in which the mechanization of vision evolved, has been surpassed. A mechanical model has been usurped by a technological model. If

there is a common denominator within the discourses of postmodernity, it is in the ascendancy of a system of scientific visualization and the loss of any totalizing model of either the "real" world or its representations. Images can no longer guarantee the legitimacy of the "normality" of seeing. The "frenzy of the visible" might be adapted to read "the frenzy of the virtual." But even considering the efficacy of representational issues, a structural difference exists between the panoptic authority of modernity and the transoptic discourses of postmodernity. The privileging of vision in modernism as revelatory has been outdistanced by discursive practices in which a refigured subjectivity participates not at the level of the perceptual, but on the level of the cognitive.

III

Ultimately, the intellectual debate surrounding modernity seems part of a derealization phenomenon which simultaneously involves disciplines of expression, modes of representation, and modes of communication. If, in fact, there is a crisis today, it is a crisis of ethical and esthetic references, the inability to come to terms with events in an environment where appearances are against us. How can we no longer believe our own eyes and believe so easily in the vectors of electronic representation?[9]

Cybernetics speculated about the coupling of machine and person. Ever since the publication of Norbert Wiener's seminal *Cybernetics, or Control and Communication in the Animal and Machine* in 1948, the trajectory of technology development has been one of an increasing possibility of achieving that interface. Over the last decade, the possibility of defining a relationship not simply between but within technology has become plausible. Yet, the commercialization of cybernetics came neither as a technical panacea nor without deep ethical concerns.

As machines mutate into nanomachines they come closer to the biological. The moral, philosophical, and political values of technology are challenged to do more than confront conceptualized situations, but rather to theorize the possibility of programmed, enhanced, or simulated being. At the same time, the development of "realities" that are characterized as "virtual" are beginning to surround experience. The shift from technologies that "enframe" experience to technologies that immerse experience is portentous. The penetration of technology within the body and the socialization of simulated realities is more than a signifier of technological progress, it marks a radical transformation of knowledge, of biology, and of the cultural order in which knowledge is linked with ideology, biology, or identity in

terms of a technological imperative not fundamentally connected with necessity. The issues raised by this potential for the narrowing of the boundary between technology and experience are vast.

In many ways the development of several parallel technologies has reached a crucial point. The convergence of the principles of artificial intelligence, the rich potential of cognitive science, the systematic ability to simulate perception, the revolutionary development of computing power, the stunning maturation of computed graphics, and the lapsing efficacy of passive media is implicated in a cultural shift of daunting proportions.

Technology has outdistanced hard science and now encompasses virtually every industry. The hype about virtual reality, now retreating into the academies and backtracking from unreachable presumptions, makes it plain that the fashionabe links between technology and imagination, technology and desire, technology and the body, and technology and the liberation from actuality, are resident in the imagination in a newly mediated form. Instead of a simplistic connection between style and illusion, VR draws on the euphoria of simulation. Immersive and interactive environments appear at present as novelties. Dimensional interfaces and "tactile" feedback represent a powerful possibility. In robotics, medicine, design, simulation, the idea of spatial integration is a tremendous benefit. For the arts, access to technologies that wholly engage the participant, could be a final blow to worn traditions of images.

In a culture in which accelerated images situate experience, the immediate has become compressed and volatile. Images have never contained the potential to sustain so much information, or, perhaps, meaning. Electronic montage, photographic resolution animation, the erosion of photography by the increasing acceptability of video as a signifier of authenticity (witness the Rodney King and Gulf War videos), the abandonment of images as evidence (witness the Rodney King and Gulf War videos!), and paradoxically the concentration on the use of images in a culture where destability is sustained by fleeting computerized optical forms, conspire to suggest a refunctioned visuality.

The consequence of this unsettled state of electronic visualization is the equivocal image. Legitimated by the perceptual models of photography and by the algorithms of perception, the electronic image vacillates between actuality and conjecture. The relationship between the seen and the experienced is challenged in this environment. Indeed the transformation of knowledge generated by post photographic images affects both knowledge and communication at every level. And while the attempt to consider the utter materiality of the image as a reversal of the idealist practices of photog-

raphy may have problems, it nevertheless seems important to track the significance of the image after photography in terms of the technologies of the cybernetic and the cognitive as well as the semiotic. "Postphotography is no longer modeled on an optical consciousness operating independently of its material and symbolic contexts," writes David Tomas in "From the Photograph to Postphotographic Practice: Toward a Postoptical Ecology of the Eye,"[10] it is rooted instead in an "ecosystemic approach of contextually current processes of production." Kevin Robins' use of the term "postphotographic" appears in the article "The Virtual Unconscious in Postphotography." Rather than sheer materiality, Robins more directly implicates technology in the "postecological" and the virtual: "postphotography promises a new image where the real and unreal intermingle."[11] Photography's deteriorating efficacy as information surely isn't a consequence of the mere substitution models suggested by computer simulation, but is the result of deep problems in representation itself. The limits of photography, paralleling the limits of language, indicate that formal and self-reflexive models of expression no longer serve the symbolic imperatives of this culture.

The recognition of the dematerialization of the "real" is no shock to the art world. For more than a decade cultural and art theory has been speculating about the social transformation what is being called the New World Order. Indeed a generation of artists have disputed the claims not only of representation but of the efficacy of art without a deconstructed producer. The focus of this critique, however, was not primarily on technology, but on the status of the subject in terms of representation. But it is clear that the framework for the shift from industrial to service to information economies has been fueled by the computer. Only slowly has cultural theory come to consider this. The art world has, in too many ways, been reluctant to acknowledge technology as integral to the creative process. Often marginalized, art produced with technology (and this might include video and installation), found its forum in alternative spaces and in festivals of new media. Well-founded skepticism, though it exposed deep ethical conflicts in relation to the manipulative uses of technology, often didn't, or couldn't, pose alternatives in which technology's presumed power could be usurped or creatively deployed. The notion of "visual truth"[12] has been exposed as a fallacy at the same time that it has assumed an ever-greater instantaneous power. "Images," says Paul Virilio, "have become munitions."[13]

Suddenly, the impact of electronic media and digital imagery has become a specter to be encountered. The fear of compromise with often elaborate corporate interests and with the presumed frailty

of the machines themselves set the art world outside its status as future oriented. The decade of the eighties turned its attention instead to the no less urgent issues of sexual politics, multiculturalism, gender studies, and serious and far-reaching philosophical critiques of representation. The importance of the ideas emerging from this period have not been fully realized. But the usefulness of social theory in postmodern culture is essential for an understanding not just of the function of representation in art and media, but also of the constitution of a culture inebriated by the emerging media of technology.

IV *Only the revolution replacing real numbers and their infinite number of places behind the decimal point with calculable quantities of entire numbers has been able to bring about the modern manipulation of images.* [14]

Scientific visualization is achieving a revitalized status at the same time that the privatization of the image market drives visualization out of the research labs of NASA or the Air Force and into the entertainment industry. The motion-picture industry has been quick in funding productions that promote the technologies of photographic resolution animation. Films like *Bladerunner, Tron, Terminator 2, Until the End of the World, Lawnmower Man, Wild Palms,* and, most recently, *Jurassic Park,* have used various themes and techniques to depict a future ranging from a brutal postmodern landscape, a compulsion to experience memories plugged into virtual machinery, to the use of technology to create the spectacular attraction of a genetically recast dinosaur habitat controlled by presumptions doomed from the start. While the fascination of the ability to generate effects of impressive simulation is maturing, film studios and the computer industry are edging toward collaborations that will revolutionize entertainment and simulation. It is clear that the interest in virtual reality technology is high on the list of potential developments.

VR represents a series of developments in the human-computer interface that have reached quickly into the public's imagination. In VR, the visual experience is generated by powerful computers that track the movement of the head and body and render, in pseudo-real-time, a dimensional scene. Use of the prosthetic devices of the virtual system, head-mounted displays, data gloves, body suits, encase the body in fiber-optic cabling. Movement is computed and a representation of the body displayed within the scene. "Eyes and mouth," writes Friedrich Kittler, "long accepted as the last refuge

of intimacy, will be integrated in a feedback logic which is not ours, but that of the machine. The affect of VR would not be so unsettling if we did not realize that we are being observed by something that we cannot acknowledge as subject or persona in the traditional sense, and which nonetheless constantly demonstrates that it sees us without revealing itself."[15] Immersion, the absorption of the senses within the system, represents a "triumph of technology" and a challenge to the structures of representation. Jaron Lanier, the founder of an early VR venture and media spokesperson for so much of the field, speaks of "postsymbolic communication, communication beyond description" with the blithe confidence that VR is not utterly symbolic.

More speculative than actual, VR technology lags behind often zealous metaphysics and media hype. Lanier continues: "VR is not like the next way computers will be; it's much broader than the idea of a computer. VR is an alternative reality and you shouldn't carry over into VR the limitations that are necessary for computers to make sense. Because what we are synthesizing here is reality itself."[16] This kind of exaggeration haunts the virtual discourse of cyberspace. A series of recent books explore the issues of VR— most falling into the quagmire of concretizing or academizing VR as a substantive alternative. Despite persuasive uses in medicine, physics, biology, robotics, and data management, VR has a social presence far outdistancing its actuality.

What seems so fascinating about the issues of immersion and virtual reality is that they substantiate the problematic of representation itself. Slajov Zizek writes: "The ultimate lesson of the virtual reality is the virtualization of the very 'true' reality. By the mirage of 'VR,' the 'true' reality itself is posited as a semblance of itself, as a pure symbolic construct. The fact that 'the computer doesn't think' means that the price for our access to 'reality' is also that something must remain unthought."[17] Participatory "worlds," tactile feedback, the liberation of the body from the constraints of material imagination, pinpoint the Real, as Jacques Lacan realized, as wholly unrepresentable.

If VR is "constructed outside the grammar and syntax of language," and can "defy the traditional logic of verbal and visual information," as Michael Heim, following Lanier, suggests, then the foundations of communication are being posed within the experience of a programmed system that is itself wholly regulated. The images in VR are neither "outside," nor "defiant." They support the development of technologies that command attention, and that have a clear history in which VR is simply another manifestation. Indeed what images represent in VR often replicate simplistic pictorial traditions that

hardly demonstrate a substantive grasp of the complicated history of imaging, semiotics, or of meaningful experience. VR experiences are as underconceptualized as they are overtheorized.

While VR has played a significant part in the glamorization of technologies of representation in the past few years, it is paralleled by significant developments in the less speculative, but more practical fields of interactive media, multimedia, and hypertext. The relationship between interactive, multi-and hyper-media and the breakdown of "master narratives" (as Jean-François Lyotard suggests), is not coincidental. Rather, the links between the development of digital technology and that of postmodern culture are becoming clearer. Add to this the merging of the computer, information, telecommunication, and entertainment industries, and the foreclosure of the field seems obvious.

To address the shift from photography to interactive media some reformulations are necessary. If the essentialist characterizations of photography are to be simply grafted into "postphotography," then theory will be circumscribed by lingering of critiques of representation that are not fully adequate for interactive imagery. Complicating this developing area are reemerging relationships between text, image, and sound that cannot be articulated as linear or absolute. The relativistic potential for text/image/sound suggests a form of multivalent montage. Interactive fiction and electronic books (called e-books), and an range of CD-ROM titles, are expanding the scope of digital technology into a range of projects in the arena of participatory media. Newsweek Interactive, Time/Warner's Interactive Group, and most pertinently Voyager's ambitious projects in CD-ROM, Laserdisk, and Expanded Books, make it clear that interactive electronic publishing is being tentatively welcomed. The titles range from children's stories and games to encyclopedias, with everything in between. What emerges from these titles is not simply a convenient form of distribution but a way of navigating through information in a form that animates the process as a kind of exploration. Linked "regions" of the material can be referenced and accessed in layers which are nonlinear, connected by intention rather than sequence.

Interactive works begin to pose the problem of the breakdown not of meaning but of the linear concept of rational(ized) order. Nonlinear principles of form, in fact, are the signifier of a culture accustomed to fragmentation and montage. Unhinged from the tropes of modernity, the combinations of these differing forms of expression are liberated from normative functions and are presented as potential rather than totalized. Information in this environment comes as an array rather than as a sequence. Deciphering the array—or even producing the array—is no longer a sign of "schizophrenic" experience,

but of rendering the codes of experience as a new social logic. It comes as no surprise that multimedia, for example, emerges alongside multiculturalism as a theme in postmodern/posthistorical/postphotographic culture. Social difference, like information dispersal, is not a sign of collapse, but a form of empowerment that exposes the spurious claims of unified configurations of identity or power. The impact of deconstruction during the 1980s, particularly within feminism, reset the issues of power and identity as discursive formations whose efficacy was no longer presumed and whose authority was debunked. As Stuart Hall remarks: "Now that, in the postmodern age, you all feel so dispersed I become centered. What I've thought of as dispersed and fragmented comes, paradoxically, to be the representative modern experience." Identity, experience, and technology now assume equal status in the culture of hypermedia, whose distributed data is navigated thematically rather than sequentially.

Interactive work will also require a reassessment of the relationship linking experience and discourse. If images are to become increasingly experiential, then a theory of representation must be evolved to account for the transaction provoked by participation. Simultaneously, the repercussions of the rupture of narrative and the slowly maturing response, in the guise of hypermedia, has suggested that linear texts are exhausted and that a range of expanded forms will offer experiences consistent with demand. The intention of the producer and the intention of the participant will become reciprocal. While this endangers the authorial position of the producer, it simultaneously must account for an audience willing to investigate the space of electronic expression.

Cable companies are scrambling to develop interactive television systems capable of yielding participation in the form of user-defined selections and transactive links with an electronic order. Al Gore's widely publicized interest in technology, as chair of the Senate Subcommittee on Science and Technology, brought hearings on telecommunications and virtual reality to Washington. Gore's enthusiasm about the "data superhighway" already sparkles with the glint of a reinvented infrastructure that would be fueled not by oil but by information. A national priority, the fiber optic network signifies a consolidated intention to link publishing, libraries, e-mail, data exchange, and entertainment on the high-capacity, high-speed network. Resistance to the publicly funded "superhighway" comes from many quarters. Phone, cable, and public interest groups like the Electronic Frontier Foundation, balk at anything but government "incenting" (as AT&T Chief Executive Robert Allen suggests). On the other side, "members of a computer manufacturer's group called the Computer Systems Policy Project, which

included I.B.M., Apple, and Digital, called for the creation of a government entity to be chaired by Mr. Gore and called the National Information Infrastructure Council."[18]

Whether funded or supported by private or public funds, the media environment of the next decade is going to be situated between two forms of political regulation, one economic and the other moral. How much either faction grasps the human consequences of an information order grounded in the assumption that users (one can hardly think of citizens) are computer literate, and are in a position to have access, if not possession, of the equipment necessary to participate in the benefits of the "highway" is a disputed territory.

Information technologies demand a reconfigured model of social change. Technology has reached a stage in which its effects can be processed in a system of feedback. The technologies that emerge from this are those we think of as immersive. This transformative aspect of technology, in which there is a shift from media that "enframe" to technologies that immerse, is the most disruptive and most challenging dimension of the shift from the triumph of machines to the biologizing of technology. "Can these technologies," asks Donna Haraway, "be prosthetic devices for building connections? . . . Can these technologies be part of producing social agencies in first world cultures that are less imperializing?" "My hope," she writes, is "that the power, the visual and sensory power of the technology, can be a way of dramatizing the relativity of our place in the world, and not the illusions of total power."[19]

V "Computer art" evolved simultaneously with often radical theories of representation. A discourse between the two, however, did not occur. Caught in the rationale of technovelty, digital images (including animation, graphic design, video) somehow seemed self-justifying and immune from the concerns of cultural criticism. Any reading of the hype surrounding digital culture and art shows that the responses range from dizzying exaggeration to ethical solipsism, from paranoia to euphoria. Nevertheless, the merging discourses of creativity, technology, scientific visualization, experience, and art have reached critical mass. Theories of interactivity must be joined with theories of discourse. Without this, the affiliations between representation, intention, and technology will remain mired in outmoded presumptions about the "two cultures." Images can no longer be disassociated from the tools used to produce them.

Three principle directions are emerging from the technologies of the computer. The first is a hybrid form of montage. The second, a mixture of sound, image, and text within interactive, often screen-based, media. The third is speculative and encompasses a range of possibilities, from electronic sculpture to immersive and virtual technology. While these media aren't limited to the arts, they are decisively affecting creativity.

The works in "Iterations: The New Image" form a series of responses to the impact of digital technology. Improvising with a number of different systems, these artists have found that working with electronic media demands a revamped theory of representation that is flexible enough to integrate technology, and that considers the effects of the means of production within the making of images and experiences.

"What happens when you connect everything to everything?"[20] Kevin Kelly's question is central to the development of creative responses either to deconstruction as well as the potential of new media, Suddenly, the ability to integrate and expand the creative process with merged media allows for the realization of hypermedia and interactivity. Add to this the effects of communications technologies and computing and the fusion could be unlimited.

In the repercussions of media theorization, one of the areas that has tremendous effect on digital imaging is the ability to consume and refunction the media—including technology itself. In Michael Ensdorf's "Fiction" and "Minor Players" series, the response is aimed at the falsity of memory constructed in fleeting media images. Mnemonically used, the images evoke moments of cultural transformation even as they are unhinged from their historical actuality. "Fiction" is at the root of notion of the virtual. What becomes evident in these deceptively simple works is an idea of repetition, whose history lies in the legacy of Pop art but whose salience is connected not simply with repetition and consumerism, but also with the singularity of events and the recapitulation of an ideology of prevarication. Grids made up of faces from events whose stunning signification has been marginalized and depoliticized emerge in Ensdorf's sequences. While the fictions of events, in some sense, demand a rethinking of the historicity of images in terms of culture, the acceleration of images pervades our experience.

Michael Brodsky's *Dark Passages* interrupts this flow without halting the convergence or collision of data. Utilizing the simplest—one might say primitive—form of graphic representation for the computer, the images merge the bluntness of pixels into the patterns of images. Yet the delicately

sutured edges of these composite images surge with tension. One image discharges into another. The pulsing of the sequence, like the oscillations of electrical energy, are the packets of data ebbing in a network of visibility. Never incoherent, yet never totalized, the imagery in Brodsky's work confront the electronic environment with a cryptic logic that equates the flow with movement and narrative.

While the fascinations of digital imagery surface primarily in the form of entertainment, the development of the technologies of imaging have deep roots in military and space research. Never was the use of militarized media so persuasive (and perverse) as during the conflict in the Persian Gulf. Technology served to convince the public that its effects were so precise they could be identified as "surgical." A generation of "smart" technologies was heralded as a panacea of the process. At the same time, the Gulf War was a conflict wholly about representation and technology. The fascination with the aesthetics of violence and the link between entertainment and illusion are an increasingly manifest component of critical theory. What emerges from the work in Gretchen Bender's *Entertainment Cocoon*—from an ongoing work deconstructing the barrier that shields the bond between representation, power, and technology—is a grasp of the "seduction" of imagery as an essential element in the strategic arsenal of power. Bender's works are poised to assimilate the forms of technological production, and refuse the logic of authority.

Layered in the imagery of electronic montage is a possibility to merge memory and temporality. What particularly hindered traditional photography was the limitation of instantaneity. If time and narrative are reconnected, the breadth of issues can be refigured. Carol Flax's images fuse personal memory with an overlay of both irony and narration. Layers of images meet layers of text, personal history mingles with social image. Flax's sentimental deconstructions reintroduce the idea of subjectivity into art production, while at the same time demonstrating the fluidity of the digital image as an ideal mechanism for constructing history in terms of experience.

Like memory, history is constructed of stratified information. The succession of events, though, doesn't fully suffice to unveil the relationship between history and the present, public and private. Indeed the opposition between the two is not apparent in a singular form. Esther Parada's *2-3-4: Digital Revisions in Time and Space* produces a dialectic between history and culture that is neither nostalgic nor allegorical. Rather, Parada finds woven in the texture of the historical an image of power relations whose effects are linked directly with culture. The monuments of European expansion, exem-

plified by Columbus, are disconnected from their status as genuine or celebratory and are contextual-
ized as markers of imperialism.

Concerns with social impact of the transformation from industry to technology have been a
continuing interest of both cultural theory and art. For the past decade the works of MANUAL (Ed Hill
and Suzanne Bloom) have focused on the evolving technologies of representation in terms of their
relationship both to language and to the transformation of nature. *The Constructed Forest* represents a
culmination and a revitalized interaction with the issues of power and the opposition between simula-
tion and the material world. The linking of photography, video, and interactivity within the exposed
frames of a wooden wall, posit the autonomy of nature as a fallacy whose survival is wholly immersed
in technology; from the management of resources, the development of controlled growth, the design of
forests as profiles in ecology, to the development of ersatz environments whose efficacy lies more in
cunning illusion than in enlightened ecological policy.

If issues of the shift from "nature" to a nature mediated and controlled by technology represent
one facet of the response to computer-produced progress, the issue of the individual is yet another.
One significant aspect of the "simulation industry" is found precisely in posing the question of identity
in stark terms. Rather than consider the impact of technology on a conception of nature, Keith Piper
examines the social effect of technology of the self, as circumscribed by technologies of information
and surveillance. *Tagging the Other* is an investigation of racial stereotyping and data collection. Like
information collection itself, the effect of the work is cumulative. Superimposed streams of collected
data pour across and within the screens. And while the politics of information, intellectual property,
the management of culture with electronic media creeps closer to maturation, the issues of identity are
being outdistanced by the destabilization of identity and by incipient racism and classism that often
emerge from technologies.

Parody and deconstruction have an uneasy kinship. Yet the pairing of the two can produce results
whose comic politics expose some of the deepest illusions in the construction of reality. Jim Pomeroy's
Apollo Jest reconstructs the Apollo landing on the moon. Using a parodic documentary-narrative
coupled with illusory stereographic perspective, *Apollo Jest* fictionalizes using two forms of depth, one
narrative and the other spatial. The use of found, appropriated, and created images represents a mix of
genres that find curious bonds in the narrative that accompanies the images. The work confronts the

construction of social mythology at the same time that it unhinges the comfortable assumption that what we see and hear is inexorably linked with fact. A word of caution comes at the end of the introduction to the work: "Use of this product may contribute to violation of the sacred integrity of a spiritual unifier. This is definitely the wrong stuff."

The bond linking emotion and imagery has been a continuing presence in the history of photography. Photographs came to serve more than mimetic functions, they attempt to capture states of mind. These moments, curiously temporal and timeless, have a place in the work of such opposing photographers as Henri Cartier-Bresson, with his "decisive moments" and Alfred Stieglitz, in the "equivalents." These images stood as signifiers of the image's ability to transcend language and invoke the pathos of recognition. George Legrady's *Equivalents II* stands against this immediacy, and yet invokes a deeper affinity between image and subjectivity. The images rendered on the screen are based on the reciprocity between language and desire. The computer's ability to create an image from sequences of letters forming an algorithm would seem to be an exercise in processing and randomness. Yet the opposite occurs. Emerging from the clock cycles and the resolution developing in the screen image, images are produced that evolve toward representation. There is an inversion of tradition in which images are broken into constituents. *Equivalents II* interrogates representation as a presumption and poses the possibility of a poetics of information.

One of the catchphrases in recent computing is "real time," the ability of the computer to display rendered images without the delays in processing that leave slow and jerky images. Jim Campbell's *Digital Watch* and *Memory/Recollection* establish a relationship with temporality that investigates time, memory, and history in pertinent forms. *Digital Watch* confronts the viewer with the superimposition of time and recursion. Presence and absence play important roles. The audible ticking of the clock becomes as much a signifier of mortality as a metaphor for the seeming coexistence of memory and history. The work juxtaposes live and recorded moments. Interactivity and participation are a negotiation with the work's presence. More subtle in its historicity, *Memory/Recollection* is about presence but also about forms of memory and history. Continuously recording the image from a video camera, the work captures and slowly disintegrates an image across the five small displays. Fragile, short-term memory, though, is only a one element in the work. Images are written to the computer's memory and recalled periodically. In some ways the work is a record of the exhibition. Stored images

recur on the screens randomly like an association disconnected from conscious thought. As a kind of witness to the exhibition, the detached memory of the computer nevertheless holds snapshots of interaction.

Subjectivity, memory, history, and temporality are issues whose relationship to digital media once seemed implausible. Yet the pervasiveness of computer databases and information gathering make it clear that the boundary between the machine and experience is narrowing. For more than a century, the technologies of representation have evolved amid developing industries and narratives. Rocio Goff's *Weaving Histories* tracks the history of the alliance between storytelling and personal history, and the connection between the mechanization of the loom and early computing. So much of the discourse of current computing is hinged on concepts of hypermedia, a form of nonlinear narration built of associations rather than on linear cause and effect. Goff's work is held together by relationships between weaving, memory, and history. Its voices are chosen and each leads to a different facet of the work. It culminates in a story that alternates between personal memory, cultural history, and the metanarratives of authority.

Much of the public discourse about interactive technologies is tinged with a seductive edge that particularly surfaces in writing about cyberspace. Tactile feedback, immersive illusions and metaphors of control are firmly rooted concepts in both culture and technology. Already the industry has discovered that sexuality and electronic distribution of interactive media are profitable. "Digital sex," "cybersex," "teledildonics," are just a few of the terms to describe the fusion of technology and sexuality. Yet the discourses of cyborg sex must confront more than the challenge of the relationship between desire and technology, and must pivot on the issue of desire itself. Lynn Hershman's *Room of One's Own* both invites and dissuades. The act of looking becomes one that is controlled by the viewer at the same time that this act is questioned by the content of the work. The boundary linking voyeurism and the power of the gaze as objectifying and imposing are structured as synonymous. The potential scenes in the work call for volition and for violation. The work indeed dissuades you, asking "what are you looking at . . . why don't you look away . . ." while "enticing" a continuing look. In the end the reciprocity between seeing and power are unfolded. The gaze is uncomfortably returned and intent is queried by the seemingly anonymous woman within technology.

So much of our fascination with technology is rooted in the spectacles of military and space

research that their successes and failures have powerful effects on our history. Alan Rath's *Challenger* is an ambitious response to the tragedy and history of the explosion. Virilio has written that "every technology brings a corresponding form of accident," a remark that acknowledges the inversion of facile notions of progress. Rath's work is an exemplary deconstruction, but at the same time refuses to slip into the trap of nihilism. The fifteen-minute cycle of the work forms an allegory of technoculture without losing sight of the human scale of the space-shuttle disaster. With a narrative of appropriated images and broadcast accounts of the history of the space program (beginning with John Kennedy's proclamation initiating the events that led to the Apollo landing in July 1969 and ending with the recurring question "What went wrong?"), *Challenger* situates the explosion as a fact and simultaneously evokes far more than a mere representation of the fiasco itself. The work addresses a series of issues concerning the infallibility of technology and the responses of a culture too easily swayed by spectacle.

The Gulf War, with its endless video sequences of "smart" weapons performing surgical strikes on military targets within Iraq, raised a number of issues about the triumphs of technology. But these questions are more deeply rooted in our experience than we might readily admit. The images in Ken Feingold's *Childhood/Hot and Cold Wars/The Appearance of Nature* involve anxious memories of a culture whose associations with violence have been shaped by strategies and dissimulations not directly produced or situated within the Pentagon, but located within the shared experience of the media. The clockface/screen in this work locates experience within a flow of images—from sci-fi and propaganda films, TV shows, cartoons, documentary footage—that correspond to the violent aesthetics of cold war media. In this work, Michel Foucault's "archaeology of knowledge" collides with Jacques Lacan's "screen memories." Personal history and childhood are overshadowed by truculent entertainment. Cultural history loses its quotidian value. As Walter Benjamin remarked, "there is no document of history which is not at the same time a document of barbarism." Feingold's work dismantles the notion of history as comfortable narrative and instead provokes an evaluation of its consequences in persuasive form. The participant in this work is drawn into a curious position of power. Sequences of images are accessed by moving a globe that tracks rotation in terms of temporality and in terms of the imagery projected on the clock screen—where history and temporality meet.

Considering the exaggeration surrounding the hypermedia and non linear narrative, issues of

order become crucial in developing meaning whose "resolution" is not sequential but thematic. In some ways hypermedia represents the convergence of technology and narrative while it is, in other ways, the culmination of radical innovations in cinema and fiction. Rather than the senses, *Sonata* is directed at the emotions. Multiple representations are linked with multiple readings. The screen, unencumbered with the icons that usually append interactive works, allows the viewer to guide the narrative through past, present, and future. More precise movements are possible during scenes that allow what Weinbren identifies as "vertical development." The complexity of the sources for *Sonata* demand this kind of interaction. Based on Leo Tolstoy's short story "The Kreutzer Sonata," Sigmund Freud's case study "The Wolfman," and the biblical theme of Judith and Holofernes, the dense layering of related thematic material presents a work of absorbing intricacy. Fiction, memory, and the psychology of association are bound in a scenario of interpretation and interaction.

VI
Conclusion

We used to live in the imaginary world of the mirror, of the divided self and of the stage, of otherness and alienation. Today we live in the imaginary world of the screen, of the interface and the reduplication of contiguity and networks. All our machines are screens. We too have become screens, and the interactivity of men has become the interactivity of screens. Nothing that appears on the screen is meant to be deciphered in depth, but actually to be explored instantaneously, in an abreaction immediate to meaning— or an immediate convolution of the poles of representation.[22]

No cultural transformation has been achieved without a corresponding technology. To imagine that the computer and multimedia have invented interactivity is simply not justifiable. At the same time one must add that the scope of the shift represented by the convergence of information technologies, artificial intelligence, animation, and interface design has occurred in tidal proportions. Computed environments play a central role in the developing digital media. Creativity and technology might emerge on equal footing, but what will drive this field forward is a commitment to content-based ideas. While infusing imagery with layered content, the essentialist conception of images has been shattered and supplanted. Simultaneously, the swift maturation of technologies that permit the inclusion of sound, video, and text, have offered a set of possibilities that extend the complexity of imagery and suggest that experience can be situated *within* the images.

Experiential imagery is a provocation to traditions of images that have become ragged in an environment that is itself immersed in representation. The challenge lies in the formulation of a social framework for understanding the effects of developing networks of digital information, the assimilation of technologies (without mistaking a shift in technique for substantial cultural progress), and the development of a meaningful transaction with representation as it merges with technology. After all, it is not data that substantiates or constitutes the self, it is language and interpretation. The role of vision in interactivity has been rightly emphasized as central. Images have never contained the potential to sustain so much information, or, perhaps, meaning. At the same time, images have never contained so much fascinating disinformation. Weaving between the two, the viewer/participant must distinguish not between fact and fiction but between communication and discourse. Interactivity, both as a theory of representation and experience, and as a measure of production, is emerging as an essential discourse in the extension of ideas in the sphere of the experiential.

Technological art is even less likely to fulfill the aesthetes' divine regard for "timeless" art, since a good deal of the art produced with advanced tools can become obsolete quite quickly. . . . Intelligent and accessible applications take a back seat to ever fresher tributes to corporate mystification on the part of commercial illustrator/programmers. . . . In contrast to the remote, exclusive aura of tasteful connoisseurship, techno-art is usually directly engaging and context specific. While ever performing the roles of Recognition, Simulation, Containment, Inversion, Projection, Estrangement, and Identification, techno-artists have long been busy building up their own store of technical knowledge necessary for survival. [23]

Notes

1 From a talk at Ars Electronica, Linz, Austria, 1990.

2 Jacques Lacan, The Seminar of Jacques Lacan, Book II: The Ego in Freud's Theory and in the Technique of Psychoanalysis, 1954-55, ed. Jacques-Alain Miller (New York, W. W. Norton: 1988) p. 83.

3 Paul Virilio, War and Cinema, (New York, Verso: 1990) p. 108.

4 Alan Sekula, Photography Against the Grain, (Halifax, Nova Scotia College of Art and Design: 1984) p. 79.

5 John Tagg, The Burden of Representation, (Amherst, University of Massachusetts: 1988) p. 88.

6 See Rosalind Krauss, The Optical Unconscious, (Cambridge, Mass. MIT Press: 1993), Martin Jay, "Scopic Regimes of Modernity" in Hal Foster (ed), Vision and Visuality, (Seattle, Bay Press 1988), and Jonathan Crary, Techniques of the Observer, (Cambridge, Mass., MIT Press: 1990).

7 Krauss, p. 23.

8 Jean-Louis Comolli, "Machines of the Visible," in Teresa de Laurentis and Stephen Heath, The Cinematic Apparatus, (New York, St. Martins Press: 1980) p. 121.

9 Virilio. War and Cinema, (New York, Verso: 1989), p.

10 David Tomas, "From the Photograph to Postphotographic Practice: Toward a Postoptical Ecology of the Eye" Substance 55 (1988), p. 64.

11 Kevin Robins "The Virtual Unconscious in Postphotography," Science as Culture no.14, 1992. p. 101.

12 see William J. Mitchell's The Reconfigured Eye (Cambridge, Mass., MIT Press: 1992).

13 Paul Virilio, Interview, Flashart, Jan/Feb. 1988. p. 60.

14 Friedrich Kittler Interview by Peter Weibel in On Justifying the Hypothetical Nature of Art and the Non-Identicality Within the Objective World edited by Peter Weibel, (KÖln, Galerie Tanja Grunert: 1992) p.166.

15 Kittler, p. 169.

16 Jaron Lanier, Interview, Whole Earth Review, Fall 1989, p111.

17 Slavoj Zizek, "From Virtual Reality to the Virtualization of Reality," in Weibel, p. 138.

18 New York Times, 1, January 1993.

19 Donna Haraway, "The Materiality of Information," in Janine Cirincione and Brian D'Amato, Through the Looking Glass: Artist's First Encounter with Virtual Reality (New York, Jack Tilton Gallery: 1992) p. 23.

20 Kevin Kelly in The Global Mind (Barcelona, Art Futura 1993) p. 15.

21 Jean Baudrillard Xerox and Infinity Agitac, 1988. unpaginated.

22 Jim Pomeroy, "Black Box S-Thetix: Labor, Research, and Survival in the He[art] of the Beast," reprinted in Timothy Druckrey and Nadine Lemmon ed, For a Burning World is Come to Dance Inane: Essays by and About Jim Pomeroy (New York, Critical Press: 1993) p. 74.

From the Analytical Engine
to Lady Ada's Art

by Regina Cornwell

Ada and a New Start

"The First Programmer Was a Lady" is the claim of writer Howard Rheingold and devotees of the Countess of Lovelace. Born in December of 1815, Augusta Ada Byron was the daughter of the Romantic poet Lord Byron. When Ada was a month old, Lady Byron left her husband, and he departed for Italy and Greece, never to see his daughter again. She was reared under the strict hand of her mother. The family's upper-class privileges and status brought her good tutors as well as exposure to many important and influential people. One of these was the eccentric mathematician and inventor, Charles Babbage, whom she met when she was in her teens. At first her attention was caught by his Difference Engine: a calculating machine that combined arithmetical and logical functions,[1] and was the size of one of today's high-end computer workstations.

But it was Babbage's Analytical Engine that she found most intriguing, and without which we might not remember Ada Byron. Sometimes called the first computer, the Analytical Engine existed only as thousands of diagrams developed by Babbage between 1832 and 1834. In 1843, Byron, (now Lady Lovelace) published her translation of a French text by L. F. Menabrea on the Analytical Engine, together with her own notes. While her notes were much longer than the original essay, Babbage allegedly encouraged her to publish them. These notes are the essence of her contribution to computer history.

It has been claimed that Lady Lovelace "outlined the two basic ideas behind computer programming: repetition of routines and conditional transfer of control."[2] Her prescience has also been acknowledged: "She demonstrated an understanding of the complexity, design, and synchronization issues in parallel operation. The Analytical Engine wasn't a parallel computer, but, like any computer, it embodies some parallel processes . . . She probed possible uses of computers: metaphysical, utilitarian, musical." As the same commentator notes, she was also driven to ask "what real world problems could be solved by the computer and what it was good for."[3]

Ada Lovelace died before her thirty-seventh birthday. Always frail, often ill, sometimes suffering breakdowns, a gambler (perhaps even a compulsive one), not always faithful as a wife, she left behind three children, a bereft husband, and a household diminished by the jewels she had sold to pay her large gambling debts. She was buried, at her own request, at the side of the father she never knew. Because of Byron, she was mythologized, even in her own lifetime. She appears in his autobiographical epic, *Childe Harold's Pilgrimage*, as well as in a novel by Benjamin Disraeli, and in other writings. Recently her "genius" and her contribution to ideas of programming have been called into question,[4] but following a second wave of mythologizing, this time within computer history. In his 1950 essay, "Computing Machinery and Intelligence," Alan Turing presented and countered her anticipation of artificial intelligence in a section titled "Lady Lovelace's Objection."[5] And in 1979 the United States Department of Defense christened its programming language "Ada."

Whether she is overcredited, whether her contributions were all original, and whether she simply managed to shape and articulate meaningful questions, are not important here. What is important is that Ada Lovelace inspires us to launch our own myth. Let's believe in her contribution to programming and let's pretend that, instead of losing the family jewels, she made vast sums at the races (by making effective use of the Difference Engine). And let's imagine that she accumulated enough wealth and power to establish an institute for the study of the Analytical Engine, the building of an actual computing machine, and the pursuit of programming ideas. The programming included real-world applications, such as the development of new crops—countering the kind of starvation that took place in the Potato Famine in Ireland of 1845–48, the exploration of new sciences, as well as the fashioning of an entirely unprecedented kind of art.

With this kind of start, today's computer might look and act differently. We tend to assume that a machine *must* look a certain way, have a certain structure. But why—especially the computer? Ada Lovelace lets us probe such issues. She delved into technology with a lineage that combined art—through her poetic and ever-absent father—with mathematics through her stern mother—a "mathematical Medea."[6] She raised issues suggestive of the artificial intelligence debate, and upset convention by mixing intuitions with science. In another vein, her unlucky gambling brings to mind computer scientist Joseph Weizenbaum's commentary on "hackers," whom he compares to compulsive gamblers.

Rationalist Myths About the Computer: A Neutral Mind-Amplifier

The mythical Ada Byron, Countess of Lovelace Institute's computer software and applications might have shaped new cultural directions and forced change. It also might have avoided or at least helped to deter the easy fit the computer finds for itself within the rationalist tradition that promotes a technocist point of view.

Today the computer is often presumed to be neutral, that is, impartial and objective. From this it is just a step to the classical Cartesian split between mind and body, self and other, subject and object. The premise, "Cogito ergo sum" posits a self-supporting subject, acting alone in the world, where body and everything else outside of mind or spirit are mere extensions, automata, machines. Mathematics provides grounds for knowledge through the deductive method. For Descartes, extension was understood in terms of geometry. The primacy of the individual in bourgeois culture and capitalism develops from this self-referentiality. By the time of the Enlightenment in the eighteenth century, in an effort to improve the lot of mankind and to understand the operations of nature, reason is joined to the idea and pursuit of progress. But increasingly since that time, and notably in the computer's short life, the substantive reason of the Enlightenment has been reduced to instrumental reason.[7]

Rheingold uses the central metaphors of computers as thought-and mind-and amplifiers, or, as the title of his book reads, *Tools for Thought*. While the computer as *tool* suggests the idea of a neutral device for accomplishing a task, the metaphor of the mind-amplifier leads one to ask whether something might be atrophied at the cost of the amplification of something else. And so the commonplace assumption of the computer's neutrality is challenged.

But no technology is neutral, argues author/educator, C. A. Bowers, who asserts that this is evidenced in the way technology privileges certain goals or tasks, while neglecting or diminishing others.[8] And this becomes meaningful only in the interaction a technology has with its human subject. Here, says Bowers, technology "transforms our experience"[9] when it "chooses" to enhance one aspect while underplaying another. The telephone, for example, amplifies the voice while decreasing our ability to communicate with body language. The computer is much more complex. It highlights certain kinds of knowledge—what "can be reduced to discrete bits of data" and stored. It stresses the explicit at the price of the implicit, of ambiguity and of metaphor; it offers the objective over the interpreted, data and information over knowledge and wisdom; it eliminates context.[10] Instead of this, we face a dramatic shift that occurs in the way we perceive technology, especially the computer, when we frame

each experience as an interaction between a device loaded with features that favor certain tendencies over others and influence how and what the human agent does with it.

The mistaken idea of the computer's neutrality is supported by metaphors about language as a "conduit" for data and information passing from "sender to receiver." Bowers exposes this: "The sender-receiver model of thought and communication (or input-output, to stay with the jargon associated with computers) reinforces the view that the ideas, information, and data that are transmitted through language are objective."[11] This ignores the fact that language and the computer develop in cultural contexts, while it sustains the idea of the autonomy of the individual.[12] For instance, the points of view of a computer program's author or authors and of its financial backers become lost in the claims for the objectivity of the computer, the language used, and the information delivered.

The Military, Hackers, and Computer Games

Sadly, there is no Lovelace Institute to point out and criticize the computer's reductivisms and to balance and rectify them with the kinds of amplifications it endows upon our experiences. Rather than originating with a benign institute established by a gambling aristocrat, our computer heritage comes from the military's research and development. During World War II, computers were developed for ballistics and cryptographic purposes. From hot wars we went to cold wars and deterrence. "At that point," comments French critic Paul Virilio, "war is no longer in its execution, but in its preparation. The perpetuation of war is what I call Pure War, war which isn't acted out in repetition, but in infinite preparation." In another passage, he remarks, "The development of Technology is Pure War."[13]

The computer's origins in the military surround us, frequently spun off into daily routine applications. And of course, neither our contemporary forms of entertainment nor our art can escape this background and influence. Computer games come to us as an offshoot of projects funded by military research and development, while the interactive art installation may be the first art form in history to trace its roots to the military. We will see how they developed and now fare vis-à-vis their real paternity.

Looking back over the computer's short history, games are part of its ancient past. Electronic machines up and running in the 1940s mark the computer's real beginnings; ENIAC (electronic numerical integrator and computer), completed in 1945, was one of the earliest. First on mainframes and

then on minis, hackers began to fashion games by the early 1960s. The name itself, "hacker," and the first group, came out of MIT. As Steven Levy puts it in his book, *Hackers: Heroes of the Computer Revolution*, "While someone might call a clever connection between relays a 'mere hack,' it would be understood that, to qualify as a hack, the feat must be imbued with innovation, style, and technical virtuosity. Even though one might self-deprecatingly say he was 'hacking away at The System' (much as an axe-wielder hacks at logs), the artistry with which one hacked was recognized to be considerable."[14] Rheingold describes hackers as "mostly young, mostly male, often brilliant, sometimes bizarre."[15] He explains that the term "hacker" meant something honorable, in contrast to today's mass media sense of "antisocial urchins who break into other people's computers."[16] Weizenbaum holds a harsher view of them, as we shall see later.

Endowed with intelligence, zeal, and dedication, the hackers contributed significantly to computer development in systems programming, time-sharing, telecommunications networks, and early application programs, including graphics, and last but certainly not least—game software. What hackers learned from inventing and developing games, they applied to other areas. Reprieved from working on mainframes, with their slow, inefficient punch cards given to an operator and retrieved hours or even a day or two later, the hackers were able to work directly with the newly developed minicomputers, using paper tape and later magnetic tape, and finally even viewed the results on a monitor instead of a cumbersome teletype machine. This was circa 1960, and marked the start of *interactivity*—a user at a computer receiving an immediate response to a query.

Interactivity is a key technological and ergonomic development, not to be underestimated. It is central to the discussion here on games and art. It began in the back room, then migrated to the desktop, the front room, the kiosk, and today it is simply taken for granted. But it was only with the advent of the personal computer, well into the 1980s, that interactivity would become commonplace. Today, as we survey the vast field, games may not only be the most familiar form of computer application, but are for many the signature of interactivity—understood as pushing buttons, wielding a joystick, pivoting a trackball—to affect what is on screen.[17]

Hacker-developed Spacewar, completed in 1962, inspired by science fiction conceits and with a military bias, was one of the first, and, for its time, quickly became the best known of games. As the young hackers at MIT thought about it, "they somehow decided that the PDP-1 [a DEC computer]

Man at teletype machine, ca. 1965. Courtesy the Computer Museum, Boston, Massachusetts.

would be a perfect machine to make a combination grade-B movie and $120,000 toy. A game in which two people could face each other in an outerspace showdown."[18]

Through the 1960s, the hackers at MIT and a handful of other institutions were more often than not working under Department of Defense Advanced Research Projects Agency (DARPA) funding, until the Mansefield Amendment of 1970, which "required ARPA to fund only projects with immediately obvious defense applications," severely reducing the extent of support.[19] The hackers had an idealistic policy of making their software available to all. Anyone talented enough could refine a program, create variations, "bum" it by reducing its routines, thereby making it more elegant. They gave Spacewar free of charge to DEC, who in turn presented it to each of its customers as a diagnostic program with the new PDP-1. A few months after its development, Spacewar became a centerpiece at an MIT open house, where "no one dared predict that an entire genre of entertainment would eventually be spawned from it."[20] The connections are so direct that Pong, developed by Nolan Bushnell over a decade later, was based on Spacewar. With Pong, Bushnell began Atari, kicking off the video game industry.[21]

Working under DARPA funding, the male domain of the hackers began to shape a legacy that thrives today. The young men who hacked out and refined the first games are described as extremely bright, obsessive, asocial, and addicted to the computer as a quest. Living the computer, they were interested in neither women nor sports. Yet somehow they generated the macho formulas, digitized into absolute precision, in ways that the old analog pinball machines could never be made to do. They brought symbolic logic into their world of entertainment for "command and control."

It is ironic that these young men in their teens and twenties—who railed against IBM and ties and shirts, were disheveled, unkempt, and often unaware of the source of their paychecks—ended up creating in their games a validation for the military-industrial complex. Yet again, perhaps it isn't so inconsistent: "command and control" are, after all, the key words. The military and corporate worlds are designed to maximize control and power. Today's electronic entertainment is modeled on command and control, while genuine play and spontaneity take a back seat.

Weizenbaum throws light on the subject of hackers and control. He was a professor of computer science at MIT, observing the hackers firsthand during their heyday. In his criticism of the hackers, he labeled them "compulsive programmers," drawing a parallel between them and compulsive gamblers,

as distinct from professionals in both fields. While Weizenbaum acknowledged their contributions, he believed that they were caught in the seduction of a closed system. For instance, a hacker would write a piece of software and correct its bugs idiosyncratically, often impervious to the needs of other users. What mattered was that he got it right in his own terms. Involved with "magical thinking," like compulsive gamblers, they were trapped into a circular pattern. He described it as a form of rigid and pathological behavior. They were insecure and immature men who needed to feel masters of their world. For them, the computer defined power.[22]

In *Hackers*, Levy's romanticizing enthusiasms are often revealing:

> The game Spacewar, a computer program itself, helped show how all games—and maybe everything else—worked like computer programs. When you went a bit astray, you modified your parameters and fixed it. You put in new instructions. The same principle applied to target shooting, chess strategy, and MIT course work. Computer programming was not merely a technical pursuit, but an approach to the problems of living.[23]

Levy's comments are not only uncritical, they are irresponsible. They reflect a chillingly simplistic reduction of life to the dimensions of a computer game program as they also embody in such eager naivete some of Weizenbaum's fears.

The variations on Spacewar and other games fathered by hackers and their followers have perpetuated militaristic themes and motifs straight through to the present generation of entertainment. Visit a videogame arcade abuzz with mutations on street games—opponents gun each other Western-style, chop karate-style, or rampage urban-gang-style. You fire at enemies in the jungle, in the desert, at sea. From a cockpit, tilt in your seat and feel your hands vibrate as you shoot at unfriendly approaching aircraft. Pick up a pistol and become a Lethal Enforcer; confusion reigns until, a few quarters later, you have acquired enough skill to avoid gunning down your own allies. Pass by an electronic game store and count the variations on World War I and World War II battles, right up to the Gulf War. The abstract Tetrises are there for another kind of game of strategy, as are the Breakouts and their variations, but they are fewer. While contact sports are strong, a game of tennis, and incongruously, even golf, may be off in an arcade corner. But it is conquest, aggression, search-and-destroy that dominate,

Advertisement for Battles of Destiny computer game, 1993. Courtesy Quantum Quality Productions.

Computer Gaming World cover, January 1993, no. 102. Courtesy Golden Empire Publications

even in the family of Pac Man games. Leaf through the blindingly colorful magazines—*Die Hard Game Fan*, *Video Games & Computer Entertainment*, *Electronic Games*, or *Computer Game Review and CD-ROM Entertainment*—displaying fare for the home computer or game system for more of the same themes. One needn't look too hard in the arcades to find racial slurs popping up, thinly disguised in plays on name and dress—as in Total Carnage, with Captain Carnage and Major Mayhem opposing General Alchboob. As might be expected, sexism is even more pronounced. In the games women are, of course, underrepresented. And when they do materialize in the ads or on the screen they are almost invariably buxom, suggestively underdressed, and mostly passive, helpless, and in need of the protection of their men.[24]

A new generation of entertainment brings us Battle Tech Center, sometimes called "partially immersive virtual reality." Recently purchased by a member of the Disney family, the first example appeared in Chicago in 1990, and two more were licensed and opened in Japan in 1992. The next move for the company, Virtual World Entertainments, is Virtual World sites. Four in the planning stages for the West Coast will offer the company's versions of virtual reality and interactivity in a variety of adventures and games. At that stage, Battle Tech will be just one of the choices in this multiplex gaming boutique. One writer suggested that Battle Tech is modeled on the military's telecommunications network, Simnet,[25] through which simulations are carried out among commanders and their forces in remote locations. In Battle Tech Center, the ticket-holder is briefed, watches the action from an observation deck, manual in hand, and finally enters his or her cockpit psychologically prepared to make war. The simulation is "social" insofar as Battle Tech is a multiplayer system and one cannot fight against the computer alone, but only against other humans who appear as robots on screen. And fully immersive virtual reality, what one might call "the real thing," claims a success story with Virtuality by a British company, W Industries; the game is now found in shopping malls, theater lobbies, and other entertainment sites in the U.S. and abroad. With Virtuality, a participant is outfitted in a head-mounted display and fires a joystick in the direction of the Green Dactyl or another human presented as a graphical creature in the shared three-dimensional virtual space seen on the tiny monitors in the helmet.

Games are moving into the mainstream of popular culture as arcades are becoming more respectable and even upscale, while some PC game programs are now so sophisticated that they demand very powerful machines. More than a third of U.S. homes have game systems cabled to their

television sets.[26] Electronic games are a diet for adults as well as for children and adolescents, in which playing continues to be dominated by males.[27]

Now games are an important element of what is known as "the New Hollywood." They are securing their place in the sun as they gravitate more and more toward story-telling and movie-making techniques and devices. With the end of the cold war and lower military research and development budgets, the makers of faster chips, digital compression systems, advanced storage devices, higher level graphics, full-motion video, are seeking replacement buyers for their old military regulars. They are finding them within the developing multibillion-dollar game industry of the New Hollywood.

Because of the high profile games have in society, the way that they are played suggests how interactivity comes to be experienced and accepted in our culture. According to Eugene Provenzo in *Video Kids*, despite parental fears about the negative influences of electronic games, there are no conclusive studies about their effects on children and adolescents.[28] A 1985 study found that video games were actually useful, cathartic outlets for aggression and stress among frequent arcade players.[29] But, there are other issues that bring us back to our earlier concerns.

Woman seated in Virtuality vehicle.

Courtesy Edison Brothers.

A New Rationalism: Interactivity, Skill, Speed, Progress and Consumerism

Within the world of the electronic game, interactivity becomes a metaphor for power vested in the individual through skill, speed, efficiency, and control. It is demonstrations—as pilot, foot soldier, naval commander of mastery with the joystick, buttons, trackball—that count in attacking an enemy or a problem. It is adeptness in targeting the largest number of casualties or in reaching the highest score. It is these interactive games of military might, conquest, adventure, search-and-destroy, which return us to a rationalist outlook, dramatically transformed. In such games the values of the autonomous individual, of instrumental reason, of progress, are evident; and the dilemma of the mind/body, subject/object split is made visible. Now the rationalism of the programming is converted into a skill executed by the interacting player. In these games, as nearly everywhere with computers and their applications, speed is recast as the new reason. The faster the game, the better: speed equals progress.

As key values are metamorphosed, other changes follow. Quantity is converted into quality as the symbolic logic of the computer's program delivers to us more convincing representations. These fit the technocist view of progress in which time is crucial in the race toward a "foolproof" realism. And,

hand-in-hand with these representations, interactivity becomes a symbol and a tool of consumerism. Acquisition, efficiency, decision making, even "choice," are all part of it.

The military began using computer graphics for simulations in the 1950s. Now video games are employed for recruiting into the armed services as well as for training. Good players report having been approached by recruiters in arcades—in fact, the Navy's most successful recruiter for 1981 targeted video arcades.[30] The military has developed simulators that "appear to the soldiers as games" for training skills that range from flying to tank gunnery to missile firing, to name just a few. While they have the appearance of arcade games, they are built with the necessary sophistication actually to accomplish their military goals.[31] The armed forces' games extend beyond those for manual skills on the battlefield to war games of tactical judgments and strategy. The Army's war game Strategic and Tactical Assessment Record, or STAR, measures "the effects stress has on efficiency and speed, memory, information processing, decision making, risk taking and psychomotor skills," as a search-and-destroy mission is played on a display terminal.[32] Game developers and consultants assist the military with its war game simulations. Instead of training at each step in expensive planes, helicopters, and tanks, the Pentagon's simulation programs, though costly to develop, have saved and continue to save millions yearly.

Considerations of the game return us to Virilio's ideas: "All of us are already civilian soldiers, without knowing it. People don't recognize the militarized part of their identity, of their consciousness."[33] His statement seems even more to the point because games provide a clear crossover between the military and the civilian. It is useful to recall Levy, who uncritically hails hacker methods in which the game becomes a paradigm for a simplified and reduced form of living, in contrast to Weizenbaum, who gives us pause to hint at the danger in such extreme control and compulsiveness at the computer. Though *Pure War* was published ten years ago and since that time world politics have dramatically changed, Virilio's description of the military still holds, especially the concepts of "blurring" of distinctions between military and civilian, and the building of a war deterrence economy to assure peace. Even as a new American president attempts to cut billions from the Pentagon and to streamline the armed forces, the military powerfully resists,[34] by anticipating future battles via cybernet war simulations, finding new places to direct its technological spending.[35] Game development and the give-and-take between civilian contractors and the military and entertainment businesses perpetuate this blur in one way, as does the enthralled game public in another, at ease with entertainments based on military

might. From 1979 through 1991, over 700 war games were published for personal computers alone, produced by over two dozen companies.[36] The electronic game keeps alive a militarist mindset and perpetuates the outreach of the interactive computer into other areas of our lives. Now with the home computer networked to online games and the game black box connected to the television set, once entrenched in the home, the interactive game is the clever way to pave the path to other consumer services and entertainments.[37]

Art and Interactivity

A hundred years before ENIAC, Ada Lovelace mused about the Analytical Engine as a source rich not only for scientific and mathematical explorations, but also for art and the imagination. While today what we know of as "interactive art" presupposes the use of the computer, that wasn't always the case. In art, interactivity has another heritage in addition to its military one, one that briefly shifts us away from technology.

We can see it early in this century with the Futurists and the Dadaists, and in the late fifties and sixties with Happenings, Fluxus, Actionism, and proto-Pop, artists' performances and events. Artists had been engaged in breaking down the barriers between art and life, wearing away the walls of aestheticism built up with Modernist movements such as Cubism, Purism, Expressionism, later Abstract Expressionism. *Epater le bourgeois* was the early motto capturing the essence of a Futurist event on the streets, or in a theater in Milan or Turin, or of a Dada evening provoking the audience in a Zurich cafe. The audience was pushed, even taunted into responding to a performance or a series of tableaux, a poetry reading, a declaimed manifesto, aimed at shocking or insulting. Success for the artists was measured by the reaction of the audience—shouts, egg throwing, riots—the more the better. The provocation became an expectation for the audience, then a cliché, as the strategies wore out.[38]

Other artists chose different tactics to motivate their audiences to interact. Allan Kaprow's use of the term 'happening" in 1959 was picked up by the media and the art world and applied to various performances and events. He spoke of increasing the "'responsibility' of the observer" and finally eliminating the audience altogether as each individual present would become part of the event organized by an artist. Yoko Ono, identified with Fluxus, produced a number of works that demanded participation from her audience. For instance, in her *Cut Piece*, performed in 1965 at New York's Carnegie

Recital Hall and elsewhere, she invited her audience to come forward, pick up scissors, and cut off a piece of her clothing as she sat placidly on the stage floor facing them. This work appears as a script in Ono's book, *Strip Tease Show*. There, and in other books, such as *Grapefruit* (1964), she bids her readers to participate by following instructions, either imaginatively or in fact. As recently as October 25, 1991, *Cut Piece* was performed by one of the musicians from The Talking Drums at the Kitchen in New York City, and Ono was one of the long line of audience members who awaited her turn to take scissors in hand and appropriate a piece of his clothing.

From early on in his career—in painting, silk screens, combines and in collaborations with other artists from theater, music, and dance—Robert Rauschenberg seems to have thought about how to activate his own work, and the setting for it, as well as his viewers in their experiencing of it. He introduced technology into his work in the early 1960s. Rauschenberg cofounded Experiments in Art and Technology (EAT) with Billy Kluver in late 1966, with the goal of creating collaborations between artists and engineers. It still exists today, but in name only. *Soundings* (1968) was the first work Rauschenberg made under the auspices of EAT. It was a large installation of silk-screened panels in which sounds from the audience triggered light to illuminate images. *Soundings* insisted on engaging with its audience, otherwise the viewer only saw his or her reflection dimly in the darkened room. "To explore the work, you have to continue talking or singing. If several people are there with you, the situation is one of participation, competitiveness and cooperation as viewers try to extract more and more images from the darkness."[39]

Interactive Art Installations

Since the mid–1980s, artists have begun making and exhibiting interactive installations involving the computer. In contrast to the short-lived active period of EAT, at a time when computers were large and difficult to use, a quarter of a century later, the technology had finally become smaller and more manageable. With the microcomputer readily available, it is possible for willing artists to learn to work with computers, videodisk players, and other peripheral devices, without the large amount of engineering assistance required of EAT projects in the late sixties and early seventies.

But, significantly, at the same time in the visual arts the period of the eighties also represented the height of the art world as a marketplace and the growing commodification of art itself. Like their

forebears—but using different media and strategies—interactive artists have attempted to engage their audiences as more than traditional viewers. In doing this, the works themselves are critical of the commodification of art as well as of the appeals to the consumer delivered through interactivity.

The electronic game aficionado might be puzzled, if not stopped, by an installation of interactive art, but Ada Lovelace probably would not have been. So many of the aspects of the computer in general and the computer game in particular, discussed earlier, come up as we look at what the artworks are offering us for our consideration.

Timing is fundamental to skillful control in electronic games. Select quickly which way to storm the enemy, at what target to shoot, whether to punch, jump, or kick. But now, walk up to Ken Feingold's *The Surprising Spiral* (1991), sit at its library table and press the imprint of a hand on an open page of what is a touch screen embedded in a sizable book; images will respond, appearing on a large screen ahead, accompanied by ambient sound. Touch a detached plastic mouth and a voice is heard reading from an Octavio Paz text. Touch again and the scenes and sequences are changed. Water, cityscapes, clips from the 1963 Alain Robbe-Grillet film, *L'Immortelle*, a peripatetic journey in distant lands, philosophical text as titles on-screen are all fragments of this work where speeding to a destination has no place, and time is measured as an agreement between the artist's program and the participant's interactive moves.

Ken Feingold, detail from
Surprising Spiral, 1991.
Multimedia interactive
installation.

Electronic games, interactive television for home shopping, movie options and sports replays, airport and hotel kiosks for reservations and purchases all extol the idea of the new and seemingly endless horizon of choices offered through interactive consumer applications. But are these "choices" or simply more ways of spending money more quickly and conveniently? Press one of five, select two of seven on a menu and you will have precisely what you want, or think you want. Feingold and other artists ask their participants to consider interactivity in different ways. Here and in other works artists are confounding the idea of "choice." In Grahame Weinbren's 1986 *The Erl King*, as in Feingold's *Surprising Spiral*, when one touches the screen, one isn't certain where one will be taken. The control is not in the hands of the participant; instead the interaction opens up a space of fiction for the imagination. And such work asks more basically what we mean by choice—and whether there is any.[40]

The question of "choice" dramatically opens up the prime issue of an end to the unique object in the age of electronics. In Jeffrey Shaw's *The Legible City* (1989), the participant becomes a cyclist

pedalling before a large screen bearing an "alphabet city" in bright colors, as text makes up the avenues, streets, and byways. As the biker navigates in and out, on a turn, one colored text cuts into and picks up where the other leaves off, as a path through the streets creates a narrative out of the separate story lines. We soon realize that each traveler will have a different experience. No one will steer and read exactly the same story. Each will traverse the grid of a city in a different way. For this installation modeled on a part of New York City, the fictional text written for former mayor Edward Koch may blend uncomfortably with that of archenemy Donald Trump or somehow be mediated by words attributed to Daniel Webster, or a taxi driver.

In Weinbren's *Sonata* (1991/93), one is invited to point at the screen and a tree appears. Point again and a wolf (actually a malamute playing the role of a wolf) is now on the tree. We may hear the dream of the "Wolf Man," from a famous case history of Freud's. When enough staring dogs materialize on the tree, the screen image begins to resemble the drawing the Wolf Man made of his dream. Depending upon where we point, we may retrieve scenes connected to the dream or move into one of two other narratives and navigate through and among them interactively. Our interactions generate layers of literary, art-historical, cinematic and psychological associations within and between single frames, scenes, and sequences. Weinbren refers to his *Sonata* as interactive cinema, continuing where traditional cinema leaves off.

Some Issues for the New Art

The physical enclosure or architecture of an interactive art installation may remain the same from one day to the next, from one exhibit site to another. However, the participant's interactive experience will differ each time—whether the imagery is computer-generated graphics, as with Shaw's, or still and moving video from disk players, as is the case with Weinbren, or some combination of those and other devices programmed with the computer. In any case, each participant's encounter is relative and differs from every other through individual interactions. And, further, the artist may alter the program at any time. The more complex the sequencing and nature of the program design, the more confounded is the idea of the unique object. Powered by a digital program, without a final version, what has become of the commodity?

When the viewer is invited to take on a new role in interactive art, it is in keeping with the events and influences of the physical sciences during this century. With the relativity of each participant's

encounter is a shift in the roles of the work and of the artist. An interactive art installation stands idle and incomplete until a viewer actively engages with it. This art brings to mind Roland Barthes' "The Death of the Author," in which he calls for more attention to the reader (our participant): "We know now that a text is not a line of words releasing a single 'theological' meaning (the message of the Author-God) but a multi-dimensional space in which a variety of writings, none of them original, blend and clash." And in the same essay, "*Writing*, by refusing to assign a 'secret,' an ultimate meaning, to the text (and to the world as text), liberates what may be called an anti-theological activity, an activity that is truly revolutionary since to refuse to fix meaning is, in the end, to refuse God and his hypostases—reason, science, law."[41]

"To refuse God," as Barthes does, suggests not only the theological being but also the idea of man who has become the center of the Cartesian world. Our considerations of interactive art let us move to the position held by the phenomenologists and others who reject the mind/body, subject/object split and hold that we are inseparable from the world in which we act. Using Martin Heidegger as a base, Terry Winograd and Fernando Flores, in *Understanding Computers and Cognition*, explain that he "rejects both the simple objective stance (the objective physical world is the primary reality) and the simple subjective stance (my thoughts and feelings are the primary reality), arguing instead that it is impossible for one to exist without the other. The interpreted and the interpreter do not exist independently: existence is interpretation, and interpretation is existence."[42] We always operate within a framework. We can extrapolate from their work to our specific context—an interactive art versus games, as well as the more general ways of taking the computer's interactivity for granted. In our practical everyday world we act unreflectively. It is when an object and its properties that are taken for granted "break down" for us that they actually become present for us.[43] Summarizing Heidegger on this, Winograd and Flores write, "What really *is* is not defined by an objective omniscient observer, nor is it defined by an individual…but rather by a space of potential for human concern and action."[44]

The interactive installation has the potential for opening us up to experience "breakdowns" in our interactions with the technology. Through the fissures we can begin to see that our assumptions about interactive games and other applications aren't necessary or simply don't apply to this genre of work. Choice is exposed as something of a misnomer, when not a hoax of consumerism. While interactive consumer applications extol new "freedoms" in more selections with greater ease, when well made,

they are simply better advertising and marketing devices with which to seduce potential buyers. One may be seduced by the pleasures and stimuli of an interactive work's imagery and ideas, but one isn't *buying* anything. Here, the unique object as commodity—reinforced in the dualism between subject and object—is lost in the emphasis on the relativity of each interaction. The individual is no longer the autonomous, self-sufficient, governing actor, the center of power. The blind and irrational connotations of speed as the new progress loses its meaning; time is given a reprieve in interactive art where competition isn't a hallmark and the martial sense of urgency fueled by control doesn't exist.

While technology is here in our culture for the taking, among artists there are still too few takers. It is as if we are locked in the nineteenth century. When we see attempts at addressing contemporary issues, even those about technology itself, too often the images and metaphors are cut from old materials that are straining to be current. In the meantime, those who are working with interactivity have equipped themselves to be able to respond more decisively to the world of the visual arts, and to the culture as a whole.

Coda: Where Does It Belong?

Finally, we have to ask: what place does interactive art *have* within the art world? Does it even have a place? In the U.S. it has little visibility. As a whole the art world in this country is not particularly disposed to artists working with technology. In fact, it seems to see interactivity as the cash-machine-transaction and the arcade and home game, with interactive art as yet another variation on the electronic game.

To hold, as does Arthur Danto, that art as we have known it has ended, that it has entered its posthistorical period, might lead one to think that technology, and especially interactivity, would have a secure place. The grand historical narratives have come to an end, opening up to a pluralism of forms and styles. Now, claims Danto, the task of "what makes something art and something else not is something the art world—i.e., the 'experts'—prescribes." And, "to be a member of the art world is, accordingly, to have learned what it means to participate in the discourse of reasons for one's culture."[45] But continuing beyond Danto's argument, or, perhaps, taking it to its logical conclusion, the art world is an art market and the two have enjoyed a very close alliance since at least the eighties.

When the art world is seen as a market, it is understandable why it has virtually no interest in

interactive technology. In the visual arts, static art objects are a historical given. But time is crucial to the interactive work: it changes in time and is, by the nature of its digital electronic programming, not intended to be fixed and finalized, nor one of a kind as a unique commodity.

If the art world is largely equivalent to a marketplace, where then can this work survive, be shown? Even when pieces are rife with art-historical and literary allusions, as are Weinbren's *Sonata* and Feingold's *The Surprising Spiral,* and attend to contemporary issues with foresight in a posthistorical art world, such fullness and such rapport with the past and anticipations of the future seem not to matter anymore.

If we look for analogies, the art of the cinema immediately comes to mind. Film, a mechanical technology from the nineteenth century, has never fared well in the institutions of the art world, including that of the fine arts museum, with very few exceptions.[46] Today, among other factors, with the constantly changing state of the art of electronic technology, infinitely more complex than film, we need not waste our optimism on thinking that the museum will provide a successful haven for interactive art. Better to be optimistic and look to new spaces to accommodate such work today and in our coming century. If Ada Lovelace could imagine a terrain for the computer totally alien to her Victorian culture, we are in a much better position. Aware of technology's past history, we no longer need to buy into its old martial rules and goals. We are closer to the future and can begin to imagine and construct new settings for a new and evolving art.

Notes

1 Howard Rheingold, *Tools for Thought* (New York: Simon and Schuster, 1986), p. 32.

2 Chuck Beardsley, "Commentary: The Lovelace Letter," *Mechanical Engineering*, vol. 113, no. 1 (Jan. 1991), p. 4. These are referred to respectively as the loop and the "if."

3 Michael Swain, "Programming Paradigms: The First Programmer," *Dr. Dobb's Journal*, vol. 17, no. 4, (Apr. 1992), pp. 116, 118, and 116 respectively for the separate quotations.

4 See Dorothy Stein, *Ada: A Life and a Legacy* (Cambridge, Mass.: MIT, 1985). In this scholarly study, Stein is quite critical of Lovelace and the claims made about her. Her last chapter ends: "Yet she did work hard enough for long enough to make clear that only extremely dogged application would have sufficed to compensate for a deficiency in native quickness and talent, especially for assimilating the mathematical techniques of symbolic manipulation. It is unusual to find an interest in mathematics and a taste for philosophical speculation accompanied by such difficulty in acquiring the basic concepts of science as she clearly displayed. We can only be touched and awed by the questing spirit that induced her to launch so slight a craft upon such deep waters." p. 280.

5 Rheingold, p. 64. Except for a Rheingold reference taken from another of his books, this and all subsequent references to *Tools for Thought* are given as Rheingold.

6 Stein, p. 3. Stein writes of Lady Byron that "the extent to which she ever became a 'mathematical Medea' was greatly exaggerated by Byron, who had difficulty in keeping his accounts."

7 On instrumental reason see Jurgen Habermas, "Modernity—An Incomplete Project," *The Anti-Aesthetic: Essays on Postmodern Culture*, ed. Hal Foster (Port Townsend, Wash.: Bay Press, 1983), pp. 3–15, and other of his essays. See also C. A. Bowers, *The Cultural Dimensions of Educational Computing: Understanding the Non-Neutrality of Technology* (New York: Teachers College Press, 1988), p. 36 and elsewhere in his book.

8 The discussion on the neutrality or nonneutrality of the computer is indebted to Bowers whose book is cited above.

9 Bowers, p. 32, and pp. 32–36. See also Eugene F. Provenzo, Jr., *Video Kids: Making Sense of Nintendo* (Cambridge, Mass.: Harvard University Press, 1991).

10 Bowers, p. 33.

11 Ibid., p. 42.

12 Ibid., p. 41.

13 Paul Virilio and Sylvère Lotringer, *Pure War*, trans. Mark Polizotti (New York: Semiotext(e) Foreign Agents Series, 1983), pp. 92 and 54, respectively.

14 Steven Levy, *Hackers: Heroes of the Computer Revolution* (New York: Dell, 1984), p. 23.

15 Rheingold, p. 20.

16 Rheingold, *Virtual Reality* (New York: Summit Books, 1991), p. 178.

17 For others, the signature experience of interactivity is pushing buttons on the automatic banking machine.

18 Levy, p. 59.

19 Rheingold, p. 246.

20 Levy, p. 65.

21 Rheingold, p. 157. Rheingold also explains here that *Spacewar* spread to other campus computer centers and became a "rites of passage" for hackers. Invented by "Slug" Russell, it "was perfected in a communal effort by generations of hackers...."

22 Joseph Weizenbaum, *Computer Power and Human Reason: From Judgment to Calculation* (New York: W. H. Freeman and Co., 1976), pp. 111–131, ch. 4, "Science and the Compulsive Programmer." He quotes psychoanalyst Edmund Bergler on the idea of magical thinking and the compulsive gambler. Weizenbaum writes: "The compulsive gambler believes himself to be in control of a magical world to which only few men are given entrance." P. 123.

23 Levi, p. 61.

24 Provenzo, Jr., pp. 99–117, ch. 5, "The Portrayal of Women." His book is a very useful source for the video game discussion.

25 Tony Reveaux, "Virtual Reality Gets Real," *New Media* vol. 3, no. 1 (January 1993), p. 39.

26 Keith Ferrell, "Quiet on the Set: Interaction!" *Omni* (Nov., 1991), p.98.

27 David Sheff, "Games," *Playboy* vol. 38, no. 6 (June 1991), p. 6. According to Sheff, there are fifty million Nintendo Entertainment Systems worldwide. And Nintendo had already sold more than four million Game Boys, half of them to adults. And in his 1991 *Video Kids*, Provenzo gives the figure of more than nineteen million Nintendo game machines in U.S. homes. p. ix.

28 Provenzo maintains that "while the games probably do not contribute significantly to deviant behavior, they do—at least on a shortterm basis—increase the aggres-

sive behavior of the individuals who play them." P. 70
He complains that the studies, largely psychological,
don't deal with the social and cultural content of games,
something that he proceeds to look at in his book on
Nintendo.

29 *New York Times*, Sept. 30, 1985, sec. II, p. 11, col. 1. A
 reference to a study by Dr. Lisa Weinstein and Gerald I.
 Kestenbaum.

30 Terri Toles, "Video Games and American Military
 Ideology," *The Critical Communications Review, Vol.III:
 Popular Culture and Media Events*, ed. Vincent Mosco
 and Janet Wasko (Norwood, N.J.: Ablex, 1985), p. 220.

31 Toles, p. 219

32 "Army Trying Out Video War Games," *New York Times*,
 Nov. 20, 1983, sec. 1, p. 39, col. 1.

33 Virilio, p. 18.

34 See Jerome Wiesner and Kosta Tsipis, "7 Percent
 Pentagon Solution," *New York Times*, March 4, 1993,
 sec. A, Op-Ed, p. 25, cols. 2-4. They explain that
 although 60 percent of our military costs during the
 cold war went to defending us and our allies against the
 Soviets, the Pentagon wants only a 17 percent reduction
 by 1997 over its 1992 budget. They recommend cutting
 the military budget by 7 percent a year through the year
 2000, $681 million in current dollars.

35 See Bruce Sterling, "War is Virtual Hell," *Wired*, vol. 1,
 no. 1 (1993), pp. 46–51, 94–99. An extremely good
 article.

36 See James F. Dunnigan, *The Complete Wargames
 Handbook*, rev. ed. (New York: Quill, 1992).

37 *New York Times*, June 8, 1989, sec. IV, p. 2, col. 1. On
 AT&T and Nintendo talks about an information network.

38 This paragraph and the discussion in the following two
 are taken from my article "Interactive Art: Touching the
 'Body in the Mind,'" *Discourse* , vol. 14, no. 2 (Spring
 1992), pp. 203–221.

 For a specific discussion of Futurist and Dada perfor-
 mance, see chapters one and three respectively of
 RoseLee Goldberg, *Performance: Live Art 1909 to the
 Present* (New York: Harry N. Abrams, Inc. 1979).

39 Billy Kluver and Julie Martin, "Four Difficult Pieces," *Art
 in America* (July 1991), pp. 87–88.

40 This isn't to say that in the future interactive installa-
 tions won't be able to give a participant "choices." For
 instance, through an analogy with computer artificial
 life, participants will be able to add to the work, or even
 veer in another direction, not strictly structured into the
 program. This is akin to written forms of hypertext.
 Also, when they are more than simply fly-throughs,
 virtual environments are a form of interactivity. While
 movement of objects within virtual environments is still
 limited, it promises much more for the future.

41 Roland Barthes, *Image-Music-Text*, trans. Stephen Heath
 (London, 1977), pp. 146-47.

42 Terry Winograd and Fernando Flores, *Understand
 Computers and Cognition* (Reading, Mass.: Addison-
 Wesley, 1987), p.31. Like the Bowers book, this text is
 very important to the issues in this essay.

43 Ibid., pp. 32-36.

44 Ibid., p. 37.

45 Arthur C. Danto, *Beyond the Brillo Box: The Visual Arts
 in Post-Historical Perspective* (New York: Farrar, Straus,
 Giroux, 1992), pp. 35 and 46, respectively.

46 See Regina Cornwell, "Cinema and the Art Museum: A
 Short-Lived History," in a collection of essays edited by
 Debra Balken, to be published by Duke University Press.

Images Within Images, or, From the Image to the Virtual World

by Florian Rötzer
Translated from the German by Johanna Sophia

We think, i.e. we see, that we are situated in a stable environment in which some things move. However, this occurs in front of an immobile background. We think, i.e. we see, scenes of objects or figures that are generally well-distinguished, whether or not they move. We think, i.e. we know, that the stability of our environment and the relative movement of some objects are constructed as a result of the constant (searching) movements of our eyes as well as of our heads and bodies. Moving and nonmoving objects differentiate themselves only in relation to our retina. These objects, then (or so we think, i.e. we know), are not perceived directly by our visual sense-receptors. "What occurs here are elementary physiological reactions which are 'assembled' on a later level of the visual system into color, edges, movement etc., to form first simple and finally more complex objects and scenes."[1]

We cannot see what we know, and what we can observe as a result of other people's observations we cannot recognize in ourselves. There is a gap between seeing and knowing that is like the gap between observers of the first and second degrees. We know, for example, that we dream, but we cannot free ourselves from the dream as observers, because awareness functions as a backdrop and denies us perceptual access to the mechanisms of image production. We move around as in a theater, where the scenes are generated by ourselves. And within these scenes we constitute or else create additional scenes. These scenes could be endlessly stacked and parceled within each other without ever reaching a logical conclusion. Yet we almost always come to an end—or suffer an ending—due to certain mechanical processes.

Nevertheless, we distinguish *between* images, and we also produce images *within* images.[2] We can, for example, see pictures hanging on a wall within a virtual-3D room. Hooked up to our virtual-reality diving equipment, we approach these pictures. Suddenly the first room—in which the pictures were supposedly hanging on the wall—disappears, and we enter into a picture, into the second degree

of perception. Within it are spaces where we can travel, and there are more pictures on the walls. We find ourselves at the beginning of a development where what we traditionally identify as a picture no longer represents a window, but rather a *door* into an immaterial space of data. And, as is the way with doors, we can enter through them into other, previously invisible rooms. Or, conversely, we can exit through them, out of the artificial world, and into a reality that will now appear in a very different light.

In a 1992 publication of *Imagina*, Philippe Queau, Research Director of the Institut National de L'Audivisuel, posed the question as to whether we can still speak of "images," when the miniature screens in VR systems are going to be replaced with weak laser-scanners that will imprint color-images directly upon the posts and pins of the retina itself. There will no longer be "pics," according to Queau; instead, the optical nerve will be connected directly to the computer, without the deviation of optical apparatuses that would traditionally be used to create virtual images. Since there are no longer any traditional carriers, *is* it still possible to speak of images, or do we have to describe what is seen as simply "visual sensation"? [3] Why, though, should the sensations that create the impression of images, no longer be called "images"—particularly when immaterial mental imaginations are considered images, and when our virtually perceived images are assembled from neurological electric impulses? It may also be possible to stimulate directly the particular parts of the brain responsible for visual images in order to "see" something—even though this is not as yet implementable. And what will we be seeing then? Will we see visual information stored in our memory, synthesized into some kind of picture?

If everything that is a visual sensation can be called an image, then the significance of this word is diminished. When trying to apply limits to the term, however, we soon realize its vagueness, because the distinction between relating to images and relating to reality is still very important to our culture. Epistemologically, we have ostensibly advanced far beyond the naive ontologies connected to this. However, no convincing thinking models have as yet emerged to demonstrate how such a differentiation could be connected to a theory of cognition bound neither to representation nor to ontology. Such a theory speaks of images or simulations that are constituted by an organism from a separate world, images that (under normal circumstances—not including hallucinations) signal contact with "objects." But these images do not signal "qualities or characteristics of that which they come across."[4] No matter what the brain comes up with under the premise of viability to satisfy such a pragmatic theory of cognition, we can speak only of the failure of these constructed images in orienting an organism within

an unknown environment. In this environment, we find images of the first order, and also images of the second order that are situated *within* those of the first order. These second-order images, however, have a different status when our senses cannot distinguish them without knowledge of their context. And it is not yet possible for the nontrivial machines we now build to develop nontrivial programs for the differentiation between images of the first and second orders–that is, the differentiation of worlds within worlds, or images within images.

Moreover, the ubiquity of images causes discomfort among many still closely connected to the Gutenberg galaxy, with its declining reading culture. Pure images are, after all, an exception in audiovisual media. In schools we are still trained, albeit with dwindling success, in communication via script, while subjects such as the Language of Images or the Communication of Images are missing altogether. Images are sanctioned (as they were in the old days by theologians) only as didactic aids that can facilitate and support access to cognition. This is true even though it has become clear—particularly through the visualization of fractals and the simulation of molecular scenarios—that vision can detect patterns, and therefore also structures, faster than any abstract process in which only columns of numbers are being processed. Yet this scientific visualization remains very contradictory as regards its cognitive value. This fact alone lets us realize the deeply rooted ideal of our education and its representation of knowledge.

It is said that the consumption of images, particularly images that change in rapid succession without continuity, leads to superficial experience. Above all, it is supposed to lead to a fleeting and distracted manner of reception that is incapable of the sustained attention needed, for example, to decipher layer after layer in a chain of arguments. Images seduce us, distract us, and bar our access to reality or truth. The consumption of audiovisual media introduces, apparently, a reorientation of the architecture of our senses, particularly within the context of city life and motorized transportation. The active psycho-motor orientation in the world disappears with the continuous consumption of audiovisual media—although it is this very orientation from which our experience of complex space derives. The human being becomes handicapped, so to speak, acquiring more and more prosthetics of transportation—including the images through which we are carried into a different place. These images' increasing interactivity may soon supercede transportation in space, particularly since the time of spatial travel is annihilated by the transmission of images at the speed of light.

The "close senses" (touch, taste, and smell, as well as the motor sense), traditionally at the lower end of the value scale, degenerate under the dominance of the "far senses" (hearing and sight). The latter are the senses of control and of distant observation, while the former stimulate the body of the perceiver. Yet it is at the external surfaces of the body, or inside the body, that the difference between self and environment, as well as the difference between self-reference and external reference, can really be experienced. On the other hand, we are also experiencing, as a countermovement, an enhanced evaluation of the "close senses," now aestheticized in all their nuances. Of course, the senso-motor dimensions of behavior are only limited in a "sitting, driving, and standing society" (as Reinhard Kahl points out in his film *The Disappearance of our Senses*). One might surmise that a new behavior could develop from a predominantly audiovisual take on the world, as perceived by motor-handicapped people via automotive (literally self-moving) images, moving at considerable speed.

Speculatively, we might refer to the well-known experiment involving cats that were restricted so that they could not explore space through their own body movements, and thus could not learn the constants of objects relative to their own movement.[5] Some of the cats were allowed to move freely, but dragged a cart containing other, constrained cats—bound like the viewers of the shadow show in Plato's cave. Both groups of cats had the same visual experiences. But when all the cats were, after several weeks, allowed to move freely, the cart-pulling cats were able to orient themselves normally, while those cats restricted from any movement would continuously bump into things or fall off edges. From this experiment, it was deduced that an "intelligent" orientation in space, or any generally "intelligent" behavior, develops from an active senso-motor exploration of the environment.

Scientists have also come across this phenomenon through research in artificial intelligence. Taking this perspective a step further, medical psychologist Ernst Pöppel, presented a treatise containing several implications for a philosophical theory of the constitution of reality.

In order for an individual to be able to orient him- or herself in terms of senso-motor functions as an organism, the certainty of the direction, as well as the certainty of the identity of objects, must be constructed through more than just visual experience. Based on the neurobiological premise that only one fact at a time can be present in the mind (due to the frequency of approximately three seconds in which an event is synthesized) "all mental experience," maintains Pöppel, "in living organisms [is]

directed toward undertaking movement in space. Decisions are being made with reference to each new occurrence because we don't stand around like a tree." [6]

Like one of the cats described above, or like a tree, we find ourselves motor-handicapped but flooded with stimuli, such as audiovisual media. We can process or direct the interface with what is happening only sensorially or with limited hand movements when sitting in front of the screen or behind our windshield. Although in a constant state of excitement, we find ourselves in the tense and intensive situation of being threatened or at least confronted, without being able to escape by running away. This situation, though, constitutes the basic state of fear into which we voluntarily submit ourselves in many of the films we attend, and possibly also in the fascination with the high we experience at fast speeds. Zipping between programs confirms us as travelers constantly creating stimuli for ourselves in order to escape the tiring passivity of image consumption.

The statement by Pöppel has further consequences when it roots itself in the idea that we seek certainty in a situation in order to be able to move toward a goal. Physiologically, it would be difficult for us to be confronted with new circumstances every few seconds—even if our sensory detectors only registered differences to preceding circumstances stored in our memory as a simulation of complexity reduction. But why the preference for certainty, even when a situation does not at all conform to certainty? Visual perceptions are evaluated through our attentiveness toward deviations from expectations and through intentionality in view of a goal-oriented behavior. Visual perception is thus integrated into an intended movement-trajectory marked by a definite direction: "We are not like shapeless amoebas but are well-constructed and are spatial units. Because we are spatial, our organism must use all the information available at a particular moment for the new movement trajectory. We can only move in one direction, and therefore, definite decisions must be made based on multiple information." The creation of definite situations forces differentiations; among them is the distinction between worlds and worlds-within-worlds.

Maybe these are the reasons why some theoreticians view the linear representation of data in script-form as conflicting with the parallel presentation of the image (since this parallel would interrupt the anthropological orientation toward certainty, which is intertwined with succession).

Perhaps one intuitively attempts to use a different model of information-processing from the linear one of the traditional von Neumann computer (which occurs "step by step"), even if this "only"

leads to the realization that parallel processing of sequentially operating computers obviously works better for image recognition. Script, or linear discourse (we are here interpreting a thesis by Vilém Flusser), already is a critique of the images that precede it; their order is taken apart by it as far as their certainty is concerned. Large-scale diagnoses now emerge that speak of a transition from a reading-and-script culture to a culture based on images. There is talk of the end of linear thinking and of all the concepts connected to it, as if images were not arranged in a linear manner in terms of their motion, and as if they did not, after all, have to be perceived in sequence, as the screen is constructed layer by layer and the TV monitor line by line. In any case, the contrast between the linearity of line-by-line reading and the totality of image information is a myth, because images are coherently structured only after a sequence of fixations, occurring in visual leaps, in which the entire image is never in focus but, rather, is seen from a particular angle, with certain areas in focus and the background, for example, out of focus. [7]

While the eye movements of the reader of *script* are forced into a linear route, they are generally not when he or she is viewing a *picture* of sufficient complexity. This allows for the image's subjectability to multiple interpretations—except, of course, for symbols that are not conventionally coded. It could be assumed that with moving images, in which the cut of scenes is carried out close to the edge of rhythmically integrated movement, the searching motions of the eyes (at least the conscious motions), are largely suppressed—those movements that demand a consistent image and make possible the aesthetics of contemplative perception. With an accelerated cut of scenes, a fixed, passive perception might emerge that would only read the most pronounced figure-ground relationships, so as not to lose the overview of the flood of changing images entirely, or simply to switch off altogether. This is why signs that are supposed to be noted at great speed have to be sufficiently simple, once again approaching the vicinity of script codes, i.e. signs in the shape of defined icons. Such intense attention—similar to that in situations of danger—seems to be demanded of us in our daily consumption of audiovisual media, most evidently in our contact with video games and music videos.

Media critics also seem to hold that books necessarily consist of text only, as if there hadn't always also existed picture books. In the book, we promenade at home, saving ourselves the trip. [8] And even if, like learning children, we read letter by letter, or word by word, we must realize that a sentence—not only grammatically but also in its very meaning—is never structured in a linear fashion.

A subordinate clause such as the following, a clause enclosed within sentence, demands that while reading, we anticipate meaning both forwards and backwards simultaneously. The reading of texts, like the hearing of sentences, is structured by expectations, or contextual mise-en-scènes, which direct our visual perception. We see much less with our eyes than we do when we read or experience. Seeing—images or script—is therefore always an interpretive process.

The critique of images does not begin in the age of media. Rather, it threads with almost tiresome monotony through history, ever since the evolution—in the culture of script—of the idea of a single truth, an absolute identity. This "truth" cannot be captured in an image, and is destroyed by duplication. It emerges only through the recognition or construction of its actual appearance. Every process of recording or replication is subject to the suspicion that it falsifies or distorts reality, a suspicion that it allows humans to lose themselves in deceptive illusions. This notion was proposed by Plato, in his critique of written discourse, and it experienced a renaissance with the advent of mass-produced printed books. It was argued that reading made one passive, hindered one's own experiences, and allowed human beings to immerse themselves in illusions. Apparently, the media bring, on the one hand, claims of a truthfulness to reality, or "authentic representation" (as in photography). On the other hand, the media are the very source that allows for the fantasy of an undistorted, objective cognition—which, paradoxically, emerges through the distortions incurred within the media. So, from which source, if not through the inherent mechanism-seeking certainty (i.e. reduction of complexity), do the worries stem—initiated as they are by enlightenment, science, and philosophy—and which, via techniques developed through them, seem to re-immerse those illusions or worlds of images from which they intended to flee? With hairline distinctions, symbols, images, signs, simulations, models, differences between fictions, realities, illusions, hallucinations, and imaginations are sorted out in a roster that sometimes has bloody consequences, but which seems to be important to the maintenance of order in societies or in individuals. These distinctions provide us with an orientation; their destruction leads to new differentiations, without, however, ever allowing us to escape them.

When we speak of an image, two overlapping connotations accompany the thought: first, the image is a representation of phenomena that are in some way visual, even when we speak (for example) of "mental images of imagination," or of images based on language or even created *within* language. In some significant respects, images are "poorer" than the original they represent, even when they appear to

replace the thing they represent, and successfully deceive our perception. In both dimensions, an *interval constituent* for images—as opposed to the thing they represent, however it may be provided—is at issue. When this interval is thematized, many things (not only visual ones) are called images. Simultaneously however, the interactive images of virtual realities, which allow for tele-presence and tele-action, radically change the definition of an image, even when it is limited to visual information.

When we enter into computer-generated, or digitized, images we are able to move around in them as in a natural environment. We can carry out actions through manipulation of virtual images (for example, through a robot—which we navigate with our own body movements and through whose "eyes" we "see" the tele-present space—so that we are acting both in the "real" world and in the virtually present world in which our bodies are not actually present). This virtualization of reality and realization of virtuality lead to the collapse of the traditional difference between an image and reality. Although we are able to perform manipulations in the image, through eye-tracking systems, or with our voices via language-recognition programs, although we experience changes in the image that occur because of our own physical movements, we still do not become an integrative part of the image. But neither do we lose the position of the external observer—the very position that identified us as viewers of traditional images, and which was identified as the ideal position for objective cognition. With interactive images, we are returned to a magical relationship between images and objects, even though (in the case of tele-action) we may know why the manipulation of an image causes effects in the real world. This indicates, once again, how very much the identification of an image is connected to knowledge.

The fact that we can speak of images in language, with metaphors for instance, shows that image-likeness is constituted with the aid of an additional differentiation: namely, a "correct" use of language to identify phenomena in the world. There is always some latent realism in the form or shape through which images distinguish themselves from a "real" reference to something "real." However, while words or sentences represent without being similar to *what* they represent, images do to have some similarity, as concerns their "subject," with that which they depict, and this similarity is on the same level, that is, on the visual level. Then again, similarity can in no way mark the difference between image and object, for there are objects that are as similar to each other as twins without one being the *image* of the other. Even the relation of an image to something that precedes it as an original cannot be a general characteristic of an image. When a page is copied, when the model of a car is serially produced, or when cogni-

tion is simulated on a computer, we don't speak of the copy, the car, or the simulation as images of that which precedes them. Similarity is a relation that can be established from many aspects, and it is often regulated by convention rather than through immediate visual perception. Images seem to be phenomena—in the world or in our minds—that need for their identification a kind of competence not conditioned by general rules, but acquired and to a large extent dependent on context.

Once we start thinking about how images can be identified through their differentiation from other phenomena, we are thrown into a state of confusion. To paraphrase a sentence by Ludwig Wittgenstein: the term "image" appears confused. And, as Wittgenstein did, we have to add that the term is *indeed* confused, particularly since it has become possible, through the digital code, to reduce all forms of information-representation into an unspecific language that can be retranslated into the various forms of representation. With the computer, all forms of representation and symbols become peripheral surface phenomena of the digital code. For this reason alone, the teleology of the Enlightenment—with which we are still deeply involved—will be shaken. The path from myth to enlightenment, seen as a path from the image to the word, or from the observation to the abstraction, can now be traveled in reverse, because images cannot simply be analyzed, but can be produced from mathematical equations. We can conclude that technical developments have a considerable influence upon what we perceive to be an "image."

As an example, witness the analogy of the train.[9] The view through the compartment window produces a moving, framed image for the passive observer, who is neither steering nor in any other way controlling this high-speed progression. The train is an image-machine, like the windshield of a car or an airplane behind which an observer moves through three-dimensional scene as a projectile. Except during the occurrence of an accident, which allows reality to break traumatically into the situation, the traveling observer finds him- or herself at a distance from the environment, similar to the position of the viewer of a moving image.

The train passenger is excluded from the environment and encapsulated in a vehicle where a different perception is to be learned. For us, exposed and habituated to machines of transportation and to moving media images, this perception has become second nature. Not only do images become more fleeting every day, but we also have to digest an increasing flood of stimuli. This leads to the "shutdown" of perception. We get bored, we doze, or fall asleep, unless constantly stirred by extraordinary breaks or

shocks to our senses, which keep our attention awake. The activity of the passenger, limited to the observation of rapidly changing images, has given rise to the creation of additional media, ranging from travel readers to video. Shooting across the landscape at three hundred kilometers per hour, we can no longer focus on the foreground. The passenger must focus on targets at a certain distance if he or she wishes to identify anything with clarity. Things in close proximity, which pass by at high speed, appear distorted. Other media fulfill the function of providing images in a manner adequate to the sensory conditions, even if these images once again reach the limits of acceleration—as is the case with music videos.

John Ruskin, very much used to the old way of traveling, established a cult of slowness. Ruskin said: "If we move fast and take two houses at once then this is already too much; therefore, the most pleasant way of traveling for an emotionally balanced person is on a country road at a speed of not more than 10 to 12 miles per day; for traveling becomes duller and duller at the exact ratio to its increasing speed." Still today, people defend the reading of a book or the contemplative viewing of an image with heated words against the flood of media images, which supposedly lead to superficiality.

In 1837 Victor Hugo attempted in a well-known letter to explain the path into abstract painting: "The flowers by the side of the field are no longer flowers but patches of color, or rather red and white stripes; there are no longer any dots, everything becomes stripes . . . the towns, the church towers and the trees carry out a dance and mix in a crazy way with the horizon." Gustave Claudin reported in 1858 that human beings who travel for a long time by train fall into a "previously unknown tiredness." He wrote: "Ask these victims of velocity to tell of the places they have passed or to describe the various views, the images of which have traveled past the mirror of their consciousness in rapid succession, and the people will be unable to provide you with an answer. Their feverish minds will ask for nothing but sleep to put an end to their over-stimulation." Of course, the new stimulation of the moving image was also celebrated: "The steam-engine," said Benjamin Gastineau in 1861, "pulls backdrops and decorations along; it changes the viewpoint at every moment, it confronts the dazzled traveler in close succession with joyful and sad scenes, burlesque intermezzos, with flowers which seem like fireworks, with views that vanish immediately after they appear."[10] The train trip is thus the beginning of our conditioning with media images. The criticism and fascination with it are also astonishingly, monotonously similar to the media.

To return to the initial question: how are images separated from their environment as a world

within the world? In an era such as ours, in which art no longer has the symbolic nor the aesthetic at its core, the difference between art/nonart, image/nonimage is *processed*, and we are constantly encountering instances of this.[11] Even if we understand an image as resembling or representing something (which may be fictive), abstract art has at least shown us that it is perhaps not *content* that constitutes an image but, rather, certain differences that distinguish an image from its environment and identify it for the viewer as a world within the world.

The crisis of representation we are experiencing today on all levels—from politics to art to science—frees the image from its frame of reference. It turns it into something as elusive as language to its referent—something that occupies the philosophers of the written culture, and creates irritation through the field of artificial intelligence.

The differences between image and environment are evident when an image has a frame or a carrier, such as a movie screen or a computer display. However, images themselves can also be performative. A trash can, a piece of fat, a random pattern, or a simple color on a wall can be just that—or, in a museum, can be declared an art object or, again, an image (if we define an image as something that appears on a more or less two-dimensional level). As an image in the context of art, which is not the same as an aesthetic level, it can be criticized because it has been exhibited by the artist or the curator of the exhibition. It is interesting to note here that, at least since Marcel Duchamp, the figure of the artist has merged with the figure of the curator. If the intentionality of an author were to disappear, we would have difficulty speaking of an image, even if we see something that is an obvious representation of something. It could, for instance, happen that bees, in their dance on a sandy surface, might, by accident, create the contours of chancellor Helmut Kohl's face. We could, of course, call such a phenomenon an image. But this contradicts our expectations as to how an image is produced, and would take place in a context where we would be highly unlikely to come across it *as* an image. If we do not see something familiar, or if we don't know that what is depicted—an X-ray image, or a topographic chart—represents something other, something causally related to it, then we do not know that we are dealing with an image. This switch is of course mostly evoked by frames, though which an excerpt (i.e. a world within a world) is produced. This image, a virtual reconstruction of a scene, is based on the principle of excerpt and duplication. One can view this image as a literal "representation." We now have the scene twice: both as an image and as a reality.

We also have the capability to perceive a real scene as an "aesthetic" image through a mental operation. Clearly, this means that as observers of an image, we have to situate ourselves in order to create certainty.

Before images are materially produced, they must already have been "cut out," mentally and virtually. [12] In order to accomplish this, we have to reorient ourselves from the perspective of the first observer to that of the second, hence observing the observer. In this context, images are always created in a manner that fixes the observer within a perspective. With the division of the environment into a first and a second order, different operations are activated in the observer. One operation does not allow for the image to be present in the other. Such a differentiation is probably also at hand in the case of the recognition of images in contrast to a scene that is experienced as "real."

Naturally, we have to go back even further, since we comprehend visual perception as a form of image constructed by the neurological system in our brain that is connected to the sensors. Former theories of cognition were based on the idea that the information received by the retina reproduces reality as would a lens or a mirror. We know today that our perception is not only constituted by biological conditions, which could just as well be different, but that what we believe we see directly via our eyes is calculated into images only in the brain, from the unspecified digital neurological codes. This "informational complexity" of psychological systems as nontrivial machines has the effect of suggesting "that which stimulates the senses [has] no fixed or predetermined effects. The meanings of signals are only constituted in the brain. In this sense, the brain is not an information-receiving system but rather an information-creating system. The impact of occurrences in the environment receives a particular meaning exclusively through the context of the neurological activity in the brain dominating at the time." [13]

Perception seems to be of singular importance. In the brain, the signals that are received, for example, through the eyes, are then "translated" into a neurological code and processed in order to realize a particular perception. The differentiation between the sense modalities of hearing, seeing, tasting, and so on, takes place through an imprinted biological networking. Whether certain regions of the brain are stimulated artificially or receive "real" signals from the environment, the response will always result in an audio or visual impression. One could describe the process of perception as a screen upon which signals received through some kind of sensors are transformed into a digital code

and then reappear according to internal rules. This is true because, as observers of the first order, we can only perceive within the limits of our biological conditions; the deeper levels of neurological processing of information are closed off. Whether or not we are dealing with an audio or a visual experience cannot be determined from the observation of nerve-cell activity. According to this "picture," the perceiving person would sit in his/her brain like a pilot in the closed cockpit of a jet, and he or she would find orientation only through monitors and other instruments that rendered representations (that is, simulations of an inaccessible environment), while flying blindly through it. The only difference is that for the perceiver, the cockpit and the airplane would be his/her own body. This, however, constitutes a considerable difference, since the senso-motor conditions are not available to the consciousness of the first observer. They are the interface with the "real" world; yet this interface is the blind spot of our perception. That is why we do not have the impression that we are looking upon a screen when perceiving something in the outer world. In order to perceive something in the external world, and not as a world within the world (as in an image) we must deceive (so to speak) the normal interface by phasing out the world and making impossible the distinction between image and environment, between reality and illusion.

Even if contemporary theories of cognition, and the current attempts to emulate cognition as artificial intelligence, are hindered (as they must be) by posing the question of what something *is* (in this case what an image is) it is still necessary for an observer of the second order—a role here played speculatively and associatively—to connect the question: how is a thing constituted as an image or a nonimage by the observer of the first order? Once the differentiation is made, we can no longer perceive a thing as both an image and a nonimage. And the knowledge of such limiting conditions includes the possibility of manipulating perception very specifically via technologies, something that has always been done in the arts. Finally, there seems to be a fascination in human beings with the idea of dissolving the differences between image and nonimage, and with "experiencing" images, at least temporarily, as reality. We all know from the history of painting or film how rapidly images, once perceived as realistic, wear down while the differentiation becomes more complex, the expectations of realism increase, and a parallel derealization occurs. When certain scenes have been repeated a thousand times, the real scene finally becomes an image among others.

Apart from its "hard" areas of implementation,[14] the VR technique is probably so compelling

because the interface with an image is considerably changed in several essential dimensions. With the data-helmet—in which two miniature monitors are placed so closely in front of the eyes that one can perceive only images appearing on them—the environment fades out completely. This is also the case when an image is projected directly on the retina with laser beams. The image is no longer a world within the world, marked by a frame, but rather, an environment for an observer moving around within it. Corresponding to the viewer's head movements and measured by sensors, the perspective of the image changes—although still with delays and sometimes leaping—so that the image, to the extent that it is programmed, continuously surrounds the observer like a natural world.

When I speak of VR as of a frameless image, "frame" signifies not only the material limit of the image, but also the "framed" image does not have any continuity with its overall environment, an environment that includes other dimensions of perception. If one shifts perspective, the image disappears and its environment appears. The material world, it has been said, can be defined by the fact that it continues in all dimensions, allows for endless perspectives—it cannot be exhausted, while in a traditional image, when we get closer and closer, the scene disappears. Numerical images constructed from fractal equations cannot be identified as images solely through that process, because it is possible to zoom endlessly into them while continuously encountering images.

Because of its materiality, the image is a part of the world. However, differentiating it from the objects of the material world, it interrupts their continuity and places another limited world against them. Setting aside the problem of categorization, images of science are at most material systems, which through sense-perception remind us of something by means of certain physical effects. The criteria for the acceptance of reality, established by Descartes and later by Leibnitz, result from the hypothesis of consistency and continuity, on which science is based, and which in modified form also provide the foundation for the theory of chaos.

On the cognitive level, the impression made by an image can be avoided when the difference between the environment and the image is complicated. With film, this is done by darkening the auditorium, and in the panorama through the total mise-en-scène of an artificial reality, beginning with objects in the foreground and continuing into a painted image beyond. In both cases the stage on which the image appears remains intact while the observer remains outside the image. This is also true for the first image-machine, the train, and for its extension, the simulation of voyages in a vehicle

through virtual space, as long as we cannot step into it or travel through it via our own movements. Joachim Sauter of Art&Com has developed a provocative interactive experiment concept, with the title "The Un-Seer," in which the unconsciously and arbitrarily executed movements of the eye are linked, on a visual level, to changes in the image and thus the position of an external observer is systematically destroyed. Using an eye-tracking system, eye movements are linked to the image in such a way that each movement destroys the part of the image viewed. What remains is a color painting of motions executed by the eyes. Here, the observer is captured inside the image; he or she interferes with the image while creating a new image.

In order to perceive an environment as highly "realistic," the observer must be able to explore the environment with the senso-motor functions, and must do so in such a way that the differentiation between the body and external material world becomes perceivable. If the environment can only be experienced by sensors, without any somato-sensory link, the impression of an image will occur—an image, which, according to a statement by Walter Benjamin, remains in the distance, however close it may be. In order to simulate the experience of the embodied observer of the first order, now "within" an image as in an environment, the far-senses alone are not sufficient. Apart from the linking of one's bodily movements to the brain, the constitution of the material environment is decisively connected to our sense of touch. This sense allows us to experience the physical obstacle and the "unsurpassability" of material objects. Both experiences contribute to the sense of differentiation between body and environment, and thus to the differentiation of reference to external elements. What is new in the virtual worlds—no longer called images—is precisely the fact that both can be experienced in them even if the tactile sensations can only be simulated with unrefined mechanisms. As a realistic simulation of environments, the VR-technique may, in principle, be very limited. However, we can experience with it inaccessible or "crazy" environments, in which we may orient ourselves in a different but consistent manner which would otherwise not be possible. It is conceivable that, just as contemporary art has deconstructed the expectations of the traditional image, the ingrained expectations of an observer could be deconstructed by the virtual worlds. Because, in this circumstance, we can not only perceive *as if in* another body . . . but *as* another person. And if we don't want it to happen, the mask will not be lifted.

The fact that the objects in virtual reality have a quality of their own to some extent distinguishes them from traditional images, particularly since each virtual world has its own program and can act in

relation to changes in the environment. Exactly how difficult this is can be seen from the attempts at creating interaction with a virtual human being through image and language. Because the paths, sequences, and interactions still have to be determined, boredom almost invariably sets in after the first surprising effects, because the unexpected cannot occur. The systems are tested like a Turing machine in order to come up with the program. This will change when the virtual beings are integrated into a virtual world with their own—not too stiff and maybe at times chaotic—processes, and can react to the visitors.

Of course, there have always been created situations in which observers could participate and events were meant to move them emotionally. Magical ceremonies, shamanic seances, cult-stagings, the Eucharist service, festivals, architectural works such as churches, castles, or entire cities, Disney-worlds, performative events such as happenings or other forms of action-art, etc., have created an artificial reality not (only) on the level of the image, but a reality in which the observer is surrounded, and perceives stimulation through more than one sense, and in which it is possible to move around physically. We have a long tradition of inventing "machines" that elevate the observer into another world and in so doing are supposed to transport them beyond the world of the image. Virtual worlds go a step further in this direction. And this step promises to be more interesting, as these worlds are nontrivial simulations of the existing world and its fictions; aesthetic realism is very rapidly exhausted. It is important to develop these techniques further and, above all, to develop the imagination necessary for the creation of new worlds that differentiate themselves from our world and from which we will learn to appreciate and explore even more deeply through the journey into simulation. But to construct these worlds, artists, technicians, and philosophers will have to work together as collaboratively as they did in the Renaissance, at the time of the invention of perspective.

Notes

1 Gerhard Roth, "Das konstruktive Gehirn" (The constructive brain), in S. J. Schmidt, ed., *Kognition und Gesellschaft* (Cognition and society), (Frankfurt: Suhrkamp Verlag, 1992), p. 906.

2 See Florian Rötzer, *Von Beobachtern und Bildern erster, zeiter und n-ter Ordnung* (On observers and images of the first, second and nth order)(Linz: Veritas Verlag, 1992).

3 Philippe Queau, "La puissance du virtuel" (The power of the virtual), in *Les metaphores du virtuel* (The metaphors of the virtual) (Paris: Ministère de la culture et de la communication, 1992).

4 Ernst von Glaserfeld, "Konstruktion der Wirklichkeit" (Konstruction of reality), in *Einführung in den Konstruktivismus* (Introduction to constructivism) (Munich: Piper Verlag, 1992), p. 21.

5 R. Held and A. Hein, "Movement-produced stimulation in the development of visually guided behavior", in *Journal of Comparative Physiology and Psychology* 56, pp. 872–876.

6 Ernst Pöppel from an interview in *Kunstforum International*, Oct/Nov. 1993. (forthcoming).

7 Manfred Schneider very elegantly derives a critique of media criticism from this: "If one actually experimentally assures that the retina-image in a volunteer cannot move, through rendering immobile the volunteer, his/her eyes as well as the perceived image, then the visual impression becomes weaker and weaker until it finally fades away entirely. Our old pedagogics with its fantasies of increasing the efficacy of the eye via privation . . . educates children into blindness. . . . Only the extreme dispersion assures the ability to decipher perception, an ability which provides our orientation with sufficiently differentiated data. . . . The beautiful, quiet entirety of the world dissolves in countless nerve-switches and connections. Our vision, our perception, takes whatever it needs: even the noise on a TV-set." Schneider, "Was zerstreut die Zerstreuung?" (What distracts distraction?), in W. Tietz and M. Schneider, eds., *Fernsehshows* (TV shows) (Munich: Suhrkamp Verlag, 1991), p. 21 f.

8 "Many a man travels through foreign lands / mountains and valleys / to explore God's creations. Here they are all as in a garden of animals / all in shape and form / nature and character as in a pleasant paradise / properly to be viewed for the eyes to perceive and understand." Konrad Forer in 1536, quoted in Michael Giesecke, *Der Buchdruck in der frühen Neuzeit* (Book printing in the early New Age) (Frankfurt: Suhrkamp Verlag, 1991), p. 518. The advantages of books are described by Forer as follows: "Here one finds everything together so thoroughly / actually and truly gathered together / entirely entertaining and funny / even to be seen with one's eyes / and to hear with one's ears / for everyone in his house / and under his roof. (Op. cit.)

9 See Wolfgans Schivelbusch, *Geschichte der Eisenbahnreise* (History of the journey by train) (Munich: Hanser Verlag, 1977).

10 John Ruskin; Victor Hugo, Gustave Claudin quoted from Wolfgang Schinelbusch, *Geschichte der Eisenbahnreise*, Frankfurt Am Main, m 1989. pp. 57, 54, 57 & 59.

11 See the catalogue "Bildlicht" (Imagelight) (Vienna, 1991), and the text by the two editors W. Drechsler and P. Weibel.

12 Albrecht Dürer, for example, says that one should make it a habit to draw pictures of the environment with a perspective without technical aids: "However, where it pleases, to practive in such a skill / and to demonstrate one's mind / may one have such squares in mind / and know to imagine or fantasize / that one may always imagine a horizontal line and a vertical or perpendicular line / quite perfectly in one's mind / and constantly be aware of it / where the point observed is placed in the painting." (Quoted in Giesecke, op. cit.) p. 612 f.

13 Wolfgang Krohn and Georg Küppers, eds., *Emergenz: Die Entstehung von Ordnung, Organization und Bedeutung* (Emergence: The development of order, organization and meaning) (Frankfurt: Suhrkamp Verlag, 1992), p. 390.

14 See Howard Rheingold, *Virtuelle Welten. Reisen im Cyberspace* (Virtual worlds. Traveling in Cyberspace) (Reinbek near Hamburg, Rowolt, 1992)

On Dramatic Interaction

by Brenda Laurel

Art or existential recursion? Virtual reality, like drama, can turn a transformational lens on human experience. Fourteen years ago when I was a graduate student in theatre, I had a conversion experience. A friend of mine worked at a large think tank where he was head of a new department in computer graphics and imaging. Late one night he asked me if I wanted to see a computer. We went through three security checks and up an elevator and through a maze of cubicles to a workstation where images were materializing on a little screen. I think it was Mars we were looking at. All I remember now is that I saw a portal to a new world, a million new worlds. I fell to my knees and said, whatever I have to do, I have to get my head into this stuff. Since the beginning of my involvement with the medium, I've been driven by one very rich metaphor. Like a fractal, the closer I look at it the more I see. Computers are theatre. Interactive technology, like drama, provides a platform for representing coherent realities in which agents perform actions with cognitive, emotional, and productive qualities. Novices are often struck by the computer-as-theatre metaphor when they first encounter the virtual world of a computer game. Designers incorporate theatrical jargon into their process—computer-generated "actors" receive "directions"; users "willingly suspend disbelief." But the comparison languishes once its superficial levels have been mined. The rich substrata of formal and productive knowledge that give the computers-as-theatre metaphor its power remain unexplored. Yet millennia of dramatic theory and practice have been devoted to an end which is remarkably similar to that of human-computer interaction design, namely, *creating artificial realities in which the potential for action is cognitively, emotionally, and aesthetically enhanced.*

A "scientific" approach still dominates the design of human-computer interaction. We count keypresses, measure users' eye movement, and analyze errors, drawing on such disciplines as cognitive psychology and ergonomics. More recently, artistic disciplines like graphic design and storytelling have

gained grudging acceptance, but contemporary design practice accommodates them as something fundamentally alien to the computer landscape. Art and Science, soft guys and hard guys, those who dream and those who write code—these form the thesis and antithesis of the computer dialectic.

But art is lawful. This view turns the dialectic on its head. It is no accident that Aristotle, the originator of poetics, was also the progenitor of Western science. When we examine human-computer experience with the same rigor and logic, we can derive a set of principles—a poetics of interactive form—that can far surpass the piecemeal science which is currently the heart of human-computer interaction design.

Mimesis The root of similarity between computer-based environments and art is the notion of mimesis: a representation whose object may be either real or imaginary. Computers blow a third dimension into the concept by adding *interactivity*—the idea that users can become co-creators, collaborating at the deepest levels in the shaping of a mimetic whole.

We are familiar with the idea of the computer as a medium-*emulator*. We paint with virtual brushes and make music with Macintoshes. We know that computers can mimic, expand, and augment the concrete tools of art. But we are less aware of the profoundly mimetic nature of the technology which allows us, not only to emulate existing media, but to create wholly new ones. And in order to do that, we have to decide what we're trying to create. Most of us begin by looking to technology for answers. There it sits, the ultimate shape-shifter. What does one do with a shimmering blob of unlimited potential?

Big Ideas I got my first answer to that question from Alan Kay when I was working for him at Atari Research lab. He said that the way to know where you're going is to generate the right Big Idea. This Big Idea must be powerful enough to capture all of your imagination, good enough to satiate you completely if you ever reach it. It must be impossible to reach from where you are now. When you've got the right Big Idea, then all that you think about and all that you do will align itself toward it, like magnetic particles, and you won't ever have to worry about doing anything irrelevant again. The computer landscape is dotted with Big Ideas, like vortices, magnetizing thoughts and expressions. Some of them are quite familiar. Long ago and far away, in the land of punch cards and batch processes, there was the para-

digm of conversationality. It was huge and impossible. Eventually it led to the command-line, tit-for-tat interface that we now find so unhip, but which exponentially increased the user's experience of interactivity. Sketchpad and Smalltalk were signposts to another Big Idea—the representation of manipulable objects. The object paradigm posits that we can emulate the physical properties of things—shape and mass and containerness—and that these virtual objects can provide a powerful metaphorical context for doing things with computers. Desktops, icons, files, and folders all materialized in this magnetic field.

Virtual Reality

The Big Idea of the moment is undoubtedly the notion of virtual reality. From Mad King Ludwig's grottos to Disneyland to computer games, virtual realities have been lurking in our culture for a very long time. Now, at the intersection of fantasy (Vinge's *True Names*, Gibson's *Neuromancer*) and technology (the NASA VIEW system, Lanier's *Reality Built for Two*), the paradigm has finally coalesced. John Walker at Autodesk describes it as diving through the screen into the world inside the computer. Finally, no more iconic representations, no more metaphorical indirection. We can treat the virtual world just like it's real. Alternate reality in a box. So what are we going to do when we get there? In the NASA system, you can zoom through a model of the space shuttle or climb inside a robot. The Autodesk team envisions CAD workers working around inside their own designs. In Lanier's version, two people can virtually inhabit the same virtual space and play virtual ball. The entertainment industry will undoubtedly bring us countless sports simulations and virtual travelogues. But I keep seeing this image, like something out of a sad surrealist movie—a bunch of figures wandering around inside a lonely masquerade, occasionally tossing a ball. After the first techno-rush, you're going to want to talk to somebody. And maybe not just somebody hooked into another terminal. A *virtual* somebody. Marilyn Monroe, Einstein, Captain James T. Kirk. I predict that, just as with computer games, we'll rip through the repertoire of imitations of games and physical activities, improving the technology and planting little signposts of convention, and then we'll start to hunger for more complex interactions.

The IF Paradigm

And that's where all this hooks back into the theatrical metaphor. In the *Poetics*, Aristotle observed that humans are hard-wired to learn, that they enjoy it tremendously, and that their favorite way of doing it is through imitation—acting things out. This is the impulse behind both theatre and computer games.

The Big Idea is a vision of an experience where I can play make-believe, and where the world automatically pushes back. It's like cowboys and Indians or theatrical improvisation, only better—because half of my brain doesn't have to be concentrating on making an interesting plot. I just get to be in this other world, first-person, acting as myself or Captain Kirk or some other character altogether, and I get to see what would happen IF.

The heart of the Interactive Fantasy paradigm is the ability to produce robust dramatic interaction through manipulation of the same formal and structural dynamics that are present in any good play. The system would behave very much like a human playwright who is operating with a bizarre constraint: one of the characters is a real guy, wandering around in your study, injecting lines and doing things that you have to work into your script. By embodying dramatic rules and heuristics in a computer-based system, dramatic action could be formulated in real time, shaping the responses of the virtual world and characters according to the choices and actions of the user.

The impulse to create an "interactive fantasy machine" is only the most recent manifestation of the age-old desire to make our fantasies palpable—our insatiable need to exercise our imagination, judgment, and spirit in worlds, situations, and personae that are different from those of our everyday lives. Perhaps the most important feature of human intelligence is the ability to internalize the process of trial and error. When a person considers how to climb a tree, imagination serves as a laboratory for virtual experiments in physics, biomechanics, and kinesiology. In matters of justice, art, or philosophy, imagination is the laboratory of the spirit.

It is not enough to imitate life. Drama presents a methodology for designing worlds that are predisposed to enable significant and arresting kinds of actions—where characters make choices with clear causal connections to outcomes, where larger forces like ethics, fate, or serendipity form constellations of meaning that are only rarely afforded by the real world. Dramatically constructed worlds are controlled experiments, where the irrelevant is pruned away and the bare bones of human choice and situation are revealed through significant action. The predispositions of such worlds are embodied in the traits of their characters and the array of situations and forces embedded in their contexts. If we can make such worlds interactive, where a user's choices and actions can flow through the dramatic lens, then we will enable an exercise of the imagination, intellect, and the spirit that is of an entirely new order.

Artist Sections

Gretchen Bender

Michael Brodsky

Michael Ensdorf

Carol Flax

Esther Parada

MANUAL (Ed Hill & Suzanne Bloom)

Keith Piper

Jim Pomeroy

George Legrady

Jim Campbell

Rocio Goff

Lynn Hershman

Alan Rath

Ken Feingold

Grahame Weinbren

Gretchen Bender

With any art-making medium, the structures of the tools are acknowledged even as there is a challenge to explore and transcend their formal nature.

Computer research provokes a conceptual curiosity about apprehending as-yet-unperceived terrains of existence, and exploring what their effects upon temporal human experience might be. It still becomes a series of discoveries concerning relations of control and play, which take place through a refiltering of a visual, psychological, and spiritual experience that shifts from one conceit about humanness to another.

A continual reperceiving of our cultural conditioning may inspire us to ignite for ourselves a more inquisitive and active present tense, both socially and politically, through our evolving definitions and creations of interactive art-making.

Entertainment Cocoon, 1993

Michael Brodsky

"Dark Passages" explores the darker side of technology and personal relationships. Using contemporary video- and computer-graphics, I seek to create both didactic and evocative images that concern the human condition, as well as man's alienation from technology, society, personal relationships, and even from himself.

Television images seem to move, but seldom move us. Mostly, we sit passively and watch for something to happen. The more adventuresome turn channels. Much of what we know comes from television, yet most people fail to understand the world of broadcast media (or their own personal lives for that matter). Few people see the choreography of time and space within their television set. Few people see their lives reflected in this collective transmitted experience.

Low-resolution digital imagery, as used in this work, is perfectly suited to this exploration of the media. Portions of these images are taken from broadcast airwaves and reconfigured, much in the way that our minds capture, process, and reconstruct our own perceptions of reality. The darkness, the scene edits, and the pixel deconstruction reference the synaptic gaps that feed nerve impulses to our brain.

Sweet Dreams:

Core Memory,

from the series

"Dark Passages," 1991

Ego & Id

from the series

"Dark Passages," 1991

Heartfelt Dreams:

Exit Stage Left,

from the series

"Dark Passages," 1991

Black Box for Pandora, from the series "Dark Passages," 1991

Mis(sed)conception, from the series "Dark Passages," 1991

Quick Trip (Back to Earth), from the series "Dark Passages," 1991

Heat Seeking, from the series "Dark Passages," 1991

Personal Options, from the series "Dark Passages," 1991

Burning the Candle, from the series "Dark Passages," 1991

Dark Passages, from the series "Dark Passages," 1991

Chalned Reaction, 1989

Michael Ensdorf

The images in the body of work titled **"Fiction"** begin by being digitized from books, magazines, and newspapers. The photographs are chosen for their historical import as signposts to some of the significant events of our time. These are the representations of an era—the images selected for inclusion in history books, the ones signifying memorable events. These events seem so far removed from my own personal sense of history that I question my belief in any mediated form of imagery. Ultimately, the **"Fiction"** series represents the confrontation of this disbelief. By removing these photos from their original contexts, and by using a paint program to add color and text in order to call attention to the surface of the image, I hope to question the validity of photography's authority to describe a time, or to define history. The word *"fiction"* functions as a label to desensitize the original photograph, and in turn, the actual event depicted. It references a staged reality in some images, and the questioning of a given event in others.

Stemming from a need to investigate the collective non-identity of mostly anonymous individuals depicted in the digitized media imagery, the **"Minor Players"** series attempts to lift and extract the participants from their historical environments. These witnesses go mostly unnoticed, and their identities will most likely remain forever shrouded in mystery. After working with specific images for so long, a certain familiarity is born that begins to develop into a fictional reading of their subjects' identities. I feel I know these faces, but in reality their closeness to me makes them even more distant.

The computer is used as a tool in my work. After the newspaper and magazine images are digitized and imported into a paint program, I am allowed the freedom to extract areas of an image at will. Faces are "cut" from a scene and enlarged to fit into the respective spaces of the individual grids. The amount of pixelization that occurs is dependent upon the size of the individual face in the original photograph; the more distant the person, the bigger the pixel. The face-grids are then "toned" in an image-processing program. The files are output to slides via a CI 3000 Polaroid Digital Palette. Cibachrome prints are then made from the slides.

Detail from
Fiction series, 1991

Photo credit:
Nicephore Niepce
**View from his window
at Gras,** c. 1827

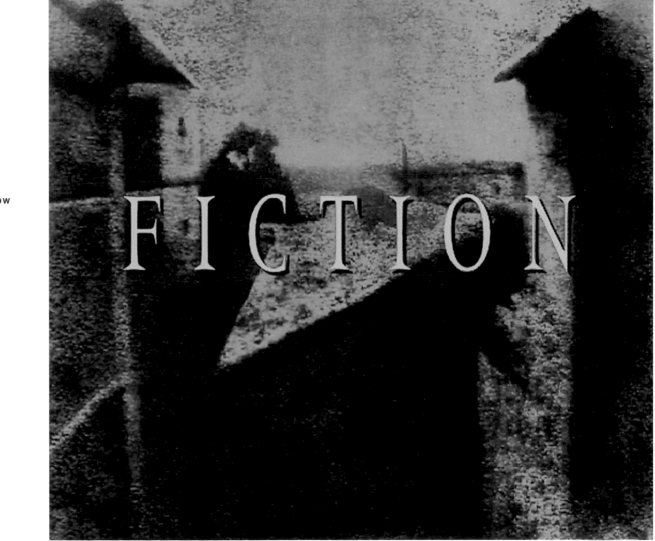

Details from

Fiction and **Minor Players**

series, 1991

Photo credit:

David Turnley

Police attack South

African anti-apartheid

demonstrators, 1985

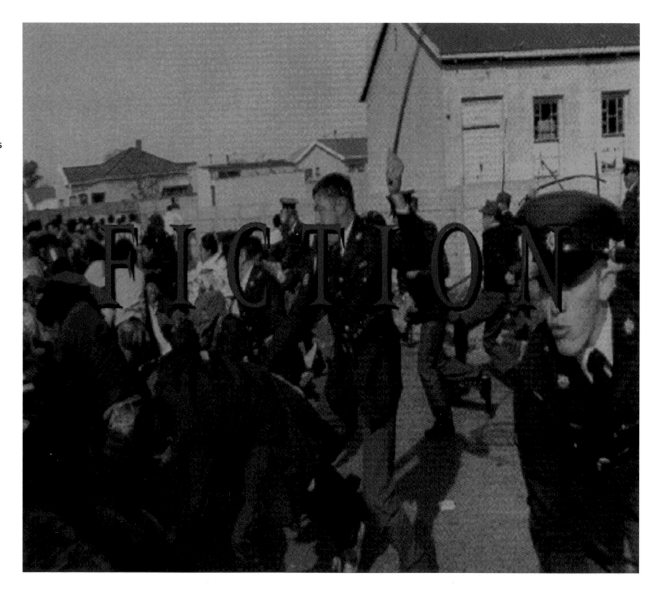

Details from
Fiction and **Minor Players**
series, 1991

Photo credit:
Marc Riboud
Klaus Barbie Trial,
Lyons, France, 1987

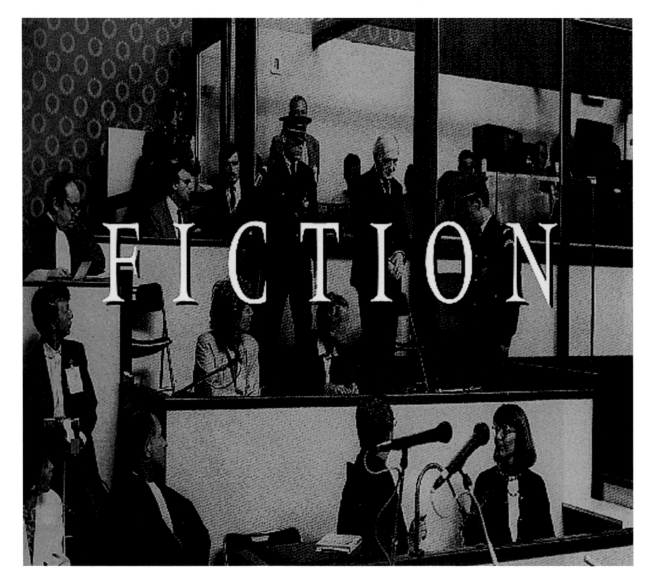

Carol Flax

My daughter comes upstairs to tell me about
mothers who sleep with their teenage daugh-
ters' boyfriends on *Geraldo*. I'm not sure
whether they are actually sleeping with them
on *Geraldo* or merely talking about sleeping
with them while appearing on the show. We
live in a world where the media freely
combines fantasy and reality; where the news,
docudramas, manufactured realities, all merge
together; where media-driven events direct our
view of the world. We all sat home watching
the Gulf War and the Los Angeles riots on TV.
The whole world gets their news from CNN,
including the newsmakers. As artists, we are,
presumably, media literate. We know how to
manipulate imagery and why. We know how to
read imagery when it's placed in front of us.
Generally we know what to laugh at and what
to take seriously. Unfortunately, this is not true
for most of the world. A large portion of the
world's population believe what they see on TV,
believe that a photograph, a printed piece, a
broadcast, bear at least some credibility. They
do not always decipher successfully the vast

I am not at liberty to reveal that. I have no further knowledge at this time.

Cleared by U.S. Military

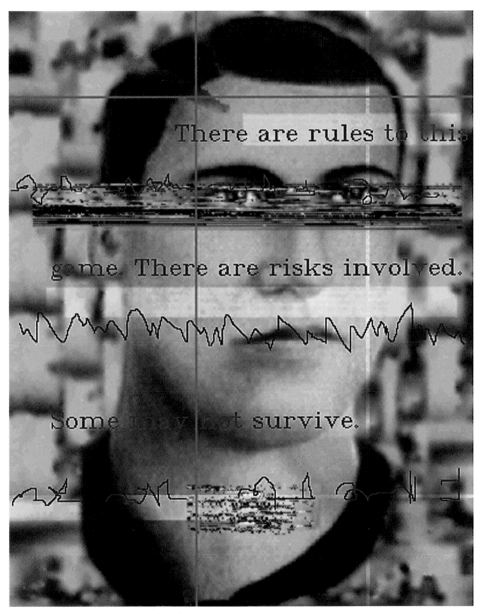

There are rules to this game. There are risks involved. Some may not survive.

Casey, 1991

amount of information that they are bombarded with on a daily basis. I am greatly concerned about this as we look to the information highways of the future.

My work is concerned with how we see and interact with the world. My particular concerns stem from my experiences as a mother. As my children reach adulthood and prepare to go out into the world, I worry whether they are prepared for the tasks and challenges ahead. Will they be savvy enough to know what to keep and what to discard? We have an education system that teaches people how to follow instructions, not how to think. Our children may be learning how to use the tools of the information age, but which among them will control the information? History has hard lessons for us about people who have lost the ability to make their own decisions. Once we've lost this ability, how do we learn from history? Increasingly I've turned to public venues for my art, hoping to use the tools of mass communication (such as billboards) to comment on both the message and the messenger. This work looks at the politics of our time, especially in terms of the media, appropriating the tools and devices of the media to comment on it.

Who's in Charge?, 1992

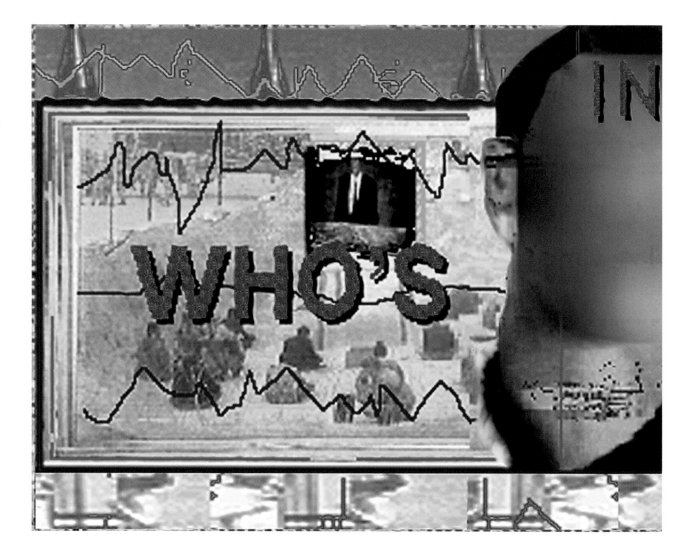

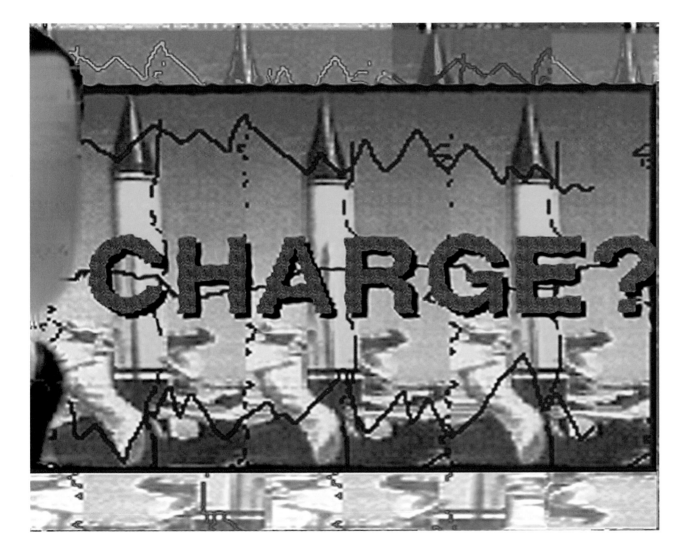

Your (He) Art, 1990

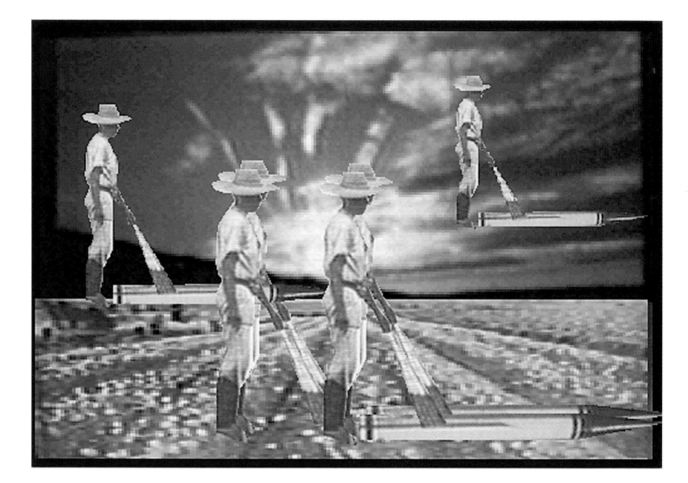

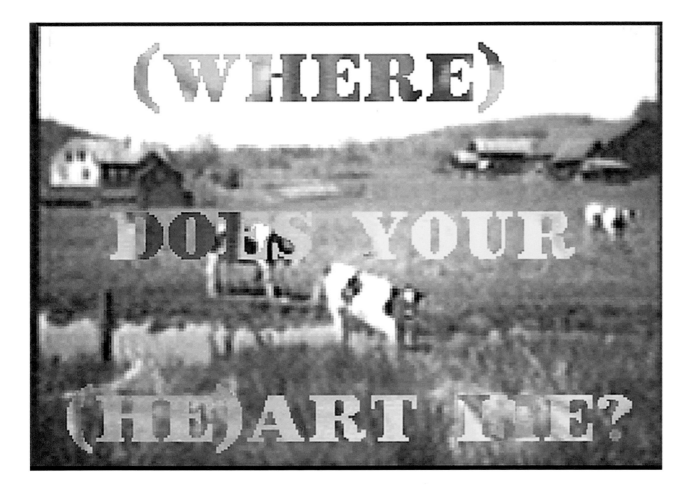

Esther Parada

"... To Make All Mankind Acquaintance"

I *The stereograph, as we have called the double picture designed for the stereoscope, is to be the card of introduction to make all mankind acquaintance.*

These resounding words were part of an extended essay published by Oliver Wendell Holmes in the *Atlantic Monthly* and reissued by Underwood & Underwood in 1898 as *The Stereoscope and Stereoscopic Photographs.*

As publisher of stereographic card sets, Underwood was anxious to establish the validity of this (at that point) innovative technology, for educational as well as amusement purposes. Indeed, a competitor of Underwood, the Keystone View Company, included in its turn-of-the-century catalog an elaborate chart detailing the myriad ways each scene was analyzed and "universal knowledge" was classified, including a dozen portraits of the venerable (male) authorities consulted in the process.

My work in *Iterations: The New Image*, from the series "2-3-4-D: Digital Revisions in Time and Space" grew out of a residency organized as part of "Society and Perception: New Imaging Technologies" at the California Museum of Photography in 1991. Building on my longtime interest in Western representation of Latin America and other Third World areas, I took this opportunity to examine in some detail the museum's impressive Keystone-Mast collection of historical stereographs, especially in relation to images of Central America and the Caribbean. The very first in a set of forty-eight scenes, titled "United States History" was of the *Monument to Christopher Columbus, Madrid, Spain*, and I found that Columbus references were prominent among the views of almost every Latin American country.

To me this indicated a double-barreled imperialism of representation—first in the ethnocentrism implicit in the fact of the images themselves—that these countries were almost invariably viewed in the context of European or North American discovery, exploration, and economic development.

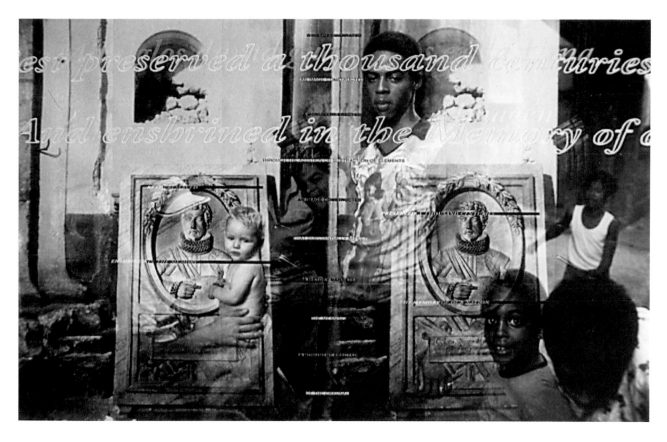

A Thousand Centuries, 1992

Second, the Columbus sculpture itself presented a racist narrative—*explicit* in the adulatory text carved on the monument, or *implicit* in the erect figure of Columbus, with natives clamoring at his feet. Also imperialistic were the grandiose claims of the authenticity of the stereographs, and the encyclopedic authority of the authors who explicated them. Making "all mankind acquaintance" was clearly, in effect if not intent, an invitation to hero-worship and self-congratulation within a narrow club of men.

II *. . . On the left-hand side, a vaguely hinted female figure stands by the margin of the fair water; on the other side of the picture she is not seen. This is life; we seem to see her come and go. All the longings, passions, experiences, possibilities of womanhood animate that gliding shadow which has flitted through our consciousness, nameless, dateless, featureless, yet more profoundly real than the sharpest of portraits traced by a human hand. . . .*

Fascinated by what he called the "incidental truths" of photography, Holmes described, in the above paragraph, "a lovely glass stereograph of the Lake of Brienz." [op.cit. p. 24] In my digital sequence *At the Margin,* two figures are both literally and symbolically marginalized in the original 1939 stereograph (panel 1) called *Statue of Columbus, Ciudad Trujillo, The Dominican Republic.* There is a black woman at the left edge of the print, and an Indian woman reaching from the base of the monument. In panels 2 and 3, I have digitally enlarged and moved them toward the center, subduing the Christopher Columbus figure in the process. In panel 4, I go beyond the subversion of relationships internal to the original stereograph and introduce an image of two young pioneer women scanned from a slide I took in Cuba in 1984. They in particular (and Cuba in general) represent for me a militant stance of autonomy vis-à-vis European influence or North America dominance in this hemisphere.

Just as the two different angles of a stereographic image create the illusion of dimension *optically*, I hope that my strategy of juxtaposing, my layering of distict perspectives through digital technology, will create a more complex or dimensional perception *conceptually*—that, in dialogue with the master narrative, the "gliding shadow which has flitted . . . nameless, dateless, featureless" across the photographic surface may articulate her name, her date, her specificity of need, dream, and desire. . . .

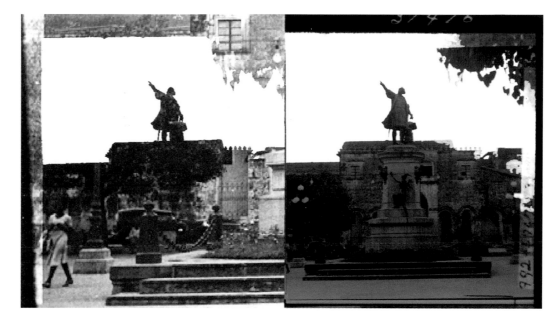

At the Margin, 1991-92

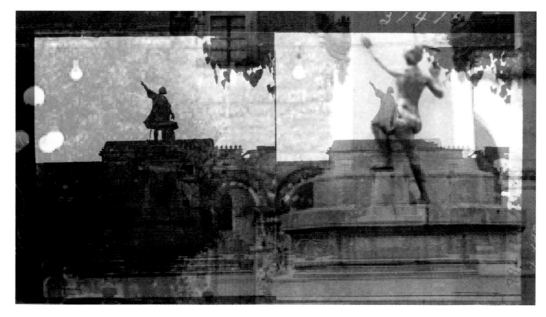



Native Fruits, 1992

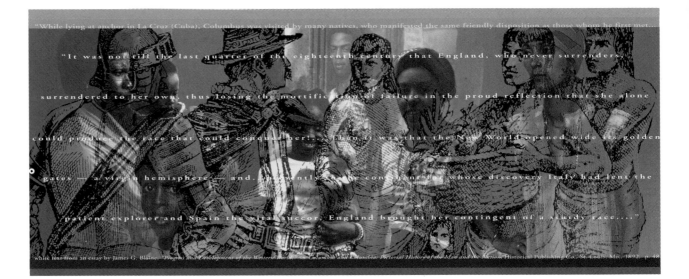

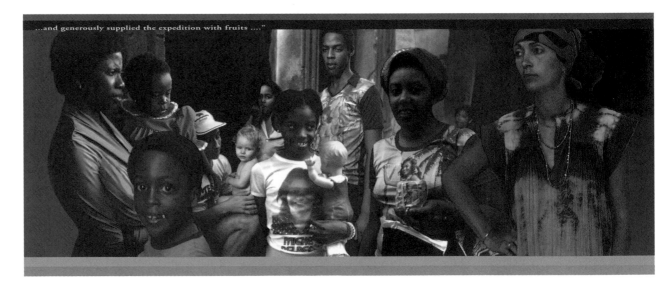

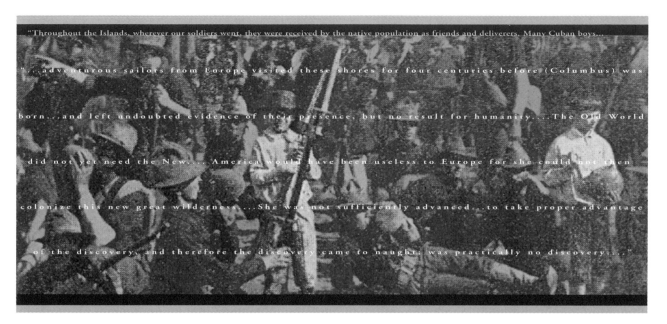

Friends and Deliveries,

1992

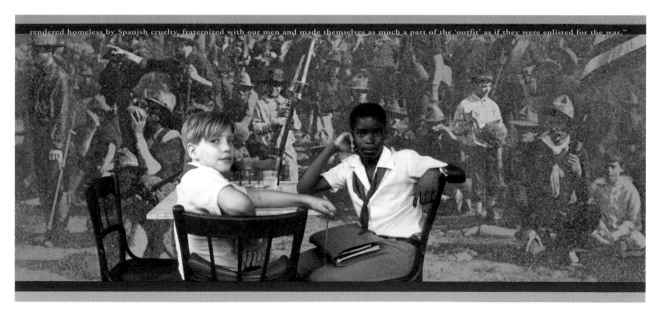

MANUAL (Suzanne Bloom / Ed Hill)

The Constructed Forest

Imagine somewhere in the electronic sprawl of cyberspace a chance encounter, linked to no known teleology, between the two historical-material worlds of Forests and Constructivism. Imagine them like two great informational clouds of particles and bits colliding, scattering, filtering, or intermingling and assimilating. What sort of dynamic (dialectic?) might result from such a serendipitous collision? Would the two disparate bodies of knowledge merge—happily or not—into a single (heterogeneous) database? Let's assume they would.

With the term "forest," we have in mind the example of those in the Pacific Northwest, contentious sites of production and acrimony. By "constructivism" we intend the model of Russian Constructivism, understood in its most vital sociopolitical form; i.e., free of Modernism's suffocating embrace.

John Muir and Kazimir Malevich make odd, if not absurd, bedfellows. Bear in mind, however, they lie together in an N-dimensional, coded space that would have terrified the one and thrilled the other, but which they now may only dream of in the virtual afterlife we have created for them—not entirely out of whimsy. Given our stated parameters of the "two worlds," Gifford Pinchot and Aleksandr Rodchenko are perhaps more appropriate representatives, since between them there is, in fact, a common material ground, bed, or palette: *productivism*. This materialist mode is viewed by the former from a position of conservative capitalism, and envisioned by the latter as the revolutionary means of creating a new life for art, that is, a new art for life.

This historical content aside, the rules for our hypothetical encounter are determined by a gated logic none of us fully command or entirely anticipate. It may sound here as though we are saying "the medium is the message." Not so. What we mean to suggest is that the cybersystem contains its share of surprises.

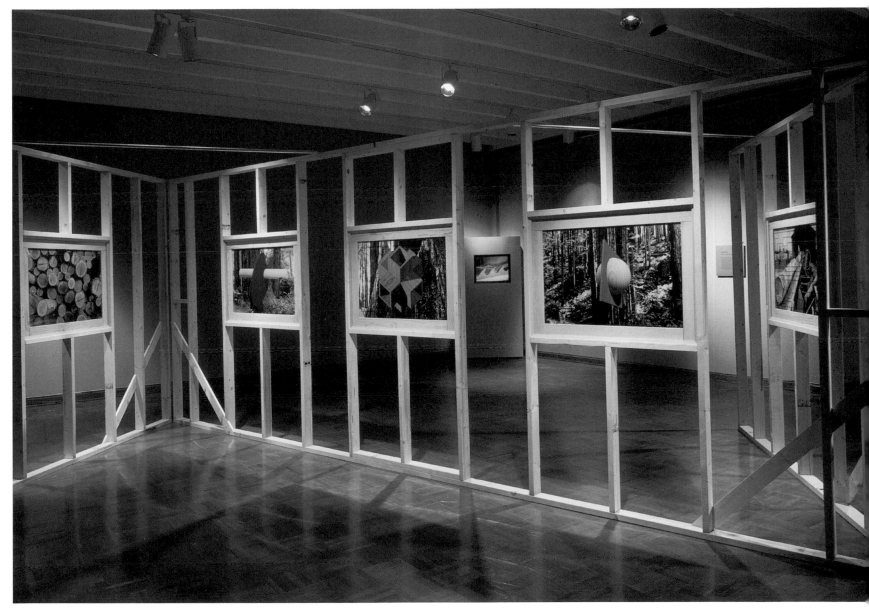

Installation view of **The Constructed Forest ('This is the End—Let's Go On'—El Lissitsky)**, 1993

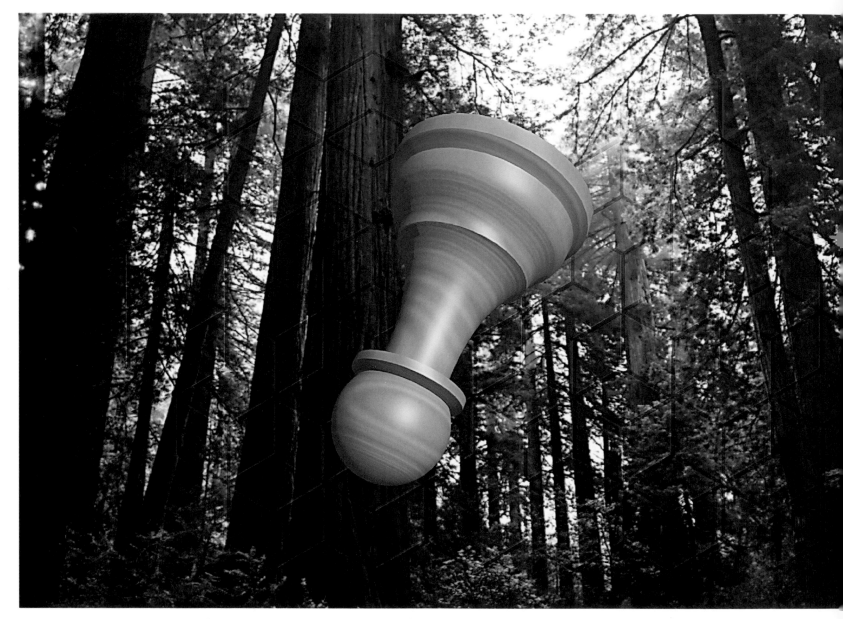

Installation view of **The Constructed Forest ('This is the End–Let's Go On'–El Lissitsky),** 1993

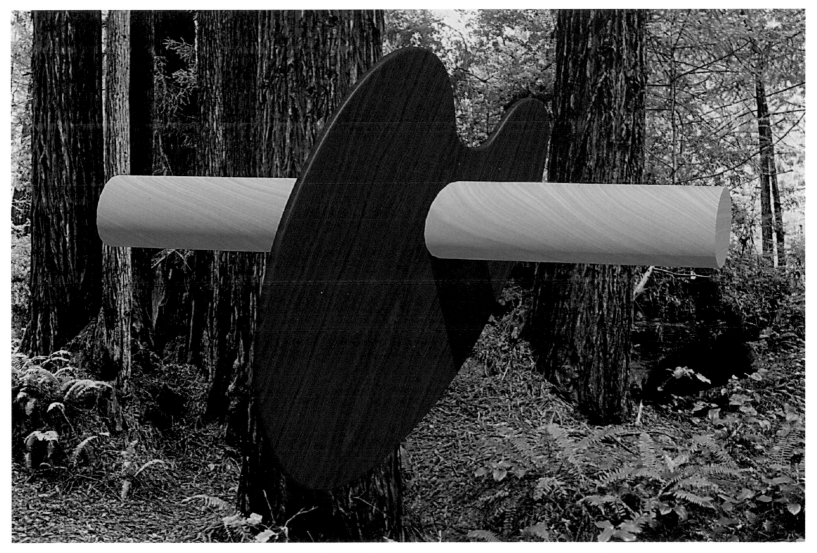

Detail from **The Constructed Forest ('This is the End–Let's Go On'–El Lissitsky)**, 1993

Left page:

Details from

The Constructed Forest

('This is the End–Let's Go On'–El Lissitsky),

1993

Right page:

Screen images from computer interactive

dictionery accompanying the installation,

The Constructed Forest

('This is the End–Let's Go On'–El Lissitsky),

1993

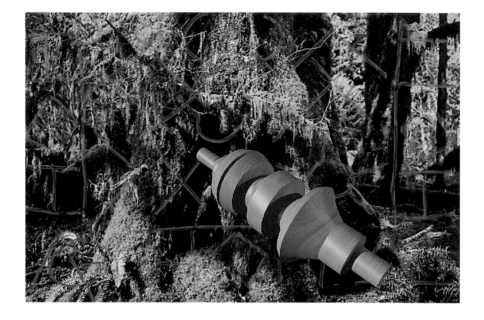

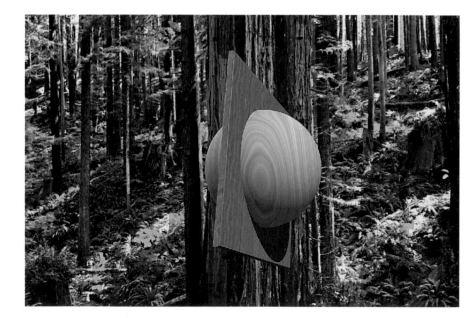

THE

AN INTERACTIVE DICTIONARY

CONSTRUCTED

OF PERSONS, TERMS, & IDEAS

FOREST

FROM THE DIVERGENT WORLDS OF...

FORESTS & CONSTRUCTIVISM

A B C D E F
G H I J K L M
N O P Q R S T
U V W X Y Z

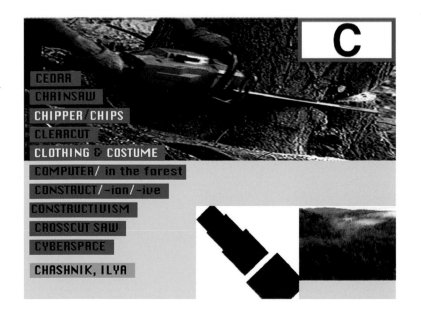

C

- CEDAR
- CHAINSAW
- CHIPPER/CHIPS
- CLEARCUT
- CLOTHING & COSTUME
- COMPUTER/ in the forest
- CONSTRUCT/-ion/-ive
- CONSTRUCTIVISM
- CROSSCUT SAW
- CYBERSPACE
- CHASHNIK, ILYA

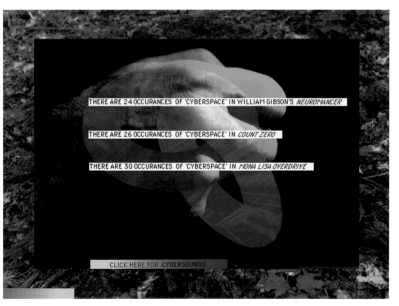

THERE ARE 24 OCCURANCES OF 'CYBERSPACE' IN WILLIAM GIBSON'S *NEUROMANCER*

THERE ARE 26 OCCURANCES OF 'CYBERSPACE' IN *COUNT ZERO*

THERE ARE 30 OCCURANCES OF 'CYBERSPACE' IN *MONA LISA OVERDRIVE*

CLICK HERE FOR CYBERSOUNDS

Keith Piper

Tagging the Other

Pan-European ethnicity was forged, initially, in violent opposition to nonwhites. Mongols, Turks, Moors, and later in opposition to Africans, Asians, and New World indigenes (with Jews providing a handy internal Eastern Question).

SCOTT MALCOMSOM, *Heart of Whiteness*

The floudering and traumatic progress of the nations of Western Europe toward a projected "economic and monetary union," and eventual federal superstatehood has, despite its dramatic failures, served to unearth a whole series of sinister fissures that transect the European body politic. Key among these has been the reappearance into full visibility of an explicit xenophobia. This has come to express itself firstly as an antagonism between white Europeans vying for the retention of regional privilege and replaying ancient rivalries across disintegrating borders. Secondly—and in this context more importantly—this xenophobia has been manifested via a reemergent fear and hostility on the part of white Europeans across the continent toward those communities of nonwhite Europeans, migrants, and "guest workers," upon whose efforts much of the resuscitation of the post–World War, ravaged continent has been based.

Part of this terror and hostility may have based itself in a contest of terrain and ownership. The opening-up of a discourse around "Europeanness" has launched a debate around what constituted the "new European citizen." To some, the idea remained an impossibility that the sons and daughters of West Indian, South Asian, or East African migrants could be included in this new agenda of Europeanness—despite the fact of their British, French, or Dutch citizenship. Adding, in their minds, to this corrosive un-European cancer lodged in the continental body politic were of course those mythic dark-skinned hordes waiting to pour into Europe in order to escape the poverty and instability of the global South, thus to further undermin that essential "Europeanness" of the New Continental order.

It is out of this network of phobias that the so-called Fortress Europe has emerged. It is a fortress

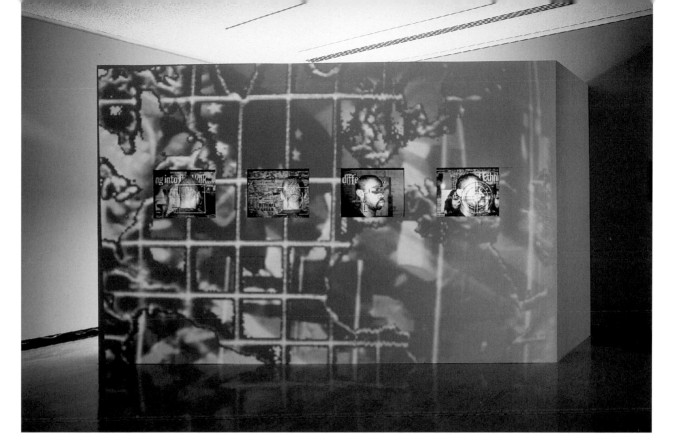

Installation view of
Tagging the Other,
1992

that exists not only in the imagination of the fringe political right, but as a concrete element of pan-European governmental policy. As the internal borders between nation states are dismantled, the "hard outer shell" defending Europe from infiltration by the non-European "other" is reinforced. As part of this process, at those points where such "infiltration" has already taken place, whole communities of "others" have consolidated themselves, and new techniques of surveillance and control are being implemented.

The new technologies that are being implemented to fix and survey the "un-European other," in the faltering consolidation of this "new European state," form the basis of *Tagging the Other*. Central to the piece are the framing and fixing of the black European, under a high-tech gaze—a gaze that seeks to classify and codify the individual within an arena where the logical constraints of race, ethnicity, nationality, and culture are unchanging, and delineated in a discourse of exclusion.

Details of

Tagging the Other,

1992

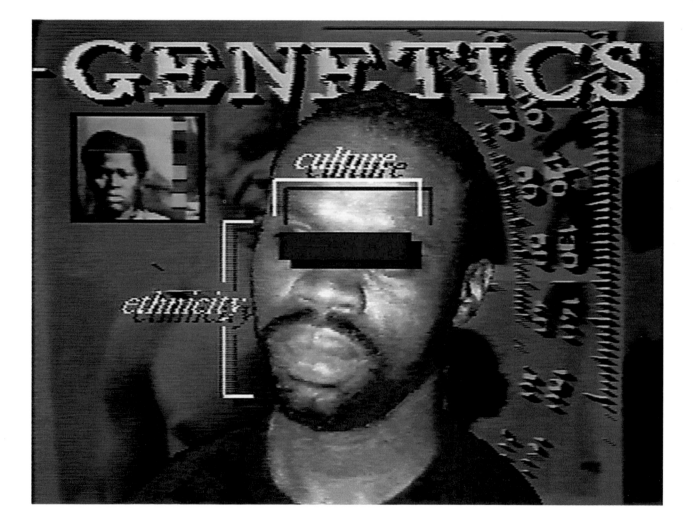

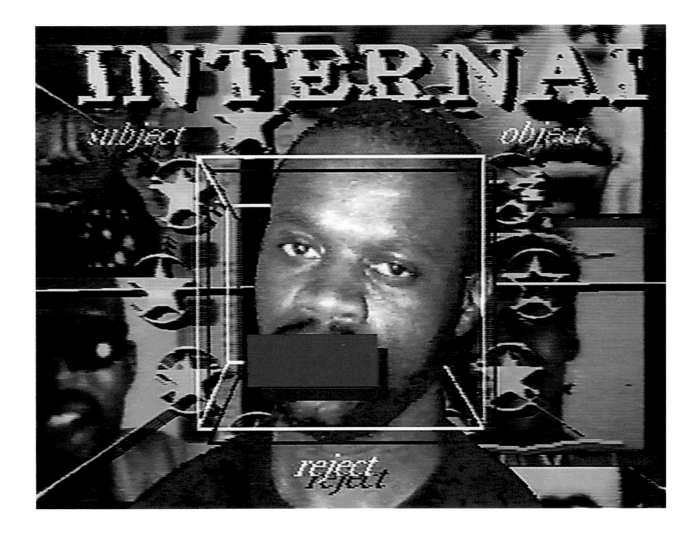

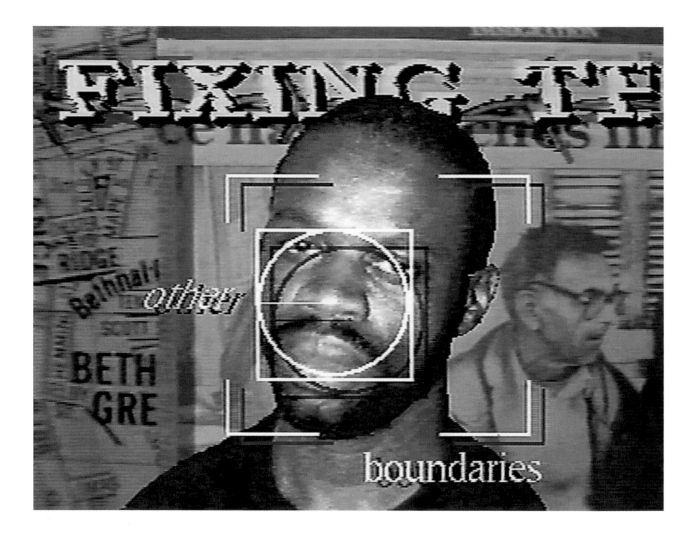

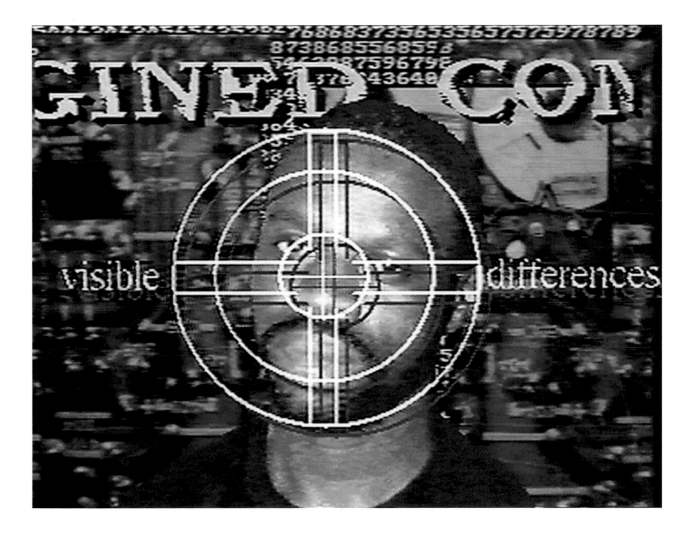

Jim Pomeroy

Apollo Jest An American Mythology (in depth)

From video introduction

Important: Pictures are not always what they seem. Since most of these images operate as visual cognates, puns, or indirect referrals, it's important to acknowledge original source, author, and intention of borrowed imagery. This work is an exercise in counterpoint. The quality of its resonance owes a great deal to the richness of these original manifestations. This work does not intend to mock or parody any image represented herein, but seeks, rather, to question the authority inherent in contemporary mythology. A few of these images are sufficiently loaded with negative anachronistic values to appear offensive to modern viewers, in other words racist, classist, and imperialist iconography. Their function here is to remind us that ideology, myth, and history are plastic. Not only are they manipulable values but they are conditioned subject to positive change when constructively addressed. If myth's function is to result in cultural contradiction, to crudely paraphrase Lévi-Strauss, then hopefully there is something here to chew on. In profound and reflexive rumination I thank all those who helped make this work possible. Caution: Use of this product may contribute to violation of the sacred integrity of a spiritual unifier. This is definitely the wrong stuff.

This work is dedicated to my brother, Alex, who died in Vietnam two weeks after men first walked upon the moon.

Shortly after the successful Apollo mission to the moon in July 1969, a rumor surfaced that charged the voyage had never

occurred, that the whole event had been staged on a Hollywood back lot. . . . To this day, 20 percent of the American people still

believe the moon landing was a fraud.

Recently, a series of photographs has come to light. Not part of the official NASA documentation (apparently surrepti-

ously exposed by one of the astronauts), these pictures chronicle that expedition and prove, beyond a doubt, the credibility of

merica's claim to landing the first men on the moon. Occasionally supplemented (for continuity) with official footage, we

resent the unauthorized proof of that conquest.

Great universities thrust the weight of their massively funded science and engineering departments behind the project.

These are truly monumental milestones in America's drive to the stars.

An interesting aspect of the orbital configuration is the absence of gravity. This apparent weightlessness posed tricky

problems, especially at mealtimes.

Armstrong radioed back to Houston the historic words, "The Ego has landed."

. . The Apollo astronauts were warmly greeted by the President . . . who congratulated them on a successful mission, furthering

merica's role in the History of Science for peace and freedom for all mankind. He left shortly afterwards to continue work

owards America's role in the History of Science for Peace and Freedom in Vietnam, Cambodia, Chile, El Salvador, The

hilippines, Nicaragua, South Africa, Uruguay

Memories are made of this.

(Taken from a slide/tape series, first presented in 1978, narrated by Nancy Blanchard, stereo Polaroids by Jim Pomeroy.)

"Archival" images are from historical stereographs and are intended to reflect the cultural values which determined their forma-

tion and currency, past and present.

George Legrady

Equivalents II

The installation project *Equivalents II* includes a computer program that produces abstract, cloudlike images, whose tonal characteristics are defined by text typed in by the viewer. The program is sensitive to certain key words stored in a databank, these words trigger further disruptions when encountered in the image-making process. At the conclusion of this phase, the computer brings up previously entered text showing matching words in the current viewer's text.

The aim of this computer-integrated media project is to test the threshold of cognitive perception and cultural interpretation. It considers the minimum conditions under which a complex set of tonal gradations produced from mathematical algorithms can be perceived as an authoritative image resembling the photographic. It asks the viewer to consider the cultural interpretive "reading" processes we use to understand images, especially once they have entered the familiar discursive context of the photographic norm, cultural narratives, and the institutional framework of the gallery or art publication. The project takes into consideration the discourse of simulated experiencefor instance, our reading of an image that evokes the emotional and the sublime, although it exists purely as the result of a mathematical formula that is, of course, impartial to form, poetics, or aesthetics.

Brownian motion (or Brownian noise) is at the heart of this algorithm. Under a microscope small particles of solid matter suspended in a liquid can be seen to move about in an irregular and erratic way. This observation, by the botanist Robert Brown in 1827, has become one of the main topics in musical composition and computer generated-graphics, as the motion simulates natural gradual shifts within larger changes. It is here used in conjunction with a recursive generating technique.

Information theory's terminology of signal and noise was the starting point for this project. Human perception and cognitive interpretation are highly dependent on the ability to identify signal (ordered information) from noise (random information). Observations in perception studies revealed

"Nothing Essential Happens in the Absence of Noise."—Jacques Attali

Installation view of **Equivalent II,** 1993

that recognition of "noisy" images could be enhanced by filtering them through additional noise-viewing an image from a distance, by squinting, by jiggling it, or by moving the head while looking. The effect of all these actions is to blur or increase the noise level of the already degraded images.

We have all learned through experience to read out-of-focus photographs. And cultural factors take significant command of the viewing experience when an image cannot be interpreted according to conventional experience; it then becomes dependent on the authority of its sources, as in medical and scientific photographic documentation.

The *Equivalents II* program uses text as the material from which the image is created, a reversal of the conventional function of the two. This "meaning-generating" process does not literally shape the image, illustrating the textual meaning, but functions, rather, to provide a grounding, a form of investment by which the outcome of a particular image is linked to a specific text. This relationship therefore remains arbitrary, and on the level of the symbolic. It raises questions about how we assign meaning to things, how languages are primarily symbolic representations that have been coded over time, and whose meanings are constructed through conventions. Most important, the project addresses how the reading of images occurs in this mode.

Research and software production made possible through the generous assistance of a Canada Council Computer Integrated Media Grant.

FIRE IN THE ASHES

ASHES IN THE WIND

BUDAPEST

MONTREAL

Jim Campbell

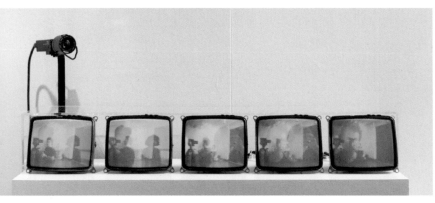

Memory Recollection, 1990

In 1978, after graduating from MIT with degrees in electrical engineering and mathematics, I began making videotapes and films while I pursued a career in engineering. In 1988 I decided to combine my engineering skills with my interests in violating to create interactive video installations that involve the viewer and the viewer's response to a given situation. By designing my own electronics (or tools), I was able to do work that otherwise would have been expensive or difficult to do.

I became interested in looking for more intuitive ways for viewers to interact with systems other than the traditional tree=structured systems. I began attempting to take a different path from the current media-related definition of interactivity, which usually conforms to button pushing and conscious, discrete decision making. Making a distinction between control and interaction (or maybe dialogue), I have a goal to create installations that are less about a viewer dominating a work and more about a viewer participating in the developing personality of a work.

In attempting to create systems that respond and progress in recognizably non-random (but at the same time unpredictable) ways, I have tried to create works that have destinies of their own. I have always been fascinated with the philosophical analogies of certain scientific disciplines, and my work has been very influenced by science, in particular some of the ideas relating to chaos and quantum mechanics. Using technological tools and scientific models as metaphors for memory and illusion, my work seeks to interpret, represent, and mirror psychological states and processes and their breakdown.

My most recent work is inspired by some of the ideas of artificial intelligence as they relate to the memory and perception of images. Such images have categorizable associations with previous memories or ideas, and I am interested in how this might relate to people's connections with the upcoming chapter of the information age.

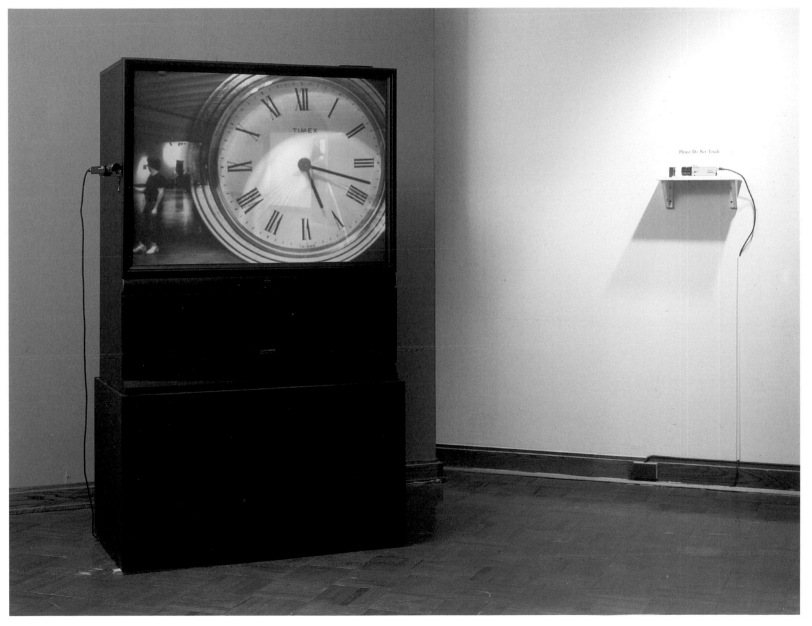

Digital Watch, 1991

Details of **Memory Recollection,** 1990

Details of

Digital Watch, 1991

San Francisco Museum of

Modern Art, Doris and

Donald G. Fisher Fund

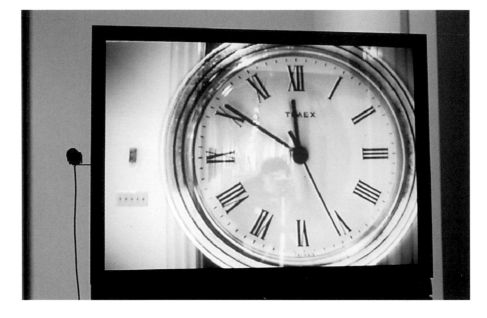

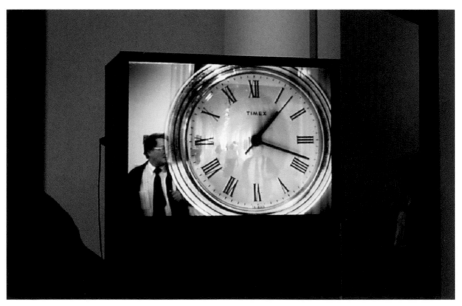

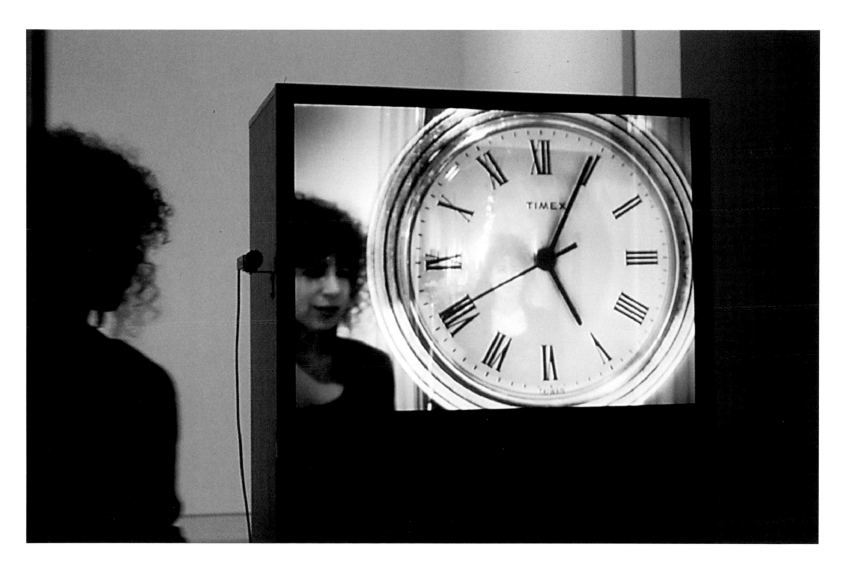

Rocio Maria Goff

The *Weaving Histories* Loom

Weaving Histories is an exercise in writing electronic writing practices. The idea was to create a space in which storytelling was possible, but also where users could begin to make their own connections as they navigated the piece. The user navigates the piece by becoming the weaver: by pushing the pedals to make the stories appcar.

The actual piece is comprised of twelve animations. Each of the pedals cycles through four animations each. Each pedal activates a different "voice," which tells a story: within each story are references to old practices of signification combined with the current electronic technology. For example, rhythm and patterning became as important as the narratives themselves. I was interested in old forms that tell something about history as a means of making sense of the past and remembering, as well as projecting into the future. I was also looking at the loom as a memory device whose function is territorializing old and new forms of storytelling.

The idea for the piece came from a book witten by Greg Ulmer called *Teletheory: Grammatology in the Age of Video*. The connections to Andean textiles and music function as an example of the cross-cultural influences that were part of my upbringing in the Untied States as an North American/Hispanic woman. My family's ties to Peru were maintained mainly by language and frequent trips to visit relatives. The parts of the work that deal with the history of computer technology and programming are connected to the course my life took as heavily involved with technology. These seemingly disparate topics are tied together by both the stories of my personal history, and the larger story of the history of weaving.

It seems that working in this medium makes one think of oneself less as a designer or writer, and more as an orchestrator or choreographer.

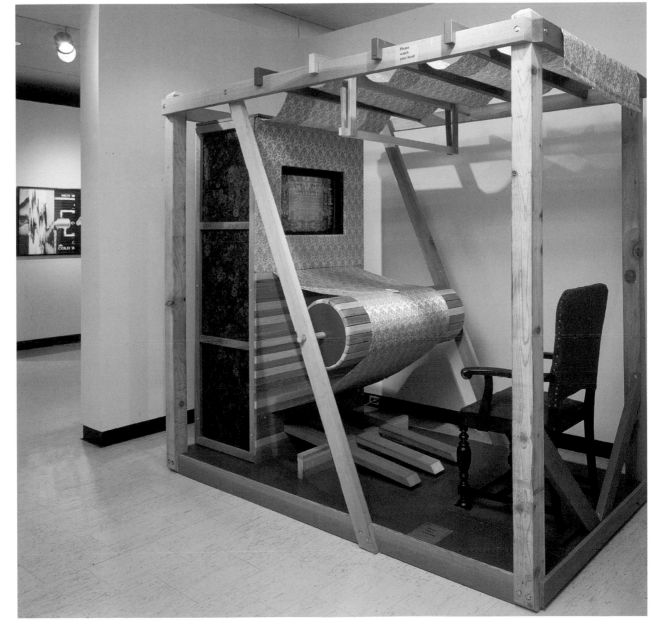

Installation view of

Weaving Histories,

1993

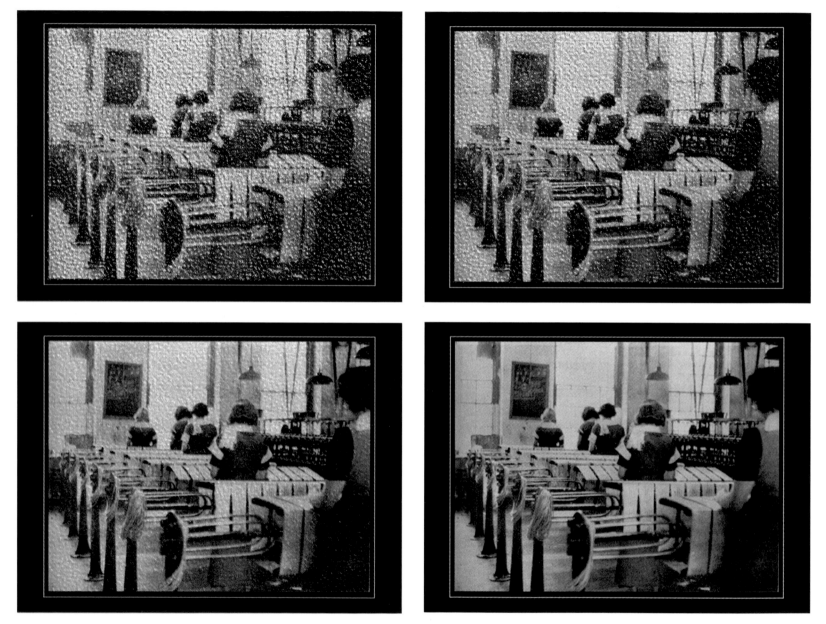

Details of **Weaving Histories,** 1993

A Donofrio ice cream, candy, and soda vendor in Miraflores.

Children playing in the center of Barranco's Municipal Park.

The view on the way to the beach with my cousin Cecilia.

Details of **Weaving Histories,** 1993

Lynn Hershman

Room of One's Own: Slightly Behind the Scenes
in collaboration with Palle Henckel and Sara Roberts

In 1888, shortly after Etienne Jules Marey perfected a gun that substituted film for bullets, he was introduced to Thomas Alva Edison. One year later the kinetograph was invented. This device, an alliance between the phonograph and the photograph, was designed so that a single spectator could peep through an eyehole and see film loops such as the *Leigh Sisters* perform their umbrella dance.[1] Known as the peep show, spectators took pleasure in the process of voyeuristically viewing seductive images of women.

The gun/camera has had a direct relationship not only on the history of film and the eroticization of female imagery in photography and phonography, but also in pornography. In fact, many serial killers, including Ted Bundy, for example, photograph their victims, as if to capture and possess them.

Women are taught to be looked at. In contemporary society this is interpreted as a manifestation of desire. Yet such objectifying observation triggers ideas of ownership and consumption. So with the association of gun to camera to trigger, the representation of women is linked quite literally to lethal weapons.

If cinema is a social technology, then the captivity of woman as subject and subject-victim through this medium situates women into precoded identities. Their submissive position is implicated into the construction of fantasy, and is positioned (ob)scenely.

I was thinking about these ideas when I was designing *Room of One's Own*. Therefore, the ideas can be considered the armature of this work.

Room of One's Own is a computer-based interactive-videodisk installation that references early "peep shows." It requires a viewer/voyeur to peer into an articulated eyepiece. A stainless-steel bow placed at eye level with a movable periscopic viewing section allows a voyeuristic view of a miniature bedroom scene. The very act of "looking inside" initiates the action within. As the viewer/voyeur focuses on any of the objects in the room, images appear on a one way mirror/wall via videodisk, projection, and computer based signals. As the viewer operates this piece, sensors activate

sound responses. Images that are called upon depend on what is being looked at: for instance, looking at the bed triggers a related sequence, as does looking at clothing, a telephone, a chair, or a small video monitor.

Within the miniature room, a small monitor shows the viewer/voyeur's eyes, so that whoever is watching becomes a "virtual" participant in the scene being seen. The piece is about voyeurism and a feminist deconstruction of the male gaze—particularly as it occurs in media—but its most important theme is the explosive effects that are attached to the social construction and media representation of female identity. Video segments of apparent and evident imprisonment that might be caused by such mediated sexual stereotypes are included in the work. Some of these, for instance, are being undressed with eyes of escaping virtual advances and expectations. Instead, the codes become literal projections of the viewer/voyeur's fantasies.

Though *Room of One's Own* is the third interactive installation I have created, it is related to the other two. *Lorna* (1979–1983) was the first interactive disk ever produced, and involved watching an agoraphobic, forty-year-old woman. Viewers used a remote unit to make surrogate choices for Lorna, as she sat in a small room and video segments were activated by calling up objects in the room. Lorna's passivity (presumably caused by media) is a counterpoint to the direct action of the participants. As the branching path is deconstructed, players become aware of the powerful effects of mediated fear. By taking action on Lorna's behalf, viewers/voyeurs travel through their own internal paths to interaction.

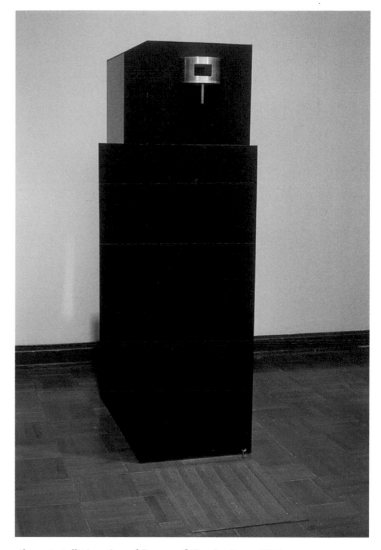

Above: Installation view of **Room of One's Own,** 1992
(with computer programming in collaboration with Palle Henckel and Sara Roberts)
Left: Detail

Deep Contact (1984–1989) required viewers/voyeurs to actually touch parts of their guide's scanned-in body to access different parts of the piece. It could be played backwards, forwards, and at different speeds. The option of changing personality or sex also existed. The choice to use the same provocative protagonist in both *Deep Contact* and *Room of One's Own* was a conscious decision to reference time and aging.

Interactive systems require viewers to react. The ways in which they may react are rapidly expanding. Eventually, permutations will emerge not only between the viewer and the system, but between elements within the system itself, and more importantly, between the nervous system peculiar to the viewer/voyeur and the interactive design. The prestructured architecture inherent in the flow plans of interactive works will incorporate the user's particular approach to the content. Increasingly, the interactive pieces I am developing involve the viewer/voyeur's own body—as, for example, when touch and eye movement activate the work.

My hope is that interactive systems will eventually become more personal and adapt to the complex but subtle differences of the user. Perhaps a radical liberation of perception will eventually emerge.

[1] See *New York Dramatic Mirror*, vol. 34, May 2, 1896, p. 19.

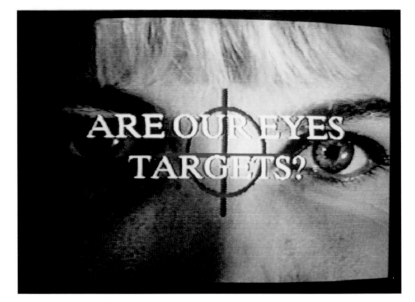

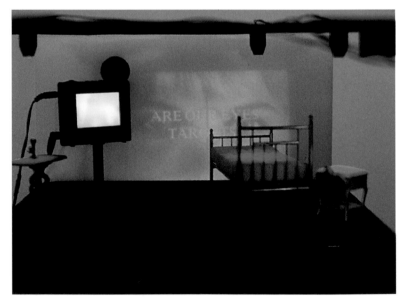

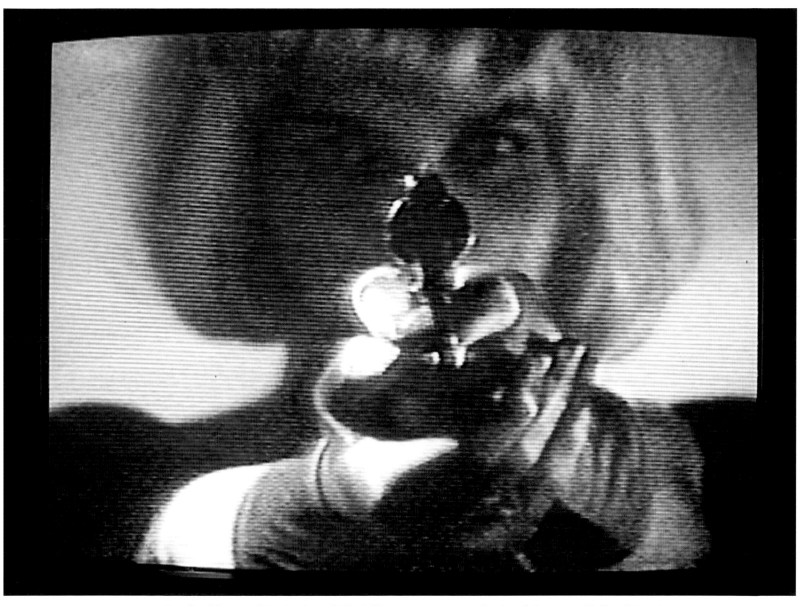

Details of **Room of One's Own,** 1992, (with computer programming in collaboration with Sara Roberts)

Details of

Room of One's Own,

1992

(with computer programming

in collaboration with Sara

Roberts)

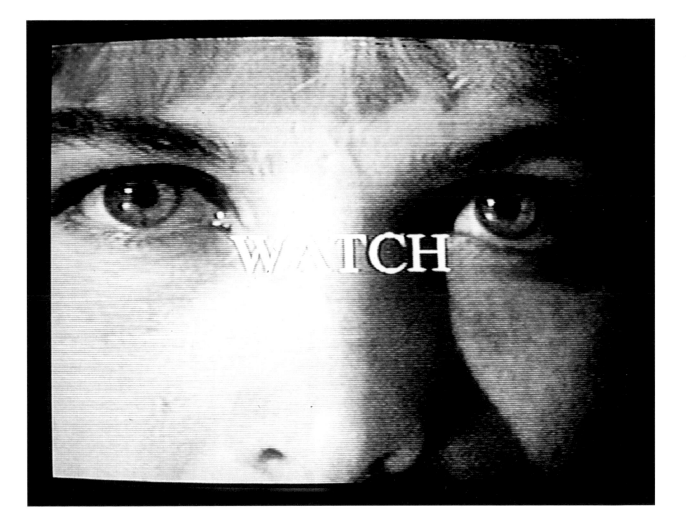

A l a n R a t h

Alan Rath: Challenger by Peter Boswell

The incident that has most absorbed Rath's attention over the past several years is the January 28, 1986, Challenger space shuttle disaster, in which seven astronauts, including New Hampshire school-teacher Christy McAuliffe, died. The tragedy was broadcast via live television, and was witnessed by millions of viewers across the country.

"It's like a fable," Rath exclaims of the incident. "The explorers, these heroes, going off into the unknown to slay dragons. It really was a modern fairy tale. And then the darker side of this mega-technology that the engineers knew it shouldn't even be launched on a cold day. It's a tragedy of Greek proportions: that we could send these people into orbit and bring them back down, as long as it's not too cold."

In the aftermath of the incident, it became clear that political pressure may have played a key role in setting the entire tragedy in motion. The launch had already been postponed several times, and the delay was seen by some as a public-relations embarrassment and missed media opportunity for NASA, which had submitted text regarding the mission for inclusion in President Reagan's State of the Union speech to be delivered later that day. To what extent such pressures affected the outcome of events is unclear, but the impact of the seventy-three-second flight was unprecedented in that it was broadcast, and perhaps occasioned, by that same advanced technology.

"It was electronic news, something that people experienced simultaneously around the country," recalls the artist. "Everybody was watching it, especially in the schools, because Christa McAuliffe was on it. Here was an actual live broadcast—not a canned program that is delayed in different time zones—with a big audience that had a simultaneous experience of the tragedy, and with that icon, that smoke trail, that was of sculptural proportions."

Rath's *Challenger* consists of three components. In the central unit seven monitors display images of, among other things, the seven astronauts, the smoke trail, McAuliffe's parents, and President Reagan and Vice-President Bush addressing the nation. The right unit features LED panels on which a

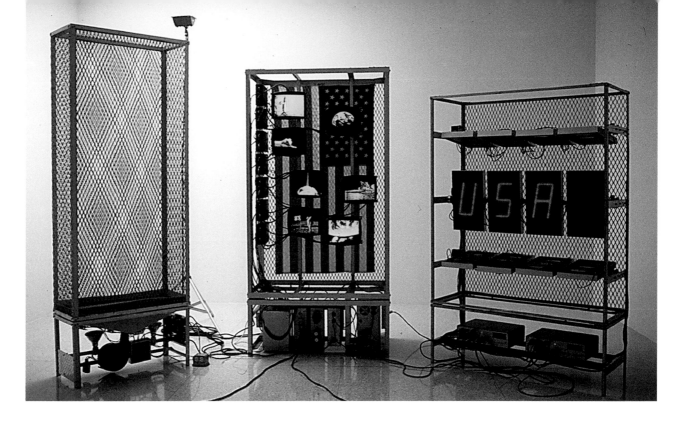

Installation view of

Challenger

1991

series of numbers, including the date of the launch, are displayed. The third element is a wire cage housing an air blower and a supply of small Styrofoam balls (about the size of Ping-Pong balls) labeled "1" and "0," indicative of the binary number system on which all computers run.

Every fifteen minutes, the computer-controlled lights illuminating the piece go out. The Styrofoam balls in the left unit are blasted around the cage in a jumbled disarray, the numbers in the right-hand panel tick off the seventy-three-second duration of the launch, and the seven monitors in the central unit display the image of the smoke trail that has been burned into our memories. At the conclusion of the aborted mission the lights go on again, the monitors return to the images of the seven astronauts, and the program begins a new cycle.

Challenger marks a significant departure from Rath's previous work. Unlike the other sculptures in the exhibition, it is inspired by a historical event, an occurrence of collective importance. Appropriately, then, it is an installation rather than an isolated object, and it is intended for a general audience rather than for the individual viewer.

Installation view of
Challenger, 1991

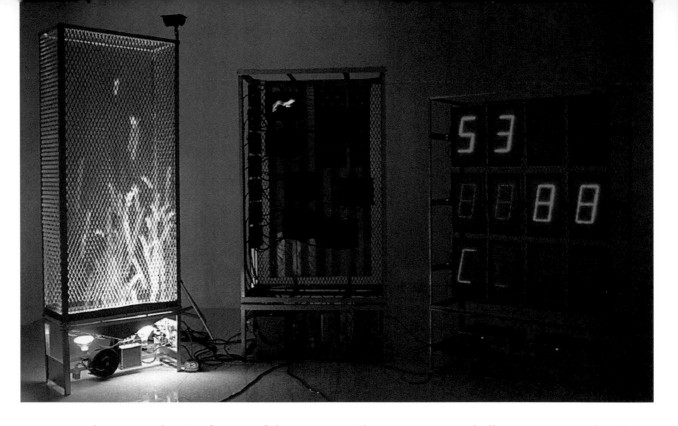

By underscoring the significance of this event as "electronic news," Challenger suggests that the shared experience made possible by telecommunications may be replacing other forms of collective self-definition. The Kennedy assassinations, the 1969 manned moon landing, the Challenger explosion, and the Super Bowl may be more meaningful to our national consciousness today than George Washington, the Civil War, or the Fourth of July. As recent developments—the Reagan Presidency, the Persian Gulf War—have made clear, the skillful manipulation of the electronic media is a fundamental means by which control and consensus are maintained in our era. Alan Rath's modest counterpoints to the technological extravagances of our time offer us a rare opportunity to stop awhile and ponder where this is all leading us.

(Reprinted, with permission, from the brochure accompanying the exhibition Alan Rath, organized by Peter Boswell at the Walker Art Center, Minneapolis, 1991)

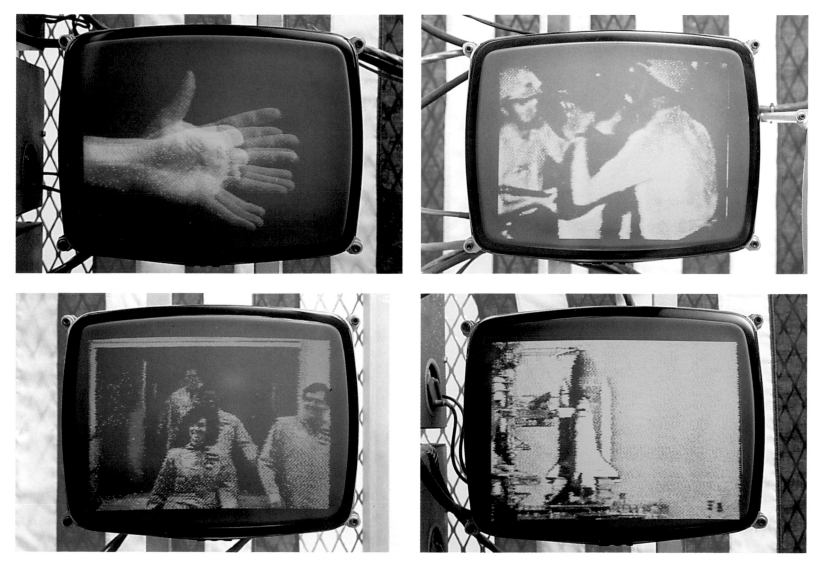

Details of **Challenger**, 1991

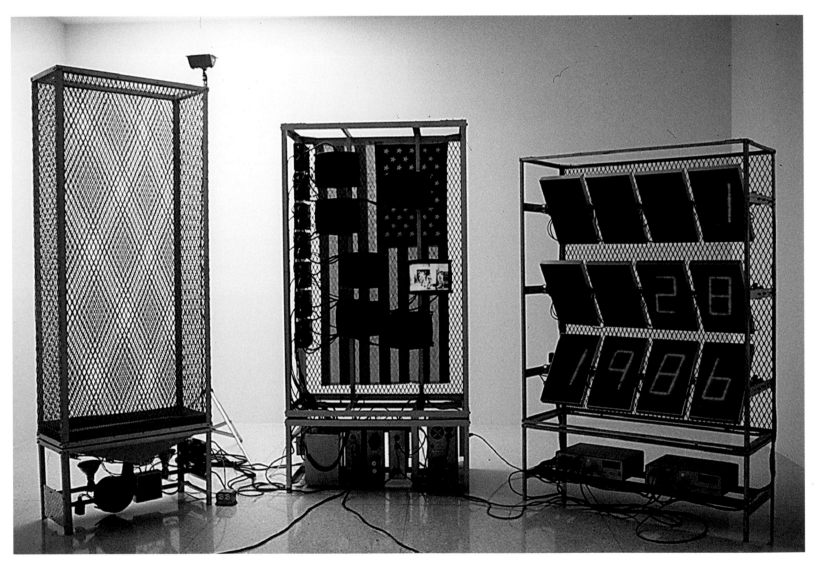

Installation view of **Challenger**, 1991

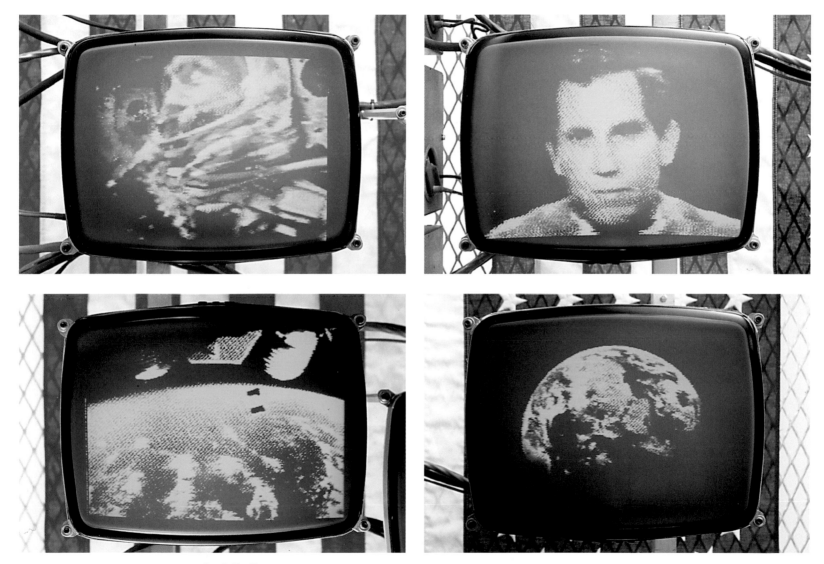

Details of **Challenger**, 1991

Ken Feingold

Childhood / Hot & Cold Wars (The Appearance of Nature)

At the center of my work *Childhood / Hot & Cold Wars (The Appearance of Nature)*, I have undertaken a search for my childhood TV memories, a kind of archaeology of those images and sounds that I remember, or see now, as having been formative in my understanding of what was going on in the world. I decided to create an interactive artwork with these images and sounds, one that will provide a means for others to search this image-repertoire, to let this part of my image-history intersect their own, to reflect on this period of American culture—a time when this new medium, television, was first used to promote values, interpretations of history, beliefs, and ideas that have had profound and often terrible effects.

I grew up watching television. Some of my earliest and most vivid sensory and emotional memories are of television programs I saw in my first years. The themes of my childhood emerged amid constant references to world war, the atom bomb, the morality of "good" and "bad," the Communist threat and the domino theory, intersected by Sputnik, the space race, and promises of endless progress in a fantastic technological future in which I would be visiting other worlds. These recurring themes were played out through TV characters, news, advertisements, science-fiction films, children's programs, and Civil Defense films—a strange mixture of cartoon violence, sci-fi monsters, cowboys and Indians, and "air raid drills"—in which "Nazis", "Communists," "the end of the world," "aliens," and "space stations" were spoken of with equal ease. We only had to say or hear the names Hiroshima and Nagasaki, Auschwitz or Dachau to feel a surge of fear, and a thrill at being the "winners" of that war. In school and at home, we practiced for nuclear attack, and watched people, monsters, and cartoon animals killing each other on TV. It seemed natural, the way things were. I was learning, in a way, to view violence as the language of the world, as a kind of entertainment.

This work is a complex, hybrid object; it has aspects of a grandfather clock, intersected by a Formica dining table, parts of a suburban tract house, and the roof is a replica of a Hiroshima building

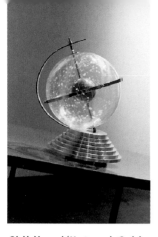

Childhood/Hot and Cold Wars (The Appearance of Nature), 1993
Above and Left: Details
Right: Installation view

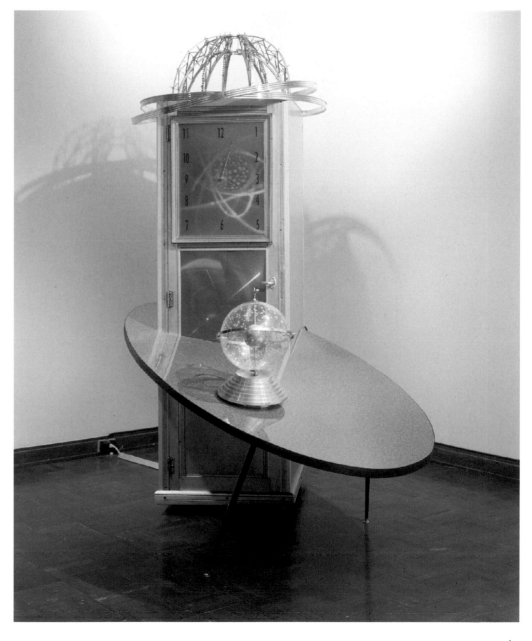

called the "A-Bomb Dome," a surviving skeleton of which now stands as a memorial. The object is made primarily of aluminum, and is approximately seven feet high. The face of the clock has numbers and hands like an ordinary clock, but this face is also a screen, upon which video images are rear-projected from within the body of the clock. The front of the clock body is a typical 1950s screen door. Intersecting the body of the clock is a skewed dining table. On it sits a transparent celestial globe mapping the heavens, with a smaller earth globe within it. Behind the globe, below the clock face, is a window through which a small tele-pendulum marks seconds.

Standing alone, the work plays these TV fragments as if "ticking" on the clock face. Playing like a step-frame animation, sequences of still images appear. It takes twenty-four hours to play the full cycle of images and sounds in this manner.

The work has interactive aspects. It has been organized so that a viewer who becomes physically involved with the work—by turning the globe—affects the ways the TV images and sounds are played, and he or she may move through them, forward and back in time. The viewer-participant interacts with the work's circuitry and computer programs, controlling the speed and direction of a video-laserdisk player, the movement of the hands of the clock, and the playback of digitized audio. At certain velocities, the viewer's turn of the globe will evoke playback of other "real-time" video/sound segments—special moments, my own "screen memories" (in a psychoanalytic sense). In this way, the viewer discovers what the work holds within. Returning to a particular time on the clock is also returning to a particular group of images and sounds. The images in the pendulum provide a cycling index of what is contained there. And if there is no turning for some moments, the images (with corresponding sounds) resume "ticking."

Other images and sounds—those played in the tele-pendulum, and during the hourly "chimes" (more like air-raid drills)—are not interactive; they proceed in an order strictly governed by the passing of time. The tele-pendulum repeats a computer animation; a short cycle of images about the human body, movement through space, passage of time, and an index of the images in the work.

Like fragments of early memories, disconnected, crystal-clear, momentary— the "seconds, minutes, and hours" in this work are stretched to infinity, going around over and over (as in my mind) with the hands of the clock, changing through the interaction of a viewer-participant, or going along without them. Forgetting, returning, forgetting, returning. . . .

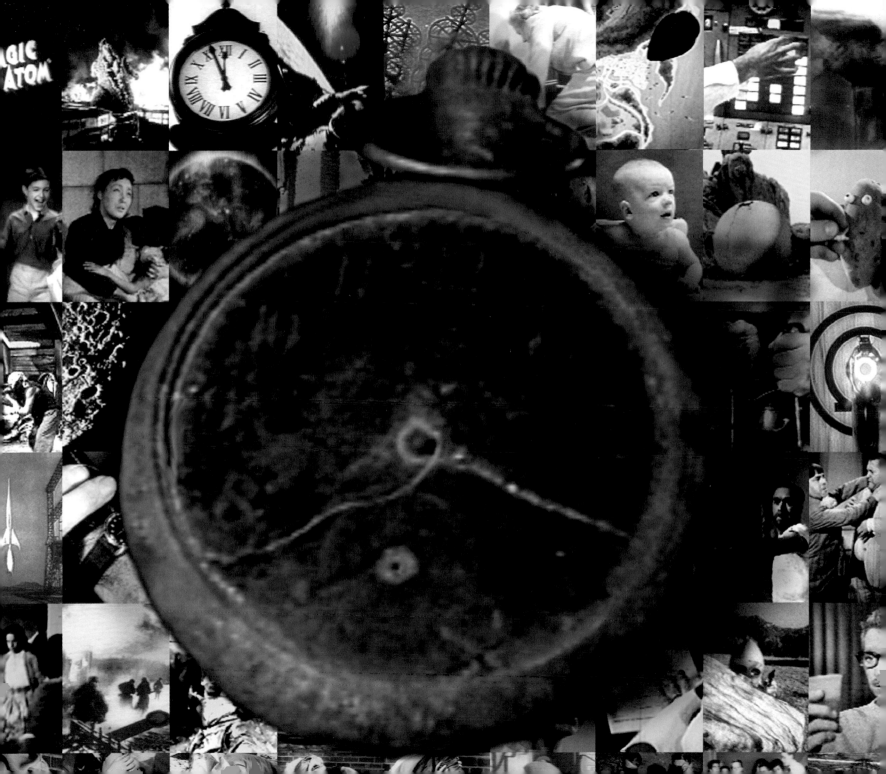

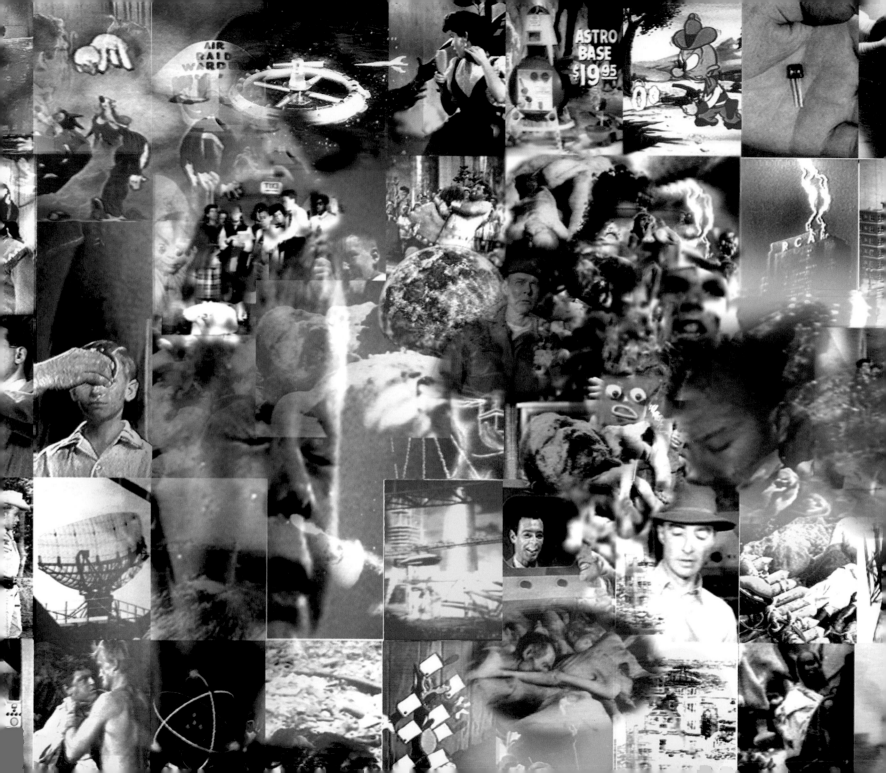

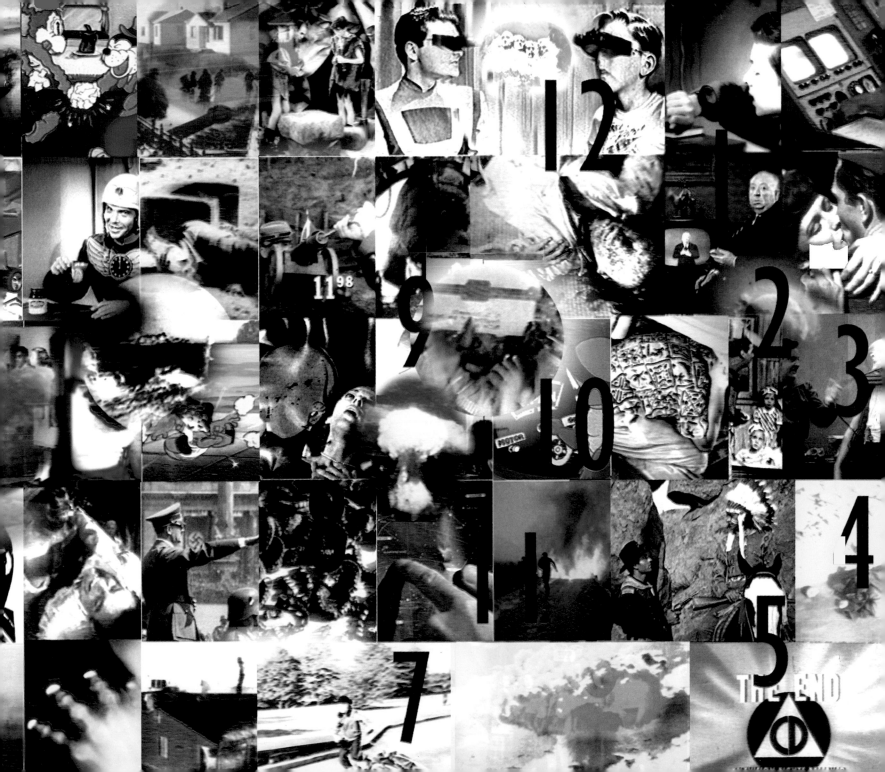

Grahame Weinbren

Sonata

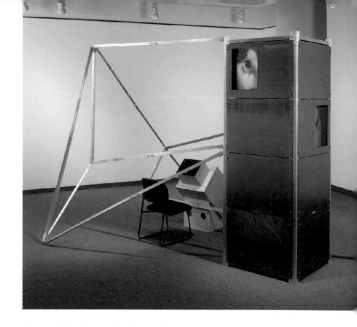

The main source for *Sonata* is Tolstoy's short story "The Kreutzer Sonata"—a study of jealousy and distrust, which culminates in the eruption of a man's murderous rage as his wife and her violinist "friend" practice Beethoven's music behind closed doors. The protagonist attributes an immorality to the sonata, and by extension to all music; the music motivates the story as forcefully as do the characters.

In *Sonata*, the story is multiplied into different points of view. We see the protagonist,

Installation design by Laura Kurgan with the assistance of James Cathcart.

pardoned for the murder of his wife, narrating his story to a sympathetic listener on a train. This is the story form chosen by Tolstoy. By pointing at the screen at any time, the viewer moves from the Þrst person account to a reconstruction of what he is describing: dramatic scenes from a deteriorating marriage. Now the main focus becomes the wife's point of view. Finally, we see the husband, racked with jealousy, pacing in his room like an animal, tortured by the violin music seeping through the door. Pointing at the screen brings on the innocent performance of Beethoven's *Kreutzer* Sonata (performed here by violinist Peter Winograd accompanied by Marian

Hahn). A rush of emotion in the music pushes the man past some limit, and he bursts into the next room and stabs his wife to death.

A primary aim of this multivalent narrative is to examine extremes of emotion. The interactive cinema allows us to approach classical issues like this one in new ways. Because it is possible to see alternate views of the same situations, one can be caught up in the drama, but at the same time analytically removed from it. Further, the availability of a variety of ways of engaging in the same story highlights the differences between memory and reality, and can explore the selec-

tivity of memory. What does the protagonist remember? What actually happened? Pointing at the screen enables the viewer to switch from one to the other.

The piece incorporates several associated

themes:—The haunting dream image of a shuttered window opening to reveal five white, bushy-tailed wolves on a tree, as described by a patient of Freud's who is called the "Wolf Man." The interactive strategy used in this section is a kind of peeling away: at the viewer's interruption, the current layer is removed, revealing its sources in the dreamer's psyche. Gradually, as the viewer descends through layers of image and interpretation by touching the screen, we see the dream as a concentration of memories, thoughts, and desires. —The biblical theme of Judith and Holofernes, a tale that addresses some of the

same issues as Tolstoy's story, and a subject depicted by numerous artists, from the fifteenth century to the present. Many of their paintings and sculptures focus on the moment when Holofernes, the enemy general, is decapitated by the Hebrew heroine Judith. The works are often ambivalent in their depiction of the heroine. Judith saved her people, but she (a beautiful woman) killed Holofernes (a virile man) in a vile and bloody act.

Part of the power of these paintings is this very ambivalence in the interpretation of Judith's character—is she angelic or bestial? This is also the fundamental question in Tolstoy's story with regard to both the wife and her jealous husband. Tolstoy apparently sides with the husband, portraying the murder as inevitable and, in the final analysis, justified. While contemporary readers may see the husband as contemptible, many still maintain a deep-seated belief that jealousy is inextricably connected with uncon-

trollable anger, that a "crime of passion" is ultimately unavoidable. Are reason and passion always in conflict? This deep and enduring issue is a central subject of this video work.

In *Sonata*, the story of Judith is presented visually through multiple portrayals, and in a narration based on the many texts that have told

and retold the story. As it unfolds, the viewer is able to move from one depiction to another and, at certain moments, to loop back to the Tolstoy story. Some of the paintings, replicated for the production, are in the background of scenes in *Sonata*—thus the viewer can make immediate visual connections between different storylines.

The viewer navigates around the narrative using a unique interface. The four compass directions of the screen—up, down, left, and right—each represent a different temporal direction. Right and left move us forward and backward in time respectively, down renders expansions of the present, and up, the introduction of material

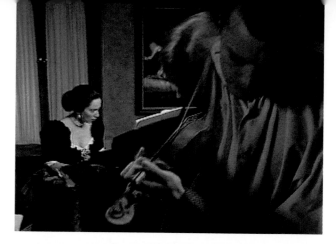

outside time. Thus, for example, touching the right side of the screen moves the narrative forward more quickly, in a range of paces from a detailed unfolding to a bare plot outline. The left side of the screen reverses the direction of time. However, when we go back through events, as in remembering or retelling them, the events are necessarily seen in a different light. Memory is not pure factual description—it always incorporates desire, explanation, justification; unlike computers, we remember what is important to us. So when the viewer activates "reverse time," a new view of the events is revealed.

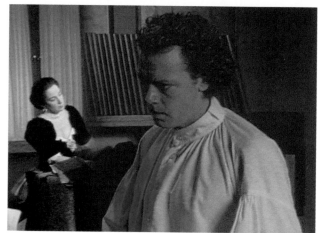

Pointing at the bottom of the screen allows an exploration of the current moment, in Maya Deren's sense of "vertical" development. This includes: an alternative viewpoint of the current narrative situation; metaphoric or associative imagery; theoretical or historical parallels; scenes of production chaos, etc. The top of the screen is reserved as "author's area." Here less-strictly linked material can be accessed, and since one of the major themes of *Sonata* is the multiple relationships of author to his or her creation, the upper portion of the screen is the area for factual, historical, literary, or biographical sources for the on-screen fictions—it is the place to find footnotes and commentary (in the broadest sense). Tolstoy's writing is a particularly

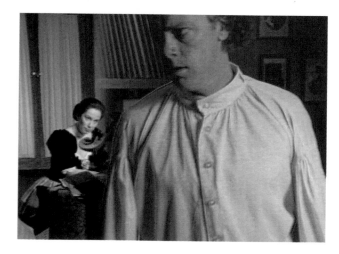

appropriate match for this kind of exploration, since he was constantly working and reworking his memories and the events in his life for the sake of his fiction. Added to this is the unique resource made available by the publication of Tolstoy's diaries, as well as those of his wife and children, all of which describe some of the events on which the fictions are based, though the versions are often quite different. Similarly, an interactive cinema can enable a portrayal of the same events from different points of view; those of the different participants, for example, or of an outside observer, or of a "neutral" "God's eye." *Sonata* is an investigation into this potential for multiple perspectives.

In its deliberate investigation of the possibilities of interactive drama, *Sonata* aspires to lay the foundation for a new cinema, a cinema in which the response of the viewer affects his/her experience, a cinema of moment-by-moment collaboration between viewer and filmmaker. It opens a new dimension for the moving image, aligning the shape of film with the shape of thought, creating a cinema that portrays the world we live in and act on, rather than a world fitted to prior conventions.

Video Selections

Each of the selections in this program has been chosen for its individual merit and for its original approach to digital video production. The works come from diverse orientations and express a range of interests: from the political to the personal, from the comedic to the incisive. They also demonstrate a variety of new technologies and effects in the contemporary world of video. The selection presented here does not, however, purport to survey the field of video art, nor is it intended as a compendium of the possibilities available to today's artists and videomakers.

Peer Bode A Few More Magic Words, 1993 19:30 minutes

A FEW MORE MAGIC WORDS is a personal foray into the nether realms of linguistic and visual communication. As Bode fetishizes glitches and deliberately misinterprets signs and symbols, he explores the manifold ways in which computer cinema is the medium most central to contemporary cultural discourse. He is also drawn to the inevitable short-circuiting that accompanies this situation.

Bode describes himself as working within a postmedia framework: his goals are to decolonize the territories of production and distribution, to wrest subjectivity and consciousness from impersonal global media markets. Bode proposes that reengaging an audience's perceptive performance and reasserting an individual voice within technological art forms are the work of postmedia artists such as himself.

Bode uses the Native American Micmac language—which is thought to share many elements with ancient Egyptian hieroglyphics to question relative degrees of linguistic impenetrability as well as the basic human drive to interpret what is at first glance illegible. Just as one can learn to interpret lost languages, so can one develop new, organic relationships with techno-

logical worlds that seem to have become immune to the human touch amid the chaos of progress.

Patrice Caire C.A.I.R.E., 1992 5 minutes

C.A.I.R.E. is a series of self-portraits that frames the artist's thought electronically through MRI (magnetic resonance imaging). MRI imposes consecutive magnetic fields on infinitesimally thin slices of the subject's brain. The resonant electricity of a thought is made legible by a momentary magnetic scrambling of atoms as they pass through the field. Serial sequences—from the top to the bottom, from one ear to the other, and from the front to the back of the head—present the viewer with an uncanny automated look into the subtleties of neuroelectronics.

Both the images and the music in C.A.I.R.E. have an alluring organicism. The work explores the dichotomy between scientific and personal perceptions. In its use of the artist's proper name as an acronym, the title illuminates other gray areas between deductive and inductive reasoning. In English, C.A.I.R.E. could be the name of a multinational corporation or a covert government agency (Central Artificial Injected Remote Entity, suggests the artist). In French however, C.A.I.R.E. makes more lyrical allusions: *Catastrophe! Ainsi Ils Riaient Ensuite,* and *Ciel! Au-delà Ils Réagissaient Excessivement* (What a catastrophe! This is how they laughed then, and Heavens! Beyond that they reacted excessively).

Sarah Hornbacher Precession of the Simulacra, 1988 67 minutes

PRECESSION OF THE SIMULACRA

PRECESSION OF THE SIMULACRA is a series of images of the American flag, the White House, and the ocean, documenting the slippage between inalienable rights and their politicization. Hornbacher uses traditionally patriotic symbols to locate two extreme points, one of sheer fact and the other a suffusion of expectation and desire within a single mirror. Hornbacher's sea, flag, and White House are simulacra (that is, truths which, according to Jean Baudrillard conceal the absence of truth). These simulacra are already afterimages of themselves, and are as antiaesthetic as they are religiously ecstatic. The piece might have been the industrious design of an overzealous patriot, yet Hornbacher presents these national symbols without a trace of didacti-

cism. Her images are culled from the electronic shrapnel littering the path of modern civilization's development. She contextualizes her artillery within contemporary culture and asks whether these simulacra affirm or extinguish ideals articulated in the Declaration of Independence and the Bill of Rights. She asserts that sanctioned efforts to abridge artistic expression threaten democracy directly. Thus, the American Flag, waving furiously, collapses in upon itself and dissolves to white.

John Knecht The Possible Fog of Heaven, 1993 10 minutes

THE POSSIBLE FOG OF HEAVEN, like a cyborg's dream, outlines a journey through the vestiges of domestic nostalgia for the King—Elvis Presley. The video montage, esoteric texts, and a breathy imitation of Elvis' voice are compounded in visual doubletalk, a seemingly nonsensical barrage of recycled imagery. Elvis' postmortem seductions are, appropriately, illogical juxtapositions that parody pop iconology. Knecht's computer animation and found images are contemporary electronic equivalents of 1920s surrealist films. The dichotomous concepts that these images provoke oscillate between the physical and the transcendent. THE POSSIBLE FOG is an illustration of kitsch immortality and a disposable afterlife.

Elizabeth LeCompte/The Wooster Group White Homeland Commando, 1992 63 minutes

"WHITE HOMELAND COMMANDO pits undercover cops against Downtown Neo-nazis longing for the promised land in the Great Northwest. Solarized and colorized, the punchy mise-en-scène is made to the measure of Avenue B after dark: this is what *Batman* should have looked like" (Amy Taubin, *Village Voice,* September 29, 1992).

Though brutality characterizes the quotidian relations between all partners in this work, whether romantic, criminal, or professional—neither sex nor violence is glamorously portrayed. Fragmentation saturates all aspects of the production. Shortly after a scene is established, digitized images deter proper synchronization and leave the viewer to reassemble dialogue from disjointed audio and video tracks. The editing techniques simulate recycled interchannel static, and present the audience with yet another challenging distraction. Solarized images heighten the video's drama as well as its edgi-

ness. One can scarcely help comparing the video play with TV programs such as *America's Funniest Home Videos* and the ubiquitous slew of hyperreal crime shows, but the lack of idealism and righteousness found in COMMANDO makes its surreal scenes seem as if they were lifted directly from any day in the city.

ACTORS: Willem Dafoe, Anna Kohler, Nancy Reilly, Peyton Smith, Michael Stumm, Kate Valk, Ron Vawter, Jeff Webster,

DIRECTOR: Elizabeth LeCompte

Jim Pomeroy Munnitox, 1990 7 minutes

In MUNNITOX, Jim Pomeroy's animated money speaks with the voice of former president Bush. Selections from the 1989 inaugural speech invoke duty, family, battle hymns, and gentleness. Bush's pontifications emanate from coins and dollars—nickels, dimes, quarters, fives, tens, and twenties—and the patriotic sacrifice Bush exhorts takes on a more hermetic and distorted quality as MUNNITOX progresses. Pomeroy not only pokes fun at the political system and its prevalent elitist rule, but also highlights the gulf between presidential and popular concerns.

Miroslaw Rogala Macbeth/The Witches Scenes, 1988 17:38 minutes

Rogala brings THE WITCHES' SCENES from Shakespeare's *Macbeth* into a contemporary context. The Witches now toil on beaches strewn with postindustrial debris and toxic decay; they boil and bubble their brews in computers rather than caldrons. Rogala's beautiful, black and white video images look as if they were washed up from seas of atomic waste.

The Witches' hair and breasts regenerate relentlessly. But, as in Shakespeare's play, their foreboding tales weave nothing more than suggestion, and it is Macbeth who seals his own portentous fate. A child falls from a jungle gym, clearly subject to mortality. The doll—a sage of sorts in the computer monitor—implores Macbeth to be "bloody, bold, and resolute." Rogala's work leads us to ask, "Who's technology it is, anyhow?"

Artist Biographies

Gretchen Bender

Gretchen Bender takes to task the proliferation of mass media. Her critical examination of the systems and strategies that underlie the mediated, televised, and filmic image proffers a uniquely apocalyptic vision of communication in the late twentieth century. Bender has had three solo shows with New York's Nature Morte Gallery (1983, 1985, 1986); a one-woman exhibition at CEPA Gallery, Buffalo (1984); and her electronic performance *Total Recall* was given at The Kitchen, New York (1987). Other individual exhibitions have taken place at Metro Pictures, New York, and at the Museum of Fine Arts, Houston (1988); and Bender's *Dream Nation* installation was shown at the Meyers/Bloom Gallery, Los Angeles (1989).

Bender has participated in a large number of group shows in New York: in the Whitney Museum of American Art's "Frames of Reference" (1982); White Columns' "New Capital" (1984); International With Monument's "New Art with Time and Electronics" (1984); and The Kitchen's "Anticipated Ruin" (1985). Also in 1985 her work appeared in "Infotainment" at the Texas Gallery, Houston and in "Kunst mit Eigensinn" at the Museum of Modern Art, Vienna. In 1986 Bender participated in "Paravision" at the Margo Leavin Gallery, Los Angeles. Her work has also been seen at Artist's Space, New York, at London's Lisson Gallery, and at the Los Angeles County Museum of Art.

Michael Brodsky

Before Michael Brodsky received his MFA from California Institute of Arts (CalArts) in 1978, he lived and worked extensively in many parts of the world: in Nepal, with the help of a grant from the U.S. State Department's Bureau of Education (1972); in East Java, as a VIA (1974); and for six months in 1974–75, he photographed Indonesia's performing arts with a fellowship from the

University of California. In 1980 Brodsky curated two video exhibits at the Sawhill Gallery in Harrisonburg, Virginia. After a tenured post at James Madison University in Harrisonburg from 1978 to 1988, Brodsky moved to Los Angeles, where he has since been a tenured Associate Professor of Art at Loyola-Marymount University. Hiswork has been published in *Afterimage, BYTE, American Photographer, Popular Photography,* and many other periodicals. Brodsky has shown repeatedly at the Houston Center for Photography: in 1987's "Photo Technology" exhibition and twice in 1992, in "Icons and Idols: Television Imagery" and in the "Laser Disk Exhi-

bition." In 1986 he participated in "Computerized Image" at the Chrysler Museum, Norfolk, Virginia, and in the "17th Annual Juried Photography Exhibition," curated by Van Deren Coke of the San Francisco Museum of Modern Art (SFMoMA). Brodsky's exhibitions at San Francisco Camerawork have included "Photo Erotica" in 1977, and "Digital Photography in 1988." In 1992, Brodsky took part in the "Fotographie Biennale Rotterdam III: A Critical View on Modern Landscape," and this year, he is making use of a research grant to study the electroencephalographic self-Portrait, or "making art with an interactive brain-wave analyzer.

Jim Campbell

In 1978, after graduating from MIT with degrees in electrical engineering and mathematics, Jim Campbell began making videos and film while pursuing a career in engineering. In 1988 Campbell decided to integrate his engineering skills and filmic interests in the creation of interactive video installations. In 1992, Campbell's *Facing the Finish* was seen at SFMoMA, and he installed *Ruins of Light*, a permanent public artwork, at the America West Sports Arena in Phoenix, Arizona. Campbell participated in Le Printemps de PRIM

at Productions Réalisations Indépendentes de Montréal the previous year, and was in the New Langton Arts' fifteenth anniversary show, as well as in the "Bay Area Media" exhibition at SFMoMA in 1990. Campbell's films and videos were screened throughout the eighties at various festivals, including the International Electronic Music Festival, Brussels (1981), the International Avant-Garde Festival, Paris (1983), the International Festival of New Cinema, Montreal (1984), the American Independent Feature Film Market, New York

(1985), and the Athens Film Festival, Athens, Ohio (1986). His films have also been seen at New York University's Grey Art Gallery and Study Center, and at San Francisco Cinematheque.

Michael Ensdorf

Michael Ensdorf received his master's degree in photography from the University of Illinois at Chicago (UIC) in 1990. His work has since been seen in several group shows in Chicago, among them "Direct Object/Crafted Image" at the Ten in One Gallery (1990), "Peculiar Faces" at the Struve Gallery (1990), and two shows at the Artemesia Gallery: "Evidence" (1990) and "Response to War" (1991). He was also a participant in "Artifice and Artifact" at the John Slade Ely House, New Haven, Connecticut, and in the Pennsylvania School of Art and Design's "Anonymous Image," both in 1991. Ensdorf has had a number of solo shows at UIC, including "Six Paintings" in 1987 and "WORK" in 1989. His free-lance work has been featured in such publications as *TEN. 8, Arts Magazine, New Art Examiner, The Chicago Tribune,* and *Technology Review,* and his essays and serial photographs have appeared in the pages of numerous art journals. He has been awarded a fellowship and two consecutive faculty prizes from UIC.

Ken Feingold

In 1976–79, after receiving his master's degree from CalArts, Ken Feingold had solo exhibitions at the Walker Art Center, Minneapolis; and at the Whitney Museum of American Art and Artists' Space, both in New York. Since then, Feingold has participated in three Whitney Biennials, and has shown repeatedly at the Museum of Modern Art (MoMA), New York (most recently in "Between Word and Image," 1993), and at the New Museum, New York (in "Signs," 1985). Feingold was included in "L'Immagine Elettronica" (1984) at Bologna's Galleria d'Arte Moderna; "L'époque, La Mode, La Morale, La Passion" (1987) at the Centre Georges Pompidou, Paris; and in "Video Art International" (1990) at the Museo de Buenas Artes, Buenos Aires. His recent solo shows have included *"(Please Touch)"* in 1992 at the Zentrum für Kunst und Mediatechnologie, Karlesruhe, Germany, and this year's "Desmontaje" at the IVAM Centro Julio Gonzalez in Valencia, Spain. Feingold's work is in the permanent collections of New York's MoMA; the Centre

Georges Pompidou; the Museo Palazzo Fortuny, Venice; the Institute of Contemporary Art, Boston; the Long Beach Art Museum; and the Art Center in Pasadena. The New York Public Library and the National Library of Australia also possess his works.

Carol Flax

Carol Flax received her master's degree in photography from CalArts in 1982. She had a solo exhibit at the LAPA Gallery in Venice, California in 1983. Over the last few years she has created shows at the Los Angeles Festival at 462 Broadway, and the 92nd Street Y, both in New York City; and at the Inverness Rail Station, in Scotland. Flax was a part of "Fotofeis: the Scottish International Festival of Photography" at the Technology Venue, Inverness (1993); SIGGRAPH '92, Chicago; "Intimate Technologie/ Fictional Personas" at the Brush Art Gallery, Canton, New York; and the Southeast Museum of Photography's "Inaugural Exhibition" (1992) in Daytona Beach, Florida. Flax was also in "Digital Photography" (1988) and "Olympic Show, *Part I*" (1984) both at the L.A. County Museum of Art. Flax is on the National Board of Directors for the Society for Photographic Education, and she was a lecturer and panel moderator during "Photography without Borders" at S.F. Camerawork in 1993. Flax taught in the photography department at Cal State Northridge from 1984 to 1987, and has been teaching classes at UCLA Extension in Computer Graphics since 1989.

Rocio Maria Goff

Rocio Maria Goff works as a computer laboratory technologist at New York's Fashion Institute of Technology. As multimedia specialist, Goff is developing a new multimedia facility and configures workstations for video and audio digitizing. She also creates interface designs and storyboards for BAM! Software. In 1992, Goff worked as a production assistant at Hub City Software in New York, where she was involved with digital image processing and animation. Clients for her Macintosh-based multimedia prototypes include the ABC News Graphics Department and Prentice Hall. In 1992 Goff did an internship at ABC News Interactive in New York, and worked with Learning Link (an online teachers network) in addition, to developing an AIDS Hypercard Stack. She is the recipient of a Tisch Award for Multimedia Production, a Tisch scholarship, and a

Carnegie Mellon National Merit Scholarship. Other of Goff's video projects include a wall installation at the Palladium in 1992 for the Clinton/Gore benefit and *Shock/Terror*, a video/performance collaboration at the Ward Nasse Gallery in New York.

Lynn Hershman

Lynn Hershman's work in electronic media spans the last two decades: one of her earliest video pieces documented her Bonwit Teller windows of 1977, while today her works include multimedia interactive artworks in addition to her continuing work in video. Hershman's *Longshot* of 1989, a sixty-two-minute piece, won grand prizes at both the Montreal and the Montbeliard festivals, and was screened at the London Film Festival, the Institute of Contemporary Art, London, the American Film Institute (AFI), the Dallas Film Institute, the Danish Film Workshop, New York's Anthology Film Archive, and the Institute of Contemporary Art, Boston. Another of Hershman's pieces, 1991's *Seeing is Believing*, fifty-eight minutes long, was screened at the AFI Video Festival, at MoMA's Video Viewpoints and at the VIGO International Film Festival in Spain. Hershman is also the auteur of three videodisks. *Lorna,* the first interactive laser-art disk, was featured in the 1986 Venice Biennale, as well as at Ars Elettronica in Bologna, Los Angeles Contemporary Exhibitions (LACE), the Fuller-Goldeen Gallery, and Gallery Orso in Helsinki. Hershman also created the first interactive sexual fantasy videodisk, *Deep Contact*. This erotic interactive touch-sensitive videodisk was exhibited at the International Center of Photography (ICP), New York, SFMoMA, Expo '91, Video Galleriet in Copenhagen, the Rijksmuseum in Amsterdam, Images du Future in Montreal, the Medianalle in Karlsruhe, Germany, and the Museum of Contemporary Art in Chicago.

George Legrady

Born in Budapest in 1950, George Legrady emmigrated to Montreal, Canada at the age of six. He completed the San Francisco Art Institute's master's program in 1976, and is currently Associate Professor in Conceptual Design/Information Arts at San Francisco State University. He has also taught at University of California, Los Angeles; CalArts; and USC, where he has been awarded numerous grants for innovative research and teaching, including a Project Socrates grant.

Legrady's solo exhibition "Illustrations" was seen at New York's PS1 space and Montreal's Yajima Galerie in 1981, and at S.F. Camerawork in 1983. His *Posing & Studies for Monuments* was seen at the Yajima in 1985 and at LACE in 1986. Legrady's later one-person exhibitions, "From the Yellow Pages," "From Noise to Signal," and "Between East & West," were shown at the Galerie Chantal Boulanger, Montreal (1987), the USC Atelier Gallery (1987), and the YYZ Gallery, Toronto, (1991) respectively. Among the group shows in which Legrady has participated are: "Fotografie, Wissenshaft, Neue Technologien" at the Kunstmuseum, Düsseldorf (1990); "The Photography of Invention" at the Smithsonian's American Museum of Art, Washington D.C.; "High Tech/New Pop" at Boston's Photographic Resource Center (1987); "La Magie de l'Image" at Montreal's Musée d'art Contemporain (1986); and "Images Fabriquées" at the Centre Georges Pompidou, Paris (1983).

MANUAL

MANUAL (Suzanne Bloom and Ed Hill) have exhibited their work in recent solo shows including "Forest/Products" at the Contemporary Art Museum, Houston (1990), and "Didactic Space" at the Frito-Lay headquarters in Plano, Texas (1989). In 1992 they showed at the Jayne H. Baum Gallery in New York. They exhibit frequently in Houston with the Moody Gallery. Group shows to which MANUAL have contributed include the "Dallas Video Festival" at the Dallas Museum of Art, and "The Photographic Book" at the Houston Center for Photography in 1989. In 1988 MANUAL participated in three group shows: "Nature and Culture: Conflict and Reconciliation in Contemporary Photography" at Friends of Photography, San Francisco; the traveling "Digital Photography" show and "Two to Tango" at ICP, New York. MANUAL'S work also appeared in "HighTech/New Pop" at the Photographic Resources Center, Boston, and in Fotographia '87, International Biennale, in Torino, as well as in "Photography and Art, Interactions Since 1946' at the L.A. County Museum (1987); "Signs" at the New Museum, New York (1985); and "Recent Color" at SFMoMA (1982).

Hill graduated from the Yale Masters of Fine Arts program in 1960, and Bloom received her MFA from the University of Pennsylvania in 1968. Both have held numerous academic appointments and each has received three individual grants from the University of Houston, where they have

both taught since 1976. Hill was awarded an NEA Individual Artists Fellowship for Photography in 1972, and Bloom has received two such fellowships, one for photography (1978) and one for video (1976). Hill and Bloom were also given a shared grant by the NEA/Rockefeller Interdisciplinary Arts Council in 1987, and together in 1991 were artists-in-residence at the California Museum of Photography.

Esther Parada

Esther Parada directs the Graduate Studies program in the School of Art & Design at the University of Illinois at Chicago. Parada's work has been represented in numerous group shows, including "The Portrait Extended" at Chicago's MCA (1980); "Big Pictures by Contemporary Artists" at MoMA in New York, and the Henry Art Gallery's "Radical Space/-Rational Time," Seattle, both in 1983. Her work is in the permanent collections of these institutions, and in those of the Museum of Fine Arts, Houston and the Art Institute of Chicago. Parada's photo-text projects have been published in several books and anthologies, including her critical essay "C/Overt Ideology: Two Images of Revolution" in *The Contest of Meaning* (The MIT Press, 1989).

She has also written for *Exposure* and *Aperture* magazines, and her photos have been reproduced in the Time-Life book *The Art of Photography*, among other places. Parada's long-standing involvement with Latin-American peoples can be traced to 1964, when she was in the Peace Corps in Bolivia, teaching art and photography. In 1980 and 1981, Parada was an artist-in-residence in Mexico City with the Mexican Council of Photography. In 1984, Parada delivered a paper at the Third Latin American Photography Colloquium in Havana, Cuba, and in 1987, she coordinated and moderated Latin American Women Photographers, a national conference of the Society for Photographic Education in San Diego, California.

Keith Piper

Keith Piper received his master's degree in environmental media from London's Royal College of Art in 1986. Piper has been closely associated with the Black Art movement in London, stating that "Black Art is not a monolithic school," but, rather, represents a wide range of views and experience. Piper's 1991 work, *A Ship Called Jesus*, exhibited at the Ikon Gallery in Birmingham, England,

examined the relationship between people of African descent and the Christian Church. The piece took its name from *The Jesus of Lubeck*, the sailing vessel Queen Elizabeth I donated in 1564 for the first English slave-trading voyage. His other recent shows have included "Father I Have Done Questionable Things" at London's Bedford Hill Gallery in 1989; and his contribution to this summer's Sonsbeek '93 in Arnhem, Holland was met with great acclaim. Piper has also exhibited his multimedia installations in numerous group shows, including two in London in 1986: "New Contemporaries" at ICA, and "From Two Worlds" at Whitechapel. In 1988 Piper participated in the "Docklands Road Show" at London's Westham Town Hall.

James Pomeroy

The stereographic technique in James Pomeroy's *Apollo Jest* was a central element of his work from the time of his earliest forays into multimedia production and performance. In 1981, Pomeroy conducted a workshop on stereo photography at the CEPA Gallery in Buffalo. Pomeroy also employed many other media, including sonic art, and his work was in the 1979 "SOUND" show at the Los Angeles Institute of Contemporary Art. He experimented with the countless applications of computerized teleconferencing, and, with one of the three Visual Art Fellowships granted Pomeroy by the NEA, he brought about the "Art Access/Networking Workshop: International Computerized Teleconferencing for Art" in October 1980 between Bath, England and San Mateo, California. The stereoscopic bubblegum cards that comprise *Apollo Jest* correlate to Pomeroy's active involvement with the making of artist's books. In 1977 he participated in "Bookworks" at Mills College in Oakland, California.

But Pomeroy was foremost a performance artist. His performance pieces include *Blind Snake Blues* (1981–82), seen at Real Art Ways in Hartford, Connecticut, the Lowe Art Museum in Florida, Target Video in San Francisco, and ZONE in Springfield, Massachusetts; *Listen to the Rhythm of the Reign,* produced while he was an artist-in-residence at the Visual Studies Workshop, Rochester, New York (1985), and shown at the Center of Contemporary Art, Seattle, and at other institutions; *The Winner of Our Dis-Content* (1986), shown at New Langton Arts in San Francisco and at SUNY Binghampton; *Celestial Mechanix* (1986–87), seen at the Walker Art Center, Minneapolis and at the Center for Contemporary Art, Santa Fe;

and *IKONIKIRONIK*, which was shown at San Francisco's Exploratorium, Boston's Brattle Theatre, and the 1989 Dallas Video Festival.

Pomeroy wrote numerous seminal articles, including "Provocative Apocrypha," published in *Afterimage* in 1986; "Reþections on the perils of specialization and the dubious wisdom of stockpiling investments in media-speciÞc histories and other special interest memorabilia" in *Exposure*, 1987; and "Black Box S-Thetix: Labor, Research and Survival in the He[Art] of the Beast" in *Tech-noculture*, edited by Penley and Ross, University of Minnesota Press, 1991. He taught sculpture at the San Francisco Art Institute from 1977 to 1987. He was a member of *Exposure*'s editorial board and of the Exhibition and Planning Committees at S.F. Camerawork. Pomeroy was also on CEPA's Advisory Board and was a tenured Associate Professor in the Departments of Art and Art History (Video/Photo) at the University of Texas at Arlington from 1990 until his death in 1992.

Alan Rath

Alan Rath received his BSEE from MIT in 1982, and the same year was awarded an Individual Artist Grant from MIT's Council for the Arts. Other awards include an Artspace (San Francisco) Sculpture Grant in 1989, and an NEA Visual Artists Fellowship in 1988. Rath shows regularly at the Dorothy Goldeen Gallery in Santa Monica. In 1992; he exhibited at the Hans Meyer Gallery, Dusseldorf. In 1991, the Walker Art Center organized and toured a one-man exhibition of his work. He has also shown at New Langton Arts and Artist's Television Access Gallery, both in San Francisco, and at MIT's Center for Advanced Visual Studies. Rath's sculptural and interactive pieces have appeared in several group shows, among them: "The Interactive Show" at Thread Waxing Space, and "Special Collections": "The Photographic Order from Pop to Now" at ICP Midtown, both in New York in 1992. The previous year Rath participated in the Whitney Biennial, and in "The Pleasure Machine: Recent American Video" at the Milwaukee Art Museum. He took part in "The Technological Imagination" at Intermedia Arts Minneapolis (1989), "Digital Photography" and "Computers and Art" at the IBM Gallery of Science and Art, New York (1988), and "High Tech/New Pop" at the Photographic Resource Center, Boston (1987).

Grahame Weinbren

Grahame Weinbren, filmmaker, author, editor, artist, CD-ROM and videodisk designer, is a veteran in the field of the digitized images. He is the recipient of four NEA and three New York State Council on the Arts grants, in addition to others from the Jerome Foundation, the Arts Council of Great Britain, the New York Foundation for the Arts and the British Film Institute to name only a few. Weinbren's earliest work was in film: from 1973 to 1984, often working in collaboration with Roberta Friedman, he made over ten films, including *The Making of Americans, Murray and Max Talk About Money, Margaret and Marion Talking About Working*, and *Cheap Imitations*. In 1983 Weinbren was on the Interactive Video panel at the American Film Institute Festival. He has given lectures and participated in panel discussions at institutions including the Walker Art Center, Minneapolis; Harvard University; the Visual Studies Workshop, Rochester, New York; the Anthology Film Archives, New York University, Media Alliance, and MoMA, all in New York; and at the Interface Symposium in Hamburg, Germany.

Weinbren is also a prolific writer and has published articles in the *Millennium Film Journal*, in L.A.I.C.A.'s *Journal,* in the *Journal of the University Film Association*, and in *New Observations*.

Weinbren has done much developmental work on CD-ROM prototypes for Microsoft and participated in the creation of the first interactive video for expansive public use, which was shown at the U.S. Pavilion at the 1982 World's Fair. Weinbren's own videodisk installation *The Erl King* has been seen worldwide. A ground-breaking musical-narrative multiple videodisk piece, this work was seen at the Walker Art Center; LACMA; the Whitney Museum, New York; the Museum School, Boston; the Oberhausen Film Festival in Germany; the Centre Georges Pompidou, Paris; and the Caixa de Pensions, Madrid. Weinbren's current works-in-progress include *Come Rain or Come Shine*, a documentary about Christo's *Umbrella Project*.

Sonata, Weinbren's second interactive film drama, was shown at both the Berlin and the San Francisco Film Festivals in 1993.

Bibliography

Books

Alexander, S. *Art and Instinct.* Oxford: Folcoft Press, 1970. Originally published in 1927.

Aronowitz, Stanley. *Science as Culture* , Minneapolis, University of Minnesota, 1989.

Ashby, William Ross. *An Introduction to Cybernetics.* New York: John Wiley, 1959. Originally published in 1956.

Ashby, William Ross. *Design for a Brain.* London: Chapman and Hall, 1960. Originally published in 1952.

Barstow, David R., Howard E. Shrobe, and Eric Sandwell, eds. *Interactive Programming Environments.* New York: McGraw Hill Co., 1984.

Baudrillard, Jean. *The Ecstasy of Communication.* New York: Semiotext(e), 1988.

Baudrillard, Jean. *Fatal Strategies.* New York: Semiotext(e)/Pluto, 1990.

Baudrillard, Jean. *Simulations.* New York: Semiotext(e), 1983.

Benedikt, Michael, ed. *Cyberspace: First Steps.* Cambridge, Mass.: MIT Press, 1991.

Beniger, James R. *The Control Revolution:Technological and Economic Origins of the Information Society.* Cambridge, Mass.: Harvard University Press, 1986.

Benthall, Jonathan. *Science and Technology in Art Today.* London: Thames and Hudson, 1972.

Berleur, Jacques, ed. *The Information Society* . New York: International Federation for Information Processing & Captus Press, 1991.

Bishton, Derek, Cameron, Andy, and Druckrey, Timothy. *Digital Dialogues:: Photography in the Age of Cyberspace.* Birmingham: Ten.8, 1991.

Bluestone, Barry, and Bennett Harrison. *The Deindustrialization of America.* New York: Basic Books, 1982.

Boole, George. *An Investigation of the Laws of Thought on Which are founded the Mathematical Theories of Logic and Probabilities.* Peru, Illinois.: Open Court Publishing Co., 1952. Originally Published in 1854.

Borges, Jorge Luis. *The Aleph and Other Stones, 1933—1969.* Translated by Norman Thomas di Giovanni. New York: Bantam, 1971.

Brand, Stewart. *The Media Lab: Inventing the Future at MIT.* New York: Viking Penguin, 1987.

Chaffee, David. *The Rewiring of America: The Fiber Optics Revolution.* Boston: Boston Academic Press, 1988.

Corn, Joseph J., ed. *Imagining Tomorrow: History, Technology and the American Future.* Cambridge, Mass.: MIT Press, 1986.

Corn, Joseph, and Brian Harrigan. *Yesterday's Tomorrows.* New York: Summit, 1984.

Cornwell, Regina, *Sonata.* New York: Critical Press, 1993.

Crichton, Michael. *Electronic Life.* New York: Alfred A. Knopf, 1983.

D'Agostino, Peter. *Transmission: Theory and Practice for a New Television Aesthetics.* New York: Tanam Press, 1985.

Davies, Duncan *The Telling Image: The Changing Balance Between Words and Pictures.* New York: Oxford University Press, 1990.

Davis, Douglas. *Art and the Future.* New York: Prager Publishers, 1974.

Dennett, Daniel C. *The Intentional Stance.* Cambridge, Mass.: MIT Press, 1987.

Dechert, Charles R., ed. *The Social Impact of Cybernetics.* New York: Simon and Schuster, 1966.

Dertouzos, Michael L., and Joel Moses, eds. *The Information Age.* Cambridge, Mass.: MIT Press, 1979.

Dreyfus, Hubert L. *What Computers Can't Do: The Limits of Artificial Intelligence.* Rev. ed., New York: Harper and Row, 1979. Originally published in 1972.

Druckrey, Timothy and Nadine Lemmon, eds. *For a Burning World is Come to Dance Inane: Essays by and About Jim Pomeroy.* New York: Critical Press, 1993.

Ellul, Jacques. *The Technological Society.* New York: Alfred Knopf, 1967.

Ermann, David, et al *Computers, Ethics and Society.* New York: Oxford University Press, 1990.

Feigenbaum, Edward A., and Julian Feldman, eds. *Computers and Thought.* New York: McGraw Hill, 1963.

Foley, James D., and Andries Van Dam. *Fundamentals of Interactive Computer Graphics.* Reprint ed. Reading, MA: Addison Wesley, 1984.

Forester, Tom, and Perry Morrison. *Computer Ethics.* Cambridge: MIT Press, 1990.

Forester, Tom, ed. *Computers in the Human Context.* Cambridge: MIT Press, 1989.

Forester, Tom. *High-Tech Society: The Story of the Information Technology Revolution.* Cambridge, Mass.: MIT Press, 1987.

Foster, Hal, ed. *The Anti-Aesthetic: Essays on Postmodern Culture.* Port Townsend, Washington: Bay Press, 1983.

Foster, Hal, ed. *Discussions in Contemporary Culture #1.* Seattle: Bay Press, 1987.

Foucault, Michel. *The Order of Things.* New York: Pantheon Books, 1970.

Foucault, Michel. *The Archeology of Knowledge and the Discourse on Language.* Translated by A. M. Sheridan Smith. New York: Harper and Row, 1976.

Friedhoff, Richard M. *Visualization: The Second Computer Revolution.* New York: Harry N. Abrams, Inc., 1989.

Fuller, Peter. *Beyond the Crisis in Art.* London: Writers and Readers Publishing Coop, Ltd., 1980.

Gablik, Suzi. *Progress in Art.* New York: Rizzoli, 1980.

Gardner, Howard. *Art, Mind & Brain.* New York: Basic Books, 1982.

Gardner, Howard. *The Mind's New Science: A History of the Cognitive Revolution.* New York: Basic Books, 1985.

Garson. Barbara. *The Electronic Sweatshop.* New York: Simon & Schuster, 1988.

Gaur, Albertine. *A History of Writing.* London: The British Library, 1984.

Gendron, Bernard. *Technology and the Human Condition.* New York: St. Martin's Press, 1977.

Gibson, William. *Neuromancer.* New York: Ace 1984.

Gombrich, E. H. *Art and Illusion: A Study in the Psychology of Pictorial Representation.* 2nd ed. New York: Pantheon, 1961.

Goodman, Cynthia. *Digital Visions: Computers and Art.* New York: Harry N. Abrams, 1987.

Graubard, Stephen R., ed. *The Artificial Intelligence Debate: False Starts, Real Foundations.* Cambridge, Mass.: MIT Press, 1988.

Greenberger, Martin, ed. *Computers and the World of the Future.* Cambridge, Mass.: MIT Press, 1962.

Grimson, W. Eric L. *From Images to Surfaces.* Cambridge, Mass.: MIT Press, 1981.

Harding, Susan. *Whose Science? Whose Knowledge?* Ithaca: Cornell University Press, 1991.

Hardison, O. B., Jr. *Disappearing Through the Skylight: Culture and Technology in the Twentieth Century.* New York: Viking Penguin, 1989.

Haraway, Donna. *Simians, Cyborgs and Women.* New York: Routledge, 1990.

Hawking, Stephen. *A Brief History of Time.* Toronto: Bantam Books, 1988.

Hayward, Philip, ed. *Culture, Technology and Creativity.* London: John Libby, 1991.

Heidegger, Martin. *The Question Concerning Technology and Other Essays.* New York: Harper and Row, 1977.

Heim, Michael. *Electric Language: A Philosophical Study of Word Processing.* New Haven: Yale University Press, 1987.

Heim, Michael. *The Metaphysics of Virtual Reality.* New York: Oxford University Press, 1993.

Henderson, Linda Dalyrymple. *The Fourth Dimension and Non-Euclidean Geometry in Modern Art.* Princeton: Princeton University Press, 1983.

Henri, Adrian. *Total Art: Environments, Happenings and Performance.* New York: Oxford University Press, 1974.

Hertz, Richard. *Theories of Contemporary Art.* Englewood Cliffs, N.J.: Prentice Hall, 1985.

Hill, Stephen. *The Tragedy of Technology.* London: Pluto Press, 1988.

Hofstadter, Douglas, and Daniel C. Dennett. *The Mind's I: Fantasies and Reflections on Self and Soul.* New York: Basic Books, 1981.

Jacobson, Linda, ed. *Cyberarts: Exploring Art & Technology.* San Francisco: Miller Freeman Inc., 1992.

Kern, Stephen. *The Culture of Time and Space 1880—1918.* Cambridge, Mass.: Harvard University Press, 1983.

Klüver, Billy, Julie Martin, and Barbara Rose, eds. *Pavilion–Experiments in Art and Technology.* New York: E. P. Dutton and Co., 1972.

Kranz, Stewart. *Science and Technology in the Arts.* New York: Nostrand Reinhold, 1974.

Krueger, Myron W. *Artificial Reality II.* Reading, MA: Addison-Wesley, 1991.

Kurzweil, Raymond. *The Age of Intelligent Machines.* Cambridge: MIT Press, 1990.

Landow, George P. *Hyper Text: The Convergence of Contemporary Critical Theory and Technology.* Baltimore: The John Hopkins University Press, 1992.

Laurel, Brenda. *Computers as Theater.* Reading, Mass.: Addison-Wesley, 1991.

Laver, Murray. *Computers and Social Change.* Cambridge, U. K.: Cambridge University Press, 1980.

Leavitt, Ruth. *Artist and Computer.* New York: Harmony, 1976.

Levy, Steven. *Hackers: Heroes of the Computer Revolution,* New York: Dell, 1984.

Lovejoy, Margot. *Postmodern Currents: Art and Artists in the Age of Electronic Media.* Ann Arbor and London: UMI Research Press, 1989.

McCorduck, Pamela. *Machines Who Think: A Personal Inquiry into the History and Prospects of Artificial Intelligence.* San Francisco: W. H. Freeman Press and Co., 1979.

McCulloch, Warren S. *Embodiments of Mind.* Cambridge, Mass.: MIT Press, 1965.

McLuhan, Marshall. *The Gutenberg Galaxy: The Making of Typographic Man.* Toronto: University of Toronto Press, 1972.

Minsky, Marvin. *Computation: Finite and Infinite Machines.* Englewood Cliffs, N. J.: Prentice Hall, 1967.

Minsky, Marvin. *Society of Mind.* New York: Simon and Schuster, 1985.

Mitchell, William J. *The Reconfigured Eye* . Cambridge: Mass., MIT Press, 1992.

Moles, Abraham. *Art and Technology.* New York: Paragon House Press. *Information Theory and Esthetic Perception.* Urbana: University of Illinois Press, 1966.

Mumford, Lewis. *Art and Technics.* New York and London: Columbia University Press, 1952.

Mumford, Lewis. *The Myth of the Machine: Technics and Human Development.* New York: Harcourt, Brace and World, 1966—1967.

Negroponte, Nicholas. *The Architecture Machine: Toward a More Human Environment.* Cambridge, Mass.: MIT Press, 1970.

Nierenberg, Gerard. *The Art of Creative Thinking.* New York: Simon and Schuster Inc., 1982.

Nora, Simon, and Alain Minc. *The Computerization of Society.* Cambridge, Mass.: MIT Press, 1980.

Ong, Walter. J. *Orality and Literacy: The Technologizing of the Word.* London: Methuen, 1982.

Parenti, Michael. *Inventing Reality: Politics of the Mass Media.* New York: St. Martin's Press, 1986.

Pask, Gordon A., and Susan Curran. *Micro Man: Computers and the Evolution of Consciousness.* New York: Macmillan, 1982.

Penley, Constance and Ross, Andrew. *Technoculture.* Minneapolis: University of Minnesota, 1991.

Pickover, Clifford A. *Computers and the Imagination: Visual Adventures Beyond the Edge.* New York: St. Martin's Press, 1991.

Pirenne, M. H. *Optics, Painting and Photography.* Cambridge, U. K.: Cambridge University Press, 1970.

Pomeroy, Jim, ed. *Digital Photography: Captured Images, Volatile Memory, New Montage.* San Francisco: San Francisco Camerawork, 1988.

Pool, Ithiel de Sola. *Technologies of Freedom: On Free Speech in an Electronic Age.* Cambridge, Mass.: Harvard University Press, 1983.

Popper, Frank. *Art of the Electronic Age.* New York: Harry N. Abrams, Inc., forthcoming.

Popper, Frank. *Origins and Development of Kinetic Art.* London: Studio Vista, 1968.

Poster, Mark. *The Mode of Information.* Chicgao: University of Chicago, 1990.

Postman, Neil. *Amusing Ourselves to Death: Public Discourse in the Age of Show Business.* New York: Viking, 1985.

Postman, Neil. *Technopoly: The Surrender of Culture to Technology.* New York: Alfred Knopf, 1992.

Pratt, Vernon. *Thinking Machines: The Evolution of Artificial Intelligence.* Oxford: Basil Blackwell, 1987.

Provenzo, Eugene F. Jr., *Video Kids: Making Sense of Nintendo.* Cambridge, Mass.: Harvard University Press, 1991.

Prueitt, Melvin. *Art and the Computer.* New York: McGraw-Hill, 1984.

Prueitt, Melvin. *Computer Graphics.* New York: Dover, 1975.

Reichardt, Jasia. *The Computer and Art.* New York: Van Nostrand Reinhold, 1971.

Reichardt, Jasia. *Cybernetics, Art and Ideas.* Greenwich, Conn.: New York Graphic Society, 1971.

Rheingold, Howard. *Virtual Reality.* Old Tappan, N. Y.: Simon and Schuster, 1991.

Rhodes, Lynette I. *Science Within Art.* Bloomington: Indiana University Press, 1980.

Rieser, Dolf. *Art and Science.* New York: Van Nostrand Reinhold, 1972.

Ritchin, Fred. *In Our Own Image.* New York, Aperture, 1990.

Rivlin, Robert. *The Algorithmic Image.* Redmond, Wash.: Microsoft Press, 1986.

Rogers, David F., and Alan Adams. *Mathematical Elements for Computer Graphics.* New York: McGraw-Hill, 1976.

Roszak, Theodore. *The Cult of Information.* New York: Pantheon, 1986.

Rothchild, Jean, ed. *Machina ex Dea: Feminist Perspectives on Technology.* New York: Pergammon Press, 1982.

Samuels, Mike, and Nancy Samuels. *Seeing with the Mind 's Eye.* New York: Random House, 1979.

Sanders, Donald. *Computers in Society.* New York: McGraw-Hill, 1977.

Sekula, Alan. *Photography Against the Grain.* Halifax: Nova Scotia College of Art and Design, 1984.

Schiller, Herbert. *Communication and Cultural Domination.* Armonk, N. Y.: M. E. Sharp, 1976.

Schillinger, Joseph. *The Mathematical Basis of the Arts.* New York: Johnson Reprint Corporation, 1966. Originally published in 1948.

Shackle, G. L. S. *Imagination and the Nature of Choice.* Edinburgh: University of Edinburgh Press, 1979.

Shlain, Leonard. *Art and Physics.* New York: William Morrow and Co., 1991.

Smith, Cyril Stanley. *From Art to Science.* Cambridge, Mass.: MIT Press, 1980.

Tagg, John. *The Burden of Representation,* Amherst: University of Massachusetts Press: 1988.

Toffler, Alvin. *Future Shock.* New York: Random House, 1970.

Toffler, Alvin. *Previews and Premises.* Boston: South End Press, 1984.

Tuchman, Maurice. *Art and Technology.* New York: Viking, 1971.

Turing, Alan. *Computing Machinery and Intelligence.* New York: McGraw-Hill, 1963. Originally published in 1950.

Turkle, Sherry. *The Second Self: Computers and the Human Spirit.* New York: Simon and Schuster, 1984.

Valery, Paul. *Aesthetics, the Conquest of Ubiquity.* New York: Pantheon, 1964.

Victorues, Paul B. *Computer Art and Human Response.* Charlottesville, Va.: Lloyd Sumner, 1968.

Virilio, Paul, and Sylvère Lotringer. *Pure War.* New York: Semiotext(e), 1983.

Virilio, Paul. *War and Cinema.* New York: Verso, 1989.

Vitz, Paul C., and Arnold B. Glimcher. *Modern Art and Modern Science The Parallel Analysis of Vision.* New York: Praeger, 1984.

Weiner, Norbert. *Cybernetics: Or Control and Communications in the Animal and the Machine.* Cambridge, Mass.: MIT Press, 1967. Originally published in 1948.

Weiner, Norbert. *God and Golem.* Cambridge, Mass.: MIT Press, 1964.

Weiner, Norbert. *The Human Use of Human Beings.* New York: Anchor Books, 1959.

Weizenbaum, Joseph. *Computer Power and Human Reason.* San Francisco: W. H. Freeman and Co., 1976.

Williams, Raymond. *Television: Technology and Cultural Form.* New York: Schocken Books, 1975.

Williams, Roberta. *The Artist and the Computer.* Louisville, KY.: Louisville Art Gallery, 1985.

Winner, Langdon. *Autonomous Technology: Technics-out-of-Control as a Theme in Political Thought.* Cambridge, Mass.: MIT Press, 1977.

Wolff, Janet. *The Social Production of Art.* New York: New York University Press, 1984.

Wombell, Paul. *PhotoVideo: Photography in the Age of Video.* London: Rivers Oram Press, 1991.

Woodward, Kathleen, ed. *The Myths of Information.* Madison, Wis.: Coda Press, 1980.

Youngblood, Gene. *Expanded Cinema.* New York: E. P. Dutton, 1970.

Zientara, Marguerite. *The History of Computing.* Framingham, Mass.: CW Communications, 1981.

Articles

Abramson, Dan. "Computer-Controlled Effects." *VideoPro,* September, 1983.

Ahl, David H. "Art and Technology." *Creative Computing,* October, 1979.

Akchin, Don. "High-Tech Is Invading the Art World." *USA Today,* 1 August, 1983.

Alloway, Lawrence. "Talking with William Rubin: The Museum Concept Is Not Infinitely Expandable." *Artforum,* October, 1974.

Ancona, Victor. "Shalom Gorewitz: Metaphoric Image Manipulator." *Videography Magazine,* November, 1980.

Ashton, Dore. "End and Beginning of an Age." *Arts Magazine*, December, 1968.

Bangert, Charles and Collette. "Experiences in Making Drawings by Computer and by Hand." *Leonardo*, Volume 7, Number 4, 1974.

Begley, Sharon. "The Creative Computers." *Newsweek*, 5 July, 1982.

Benthall, Jonathan. "Anatomy and Anomaly." *Studio International*, July-December, 1971.

Beyles, Peter. "Discovery through Interaction: A Cognitive Approach to Computer Media in the Visual Arts." *Leonardo*, Volume 24, Number 3, 1991.

Brenson, Michael. "From Young Artists, Defiance Behind a Smiling Facade." *New York Times*, September 29, 1985.

Buchloch, Benjamin H. D. "Figures of Authority, Ciphers of Regression." *October*, No. 16, Spring, 1981 .

Burnham, Jack. "Problems in Criticism IX: Art and Technology." *Artforum*, January, 1971.

Buxton, William. "Computers as Artists." *Discover Magazine*, January, 1980.

Chandler, John, and Lucy Lippard. "The Dematerialization of Art." *Arts International*, No. 12, 1968.

Cohen, Harold. "Computer Response." *Art in America*, September, 1972.

Cohen, Harold. "On Purpose: An Enquiry into the Possible Roles of the Computer in Art." *Studio International*, January, 1974.

Coler, Myron A. "Creativity in Technology and the Arts." *Leonardo*, Vol. 1, no. 3, 1968.

Cook, R. L., and K. E. Torrence. "A Reflectance Model for Computer Graphics." *Computer Graphics*, August, 1981.

Cornock, Stroud, and Ernest Edmonds. "The Creative Process Where the Artist Is Amplified or Superseded by the Computer." *Leonardo,* Volume 6, Number 1, 1973.

Couey, Anna. "Participating in an Electronic Public: TV Art Effects Culture." *Art Com* 25, 7, 1984.

Crimp, Douglas. "The End of Painting." *October*, Number 16,Spring, 1981.

Crimp, Douglas. "Function of the Museum." *Artforum*, September, 1973 .

Crimp, Douglas. "On the Museum's Ruins." *October* no. 13, Summer, 1980.

Crow, F. C. "Shadow Algorithms for Computer Graphics." *Computer Graphics*, Summer, 1977.

Csuri, Charles. "Computer Graphics and Art." *IEEE Proceedings*, April, 1974.

Cuba, Larry. "The Rules of the Game." *Arts Review*, September, 1979.

Davis, Joe. "The Last Getaway Specials: The Space Shuttle and the Artist." *Leonardo*, vol. 24, no 4, 1991.

Davis, Douglas. "Art and Technology: The New Combine." *Art in America*, January—February, 1968.

Denes, Agnes. "Politics." *Artforum*, December, 1970.

Dewar, Robert. "Computer Art: Sculptures of Polyhedral Networks Based on an Analogy to Crystal Structures Involving Hypothetical Carbon Atoms." *Leonardo*, Volume 15, Number 2, 1982.

Dieckman, Katherine. "Electra Myths: Video, Modernism, Postmodernism." *Art Journal*, Fall, 1985.

E.A.T. News 1, nos. 1 and 2, 1967. "New York: Experiments in Art and Technology, Inc."

Franke, H. W. "Computers and Visual Art." *Leonardo*, Vol. 4, no. 4, 1971.

Franke, H. W., ed. "Computer Graphics—Computer Art." *The Visual Computer*, July 1986, entire issue.

Franke, H. W. "The New Visual Age: The Influence of Computer Graphics on Art and Society." *Leonardo*, Vo. 18, no. 2, 1985.

Fried, Michael. "Art and Objecthood." *Artforum*, Summer, 1967.

Furlong, Lucinda. "Artists and Technologists: The Computer as An Imaging Tool." *SIGGRAPH*, exhibition catalogue, 1983.

Gardner, Paul. "Think of Leonardo Wielding a Pixel and a Mouse." *The New York Times*, 22 April, 1984.

Graham, Dan. "Theatre, Cinema, Power." *Parachute Magazine*, no. 31, June, July, August, 1983.

Grundberg, Andy. "Beyond Still Imagery." *New York Times*, April 7,1985.

Grundberg, Andy. "Images in the Computer Age." *New York Times*, April 14,1985.

Hachem, Damir. "A Time for Fusion of Technology and Style." *Millimeter Magazine*, February, 1983.

Haller, Robert. "Camera Eye: The Vasulka." *American Film*, December, 1981.

Harries, John. "Personal Computers and Noted Visual Art." *Leonardo*, Vol. 14, no. 4, 1981.

Hart, Claudia. "Electronic Spirits." *Industrial Design*, January-February, 1985.

Helmick, Richard. "The Unlikely Birth of a Computer Artist." *ROM*, October, 1977.

Henderson, Linda Dalyrymple. "A New Facet of Cubism: 'The Fourth Dimension' and 'NonEuclidean Geometry' Reinterpreted." *Art Quarterly*, Winter, 1971.

Hill, Anthony. "Art and Mathesis: Mondrian's Structures." *Leonardo*, Vol. 1, no. 3, 1968.

Hess, Thomas B. "Gerbil Ex Machina." *ARTnews* December, 1970.

Ho, Mae-Wan. "Renaming Nature: The Intergration of Science with Human Experience." *Leonardo*, Vol. 24, no. 5, 1991.

Hockenhull, James. "Courting the Digital Muse—With a Little Help from Microspeed." *Creative Computing*, February, 1982.

Hornbacher, Sara, ed. "Video: The Reflexive Medium." *Art Journal*, Fall, 1985.

Jacobs, David. "Of Cretans and Critics: In Search of Photographic Theory." *Afterimage*, February, 1983.

Johnson, Rory. "Computer Is Leading Artists into New Trains of Thought." *Computer Weekly*, 26 February, 1981.

Kaprow, Allan. "The Education of the Un-Artist," Parts I, II and III. *Art in America*, February, 1971; May, 1972; and January—February, 1974.

Kirkpatrick, Diane. "Between Mind and Machine." *Afterimage*, February, 1978.

Kozloff, Max. "Men and Machines." *Artforum*, February, 1969.

Landy Sheridan, Sonia. "Image Generation Survey: Interaction." *Leonardo*, Vol. 23, no. 2/3, 1990.

Lentini, Luigi. "Private Worlds and the Technology of the Imaginary: Effects of Science and Technology on Human Representations and Self-Conceptions." *Leonardo*, Vol. 24, no. 3, 1991.

Loeffler, Carl E. "Television Art and the Video Conference." *Art Com* 23, 6,1984.

Mallary, Robert. "Computer Sculpture: Six Levels of Cybernetics." *Artforum*, May, 1969.

Margolies, John S. "TV—The Next Medium." *Art in America*, September/October, 1969.

Mayor, A. Hyatt. "The Photographic Eye." *Bulletin of the Metropolitan Museum of Art*, July, 1946.

Nadin, Mihai. "Science and Beauty: Aesthetic Structuring of Knowledge." *Leonardo*, Volume 24, Number 1, 1991.

Noll, Michael. "The Digital Computer as a Creative Medium." *IEEE Spectrum*, October, 1967.

Nygren, Scott, and Woody Vasulka. "Didactic Video: Organizational Models of the Electronic Image." *Afterimage*, October, 1975.

Owens, Craig. "Phantasmagoria of the Media." *Art in America*, May, 1982.

Paulson, William. "Computers, Minds, and Texts: Preliminary Reflections." *New Literary History,* Number 20, 1989.

Peterson, Dale. "Cybernetic Serendipity." *Popular Computing*, November, 1984.

Pocock-Williams, Lynn. "Toward the Automatic Generation of Visual Music." *Leonardo*, Vol. 25 no. 1, 1992.

Popper, Frank. "The Place of High-Technology Art in the Contemporary Art Scene." *Leonardo*, Vol 26, no. 1, 1991.

Preusser, Robert. "Relating Art to Science and Technology: An Educational Experiment at M.I.T." *Leonardo* , Vol. 6, no. 3, 1973.

Raynor, Vivien. "Video Gaining as an Art of the Avant-Garde." *New York Times*, 23 October 1981.

Rice, Shelley. "The Luminous Image: Video Installations at the Stedlijk Museum." *Afterimage*, December, 1984.

Richmond, Sheldon. "The Interaction of Art and Science." *Leonardo* , Vol. 17, no. 2, 1984.

Ross, Douglas. "Computer Artists Reveal 'Esprit de Corps' as Tough Campaign Looms." *New Art Examiner,* Summer, 1983.

Schiller, Herbert. "Behind the Media Merger Movement." *The Nation,* 8 June 1985.

Sheridan, Sonia. "Generative Systems." *Afterimage*, April, 1972.

Sheridan, Sonia. "Generative Systems—Six Years Later." *Afterimage*, March, 1975.

Smith, A. "The New Media as Contexts for Creativity." *Leonardo*, Vol.17, no. 1, 1984.

Starenko, Michael. "Fast Forward: 1984 Media Alliance Conference." *Afterimage*, December, 1984.

Strauss, David Levi. "When Is a Copy an Original?" *Afterimage*, May-June, 1976.

Trend, David. "Media and Democracy: Or What's in a Namac?" *Afterimage*, December, 1984.

Tomkins, Calvin. "To Watch or Not to Watch." *New Yorker*, May 25, 1981.

Turner, Frederick. "Escape from Modernism: Technology and the Future of the Imagination." *Harper's Magazine*, November, 1984.

Veeder, Jane. "Viewer into Player: Notes on the Interactive Computer Art Installations of the 1988 SIGGRAPH Exhibition of Computer Art." *Leonardo*, Vol. 23, no. 1, 1990.

West, Susan. "The New Realism." *Science '84*, July-August, 1984.

Wilson, Stephen. "Interactive Art and Cultural Change." *Leonardo*, Vol. 23, no. 2-3, 1990.

Wilson, Stephen. "Technological Research and Development as a Source of Ideas and Inspiration for Artists." *Leonardo*, Vol. 24, no. 4, 1991.

Contributors

Regina Cornwell is a New York–based writer on contemporary art who specializes in technology and media-related work. She is the author of *Snow Seen: The Films and Photographs of Michael Snow,* and served as guest editor of a special issue of *New Observations* focused on interactive art, culture, and education. Her articles appear regularly in *Art Monthly, Canadian Art*, and *Art in America*. Cornwell was awarded a 1992 Media Arts Prize for her writing in this field, given by the Siemens Cultural Program of Germany. Her new book about Grahame Weinbren's interactive art installation *Sonata* will be published by Critical Press, New York, later this year.

Timothy Druckrey is an independent curator, critic, and writer about issues of photographic history, electronic media, and representation. He has taught in the graduate programs at the International Center of Photography, the School of Visual Arts, and the Center for Creative Imaging. He lectures widely about the social impact of digital media and the transformation of representation within technoculture. He co-organized the international symposium *Ideologies of Technology* at the Dia Center for the Arts in 1992 (publication forthcoming). As a critic of contemporary photography and a photo historian, he has curated exhibitions and has contributed to numerous publications including *San Francisco Camerawork, Afterimage,* and *Views*. He is the American Editor for two photographic journals: the British *Ten. 8* and the Dutch *Perspektief.* Druckrey is also a founding member of MergeMedia, a support group for independent computer projects; and co-founder, with Nadine Lemmon, of Critical Press, publishing monographs on technology and identity issues in postmodern culture. He is currently at work on a book called *Experimental Imaging.*

Brenda Laurel has worked in the personal-computer industry since 1976 as a programmer, software designer, producer, and researcher. She received her Ph.D. in theater from Ohio State University. Her developmental work with Atari Research, software architectures for dramatic/virtual worlds, was published in her doctoral dissertation in 1986. Laurel has since worked as a design and research consultant for such clients as Apple Computer, Lucasfilm,

American Interactive Media, Citibank, Fujitsu Laboratories, Carnegie Mellon University, and Paramount Communications. In 1990 she co-founded Telepresence Research Inc., which offers R&D services in telepresence and virtual reality. She is editor of the book *The Art of Human-Computer Interface Design* (Addison-Wesley, 1990), and author of *Computers as Theater* (Addison-Wesley, 1991).

Florian Rötzer works as a free-lance writer and journalist in Munich, concentrating on philosophy, art, and media theory. Rötzer has organized several international conferences about art theory, new media, and scientific topics, such as: "Strategies of Shine," Frankfurt 1990; "Cyberspace," Munich 1991; "Van Gogh, Malevich, Duchamp," Munich 1991; "Artificial Games," Munich 1993 and "From Simulation to Stimulation," Graz 1993. He has edited many books, including *Interviews with French Philosophers*, Munich 1986; *Interviews with German Philosophers*, Frankfurt , 1987; *The Aesthetics of the Immaterial*, Cologne, 1988; *The Aesthetics of Electronic Media*, Frankfurt am Main, 1991; *Groups of Artists—a Phenomenon of Modern Art* (in collaboration with S. Rogenhofer), Cologne, 1991; and *Cyberspace* (in collaboration with P. Weibel), Munich, 1993.

Charles Stainback is the Associate Director of Exhibitions and Curator of Video and Media Programs at the International Center of Photography. In addition to being former Director of the Aperture Foundation's Burden Gallery in New York, and Exhibition Coordinator for Visual Studies Workshop in Rochester, he has also worked with the Friends of Photography in San Francisco. Over the past decade Stainback has curated numerous exhibitions featuring some of the most challenging photographically based work being produced by contemporary artists and photographers, addressing the range of possibilities of the photographic medium. These exhibitions have included: "Before the Camera," 1986 ; "Portrayals," 1987; "Culture Medium," 1989; "The Anonymous Other," 1991; and most recently "Special Collections: The Photographic Order from Pop to Now," 1992. Stainback has also organized a series of video installations at ICP which has included work by Bruce Charlesworth, Bill Beirne, Shu Lea Cheang, Lynn Hershman, and Joan Logue.

Photo Credits

Most of the photographs reproduced in this catalogue have been provided by the artists or by the collections indicated on the exhibition checklist. We thank them for their generosity and would like to acknowledge the following for their contributions:
David Lubarsky, p. 169; Charles Stainback, pp. 162, 163; Walker Art Center, Minneapolis, MN, pp. 157, 158, 160; Jim Via, pp. 87, 115, 121, 133, 138-140, 144, 145, 150, 159-163.